Palace
of Gold
&Light

Palace
of Gold
&Light

Palace
of Gold
& Light

Treasures from the
Topkapı, İstanbul

The Corcoran Gallery of Art, Washington, DC
March 1 – June 15, 2000

San Diego Museum of Art, San Diego, CA
July 14 – September 24, 2000

Museum of Art, Fort Lauderdale, FL
October 15, 2000 – February 28, 2001

Palace Arts Foundation

Sponsors of the Exhibition

The exhibition is underwritten by Dr. Kenan E. Şahin

The exhibition's national tour has been made possible by support from Sikorsky Aircraft Corporation.

The presentation of the exhibition in Washington, San Diego, and Fort Lauderdale is sponsored by American Express Company.

Turkish Airlines Inc. is the official airline of the exhibition.

Additional support has been generously provided by Vakko, İstanbul and Kavaklıdere Wines Co., Ankara, Turkey.

Special thanks to the Ministry of Tourism and the Government Press Office, Republic of Turkey and to the Hilton Hotel, İstanbul.

Exhibition Dates

The Corcoran Gallery of Art, Washington, DC
March 1 – June 15, 2000

San Diego Museum of Art, San Diego, CA
July 14 – September 24, 2000

Museum of Art, Fort Lauderdale, FL
October 15, 2000 – February 28, 2001

Lenders to the Exhibition

Topkapı Palace Museum
Museum of Turkish and Islamic Arts
Military Museum
İstanbul Archaeological Museums
Yıldız Palace Museum
Manisa Museum
Engin and Nuri Akın Collection

Palace Arts Foundation, Inc.

Richard C. Barkley, Chairman
Mark A. Epstein, President
Susan J. Lutzker, Secretary/Treasurer
Arnold P. Lutzker, Counsel
Mary Eva Candon, Director
Linda Cohen, Director
Warren W. Eisenberg, Director
Walter B. Denny, Senior Advisor, UMass, Amherst

Exhibition Committee

Terence & Dorothy McAuliffe, Co-Chairs
Margaret Tutwiler, Co-Chair
Ahmet Ertegun
Jeffrey J. Steiner
Thomas J. Donohue
Sahir Erozan

Catalogue Presentation

Designed by Ersu Pekin
Photography by Hadiye Cangökçe
Color Separation by Gama A.Ş., İstanbul

Exhibition Consultants

Curator: Tülay Artan (Berktay), Sabancı Univ.
Exhibition Design: Staples & Charles Ltd.
Registrarial Services: Rosemary M. DeRosa and Douglas J. Robinson
Public Relations: Ruder Finn Arts & Communications Counselors
Graphics: LaPlaca Cohen Advertising
Legal Services: Lutzker & Lutzker LLP
Development Services: The Kerry S. Pearson LLC
Insurance: Alexander Forbes Risk Services and Axa Oyak Sigorta
Case fabrication: Maltbie Associates
Exhibition conservator: Catharine Valentour
Textile conservator: Polly Willman
Exhibition mounts: Francis T. Byrne, Jr. and Paul Daniel

ISBN 0-9678639-0-2

Printed in İstanbul, Turkey by Me-Pa Medya Pazarlama A.Ş.

Contents

THE WHITE HOUSE

WASHINGTON

The American people are most grateful for the generous loan by the Republic of Turkey of a magnificent collection of imperial treasures from the legendary Topkapı Palace in İstanbul. This exhibit offers us a welcome opportunity to experience firsthand the extraordinary artistic achievements of a great civilization.

The royal treasures of the Sultans reflect the rich and diverse culture of the Ottoman Empire – a multiethnic, multireligious society where tolerance for people who were different allowed many cultures to coexist and thrive together, producing some of the greatest artistic masterpieces of the last thousand years.

I hope that each of you viewing this remarkable collection will take delight in the rare opportunity to see these treasures that our good friends, the Turkish people, have shared with us and to learn more about the great cultural legacy they have given to the world.

The President

The works of art from the Topkapı Palace – the home of the Ottoman Sultans – on display in the exhibition *The Palace of Gold & Light* are part of the heritage of a vast and diverse empire and the unique multiethnic and multireligious culture which it created.

Rising from humble origins in northwest Anatolia at the end of the 13th century, the Ottoman realm would eventually encompass dozens of nationalities, spread over three continents and become a locus of commerce, communication and culture.

By the time the Empire was formally dissolved and the modern Republic of Turkey established in 1923, the Ottoman dynasty had reigned for over 600 years. Since then the Topkapı Palace in İstanbul has been preserved as a museum and has become a major attraction for visitors from around the world.

Thus this carefully selected collection from the Topkapı Palace, which includes some of the finest objects of art created in Ottoman times, offers the American public an insight into a different age and civilization.

The skills and success of the Ottomans as statesmen, administrators and soldiers are already well known. I believe this splendid exhibition will help to highlight the cultural achievements of the Ottomans as craftsmen and patrons of art.

I am also confident that the exhibition will serve as a new cultural bridge between the Turkish and American people and thereby strengthen the long-standing bonds of friendship, trust and solidarity which link our two nations.

We are proud to share with our American friends this artistic legacy of the Turkish people.

Süleyman Demirel

On the occasion of the 700th anniversary of the founding of the Ottoman Empire, the Turkish government is proud and honored to share with the people of the United States a selection of the greatest works of art and craftsmanship from one of the richest and most diverse periods in our history.

As the royal home of the Ottoman sultans from the 15th to the 19th century, the Palace itself and its contents reflect the finest artistic achievements of the age, and the exhibition touring the United States offers a rare glimpse into this world.

As Minister of Culture I am especially pleased that we are able to send a selection of these imperial treasures from the Topkapı Palace and other important Turkish museums. Many of these works will be shown in the United States for the first time. This year-long tour, to these three esteemed museums in different regions of the country, will enable a broad audience to experience firsthand an important aspect of our artistic heritage.

We are confident that *Palace of Gold & Light: Treasures from the Topkapı, İstanbul* will further strengthen the bonds of friendship and cultural understanding between our two countries.

M. İstemihan Talay
Minister of Culture

Since the dawn of human history, the lands of what today constitute modern Turkey have borne witness to the rise and fall of some of the greatest and most creative civilizations that the world has ever known. For almost two thousand years, İstanbul, the city built as the eastern Rome by Constantine the Great, and named Constantinople, served as the seat of two of history's greatest and richest Empires, first the Byzantine and then the Ottoman. It is the artistic genius of the Ottoman Empire, which dominated vast areas of Europe, Asia and Africa for much of six centuries, and which was unique in its size, and its multinational and multiethnic character, that we honor in these pages today.

The Palace Arts Foundation, which in partnership with the government of Turkey has organized this splendid exhibition, *Palace of Gold & Light,* is delighted by this unique opportunity to bring to American audiences the artistic mastery, cultural diversity, and unparalleled wealth of the Ottoman Empire at its zenith. As a Foundation dedicated to fostering international understanding through the arts, we are especially pleased to unveil through this dramatic presentation such a vital part of the rich cultural heritage of the Turkish people.

An exhibition of this quality and caliber can only succeed with the active and creative support of all its participants. We are especially grateful to the Turkish museums for their exceptional dedication in assembling this marvelous collection.

Equally, we have been blessed to work with three of the most outstanding museums in the United States. The Palace Arts Foundation is particularly indebted to David Levy, Director of The Corcoran Gallery of Art; Steven Kern, Curator of European Art at the San Diego Museum of Art; and Kathleen Harleman, Director and CEO of the Fort Lauderdale Museum of Art and Michael Kenny, Director of Cultural Tourism, Greater Fort Lauderdale Convention & Visitors Bureau, as well as their staffs, for their aid, advice and partnership. Together, our colleagues in Turkey and the United States have made possible a presentation of the highest artistic and creative merit. On behalf of the Palace Arts Foundation, I extend to them our fullest admiration and appreciation.

Richard C. Barkley
Chairman
Palace Arts Foundation

Palace of Gold & Light, Treasures from the Topkapı, İstanbul, presents a glimpse into the life of a great palace at the pinnacle of a great empire. Situated on a site for which the oracle at Delphi predicted great glory, the Ottoman Sultans' residence from the 15th century into the 19th became a museum after the Republic of Turkey succeeded the Empire in the 1920's. It has been viewed by millions of visitors and was the setting for a highly acclaimed film. It has a tremendous impact on everyone who sees it.

Through this exhibition, we hope to transmit the drama and splendor of the Topkapı. We also hope that, through this lovely exhibition, a broad American public will be introduced to the complexity and richness of the Ottoman Empire — its many peoples and its cultural and religious diversity.

The Palace had a dramatic impact on our counsel Arnold P. Lutzker, who approached me about the possibility of an exhibition. He and his wife Susan — also an attorney, and our corporate secretary/treasurer — had seen the Topkapı twenty years ago. Having once worked in the Palace as a Fulbright scholar, I agreed wholeheartedly. We contacted my friend Richard C. Barkley, whose distinguished diplomatic career culminated with his tenure as U.S. Ambassador in Ankara. He consented enthusiastically to serve as our chairman. Prof. Walter Denny, another old friend and a prominent American scholar of Ottoman art, agreed to serve as senior advisor, and in turn recommended our very talented curator, Prof. Tülay Artan.

Since then many have contributed to this effort. We are especially grateful to the Turkish Minister of Culture Mr. İstemihan Talay and Undersecretary Prof. Dr. Tekin Aybaş. Our heartfelt thanks are also due the ministry's Directorate of Museums and Monuments, its Director Dr. Alpay Pasinli, deputy Director Kenan Yurttagül, the Head of Cultural Affairs and Publications Ümit Yaşar Gözüm, Director of the Cultural Affairs Section Nilüfer Ertan, and to Asuman Çoruh, the Archeologist of the Directorate.

Without the active support and engagement of the director of the Topkapı Palace Museum Dr. Filiz Çağman, this project would have been impossible; likewise, Nazan Ölçer of the Turkish and Islamic Arts Museum. Special thanks are also due the directors of the other museums that lent objects: Halil Özek, Deputy Director of the İstanbul Archeological Museums, Sabahattin Türkoğlu of the Yıldız Palace Museum, Hasan Dedeoğlu of the Manisa Museum and Arif Tevfik Özdemir, Commander of the Military Museum. There are many additional staff and curators without whom such a project could not be realized, and we are grateful to each of them. Without their contributions no exhibition of this kind can come about.

Thanks are also due Mr. Nuri Akın & Mrs. Engin Akın for generous loans from their private collection. The Turkish Ambassador to Washington Amb. Baki İlkin, his predecessor Amb. Nüzhet Kandemir, and the Director of Cultural Affairs in the Foreign Ministry Amb. Metin Göker provided instrumental help.

As well, we are especially grateful to the three museums, their directors and staffs. Without their expert cooperation this project could not have been realized, and we thank all who were involved.

We hope the visitor and the reader will enjoy and learn from the exhibition and catalogue. Even more so, we hope to awaken interest in a place and a culture too little known to most Americans.

Dr. Mark A. Epstein
President
Palace Arts Foundation

Directors and section curators of lending museums must be the unsung hereos and silent sufferers of any major exhibition. Desiring international recognition for their beloved collections, yet reluctant to part with them for any extended period and thereby to unbalance their permanent exhibits, and worrying endlessly about everything from the condition reports to the insurance costs and packaging of their unique and irreplaceable objects, theirs are the most difficult choices to make, though in the end attention is diverted from people to things: the public sees and admires what they given, while they themselves linger in the shadows.

In this case Dr. Filiz Çağman, the Director of the Topkapı Palace Museum, and Dr. Nazan Ölçer, the Director of the Museum of Turkish and Islamic Art, have done much more than consent and approve; they have spent hours and days with me discussing and developing the concept, suggesting ideas or replacements. At all critical points, Ms. Nilüfer Ertan of the Ministry of Culture intervened time and again to solve outstanding problems. I also benefitted from the expert support of my friend Ms. Selmin Kangal, who has seen many exhibitions. As for my colleagues and friends, the curators and other stuff of Topkapı Palace Museum, the Museum of Turkish and Islamic Arts, and the İstanbul Archaelogical Museums, I can only say that, having frequently entered that world in an asking demanding, persuading role, inwardly I have been sympathizing with many of their anxieties all along. To Ms. Şule Aksoy, Ms. Ülkü Altındağ, Mr. Hilmi Aydın, Ms. Emine Bilirgen, Ms. Feza Çakmut, Ms. Zeynep Çelik, Ms. Selma Delibaş, Ms. Ayşe Erdoğdu, Mr. Deniz Esemenli, Ms. Saliha Gönenç, Ms. Sabahat Gül, Ms. Şehrazat Karagöz, Ms. Gülgün Mandıralıoğlu, Ms. Süheyla Murat, Ms. Gülendam Nakipoğlu, Ms. Birgül Önder, Ms. Alev Özay, Ms. Göksen Sonat, Mr. Cihat Soyhan, Ms. Gönül Tekeli, Ms. Hülya Tezcan, Mr. Ömür Tufan, I am therefore most truly, sincerely grateful.

Dr. Tülay Artan
Curator
Sabancı University

Accessing Ottoman history
Tülay Artan

With globalization on the rise and people on the move as never before, we are constantly witnessing an increase of humanizing, universalizing interest in identities and cultural traditions other than "our" own. The current state of affairs in the Balkans or in the Middle East, moreover, tends to attract special attention, in one way or another, to the Ottoman past of these regions, while among professional historians and art historians, courts and court societies, once discarded and deprecated as part of a one-sided emphasis on "history from below", are coming back under fresh scrutiny. All that adds up to at least three good reasons for having a comprehensive, meaningful exhibition on the artistic legacy of the Ottoman Empire.

The US has already played host to major exhibitions on Ottoman art and culture, including the "Age of Sultan Süleyman the Magnificent" exhibition in the late 1980s and then the "Splendors of the Ottoman Sultans" exhibition of the early 90s. Hence a critical question becomes: In what way might this one be different? In this continental immensity, of course, there are always new places to visit, and thus it will be the first time that any Ottoman exhibition has traveled to San Diego or Fort Lauderdale. More substantially, however, we believe that we have been able to come up with some significant conceptual and material novelties. The entire notional script underlying this exhibition has been designed and verbalized in a new way, and this corresponds to a certain change of emphasis in the range and richness of the actual objects displayed, which among other things try to compensate for the relative neglect of the crucially formative Mehmedian era in the second half of the 15th century.

With regard to the first aspect, that is to say our conceptual underpinnings, in time it will be recognized, I hope and believe, that we have made a strong effort here to create a more user-friendly exhibition, something that should be capable of providing access for the general public to the special "language" of Ottoman art and culture – of rendering its peculiar syntax in universally intelligible terms. Here we have an exhibition on an Eastern or Oriental society, so-called, that is traditionally pigeonholed as "strange" or "inscrutable", and our approach in presenting its beautiful objects to American audiences has been not just to stun them through an array of exotic sights and colors, but also to enable them to cross this outer threshold into an inner world of meanings – to help them relate what they shall be seeing to other, familiar frames of reference.

In order to facilitate this initiation, we have tried to take some key questions, and to organize the five main sections of our exhibition around them: What was the Ottoman Empire? How was power constituted and exercised, rulership legitimized and maintained? How did the state function – through what types of practice, addressed to which items of primary business? Ultimately, what kind of court came to embody all these complicated hierarchies, ceremonies, procedures and performers? What kind of matrix did the palace provide for daily life? And how did it evolve its "aesthetics of power"?

To these, our answers are equally down-to-earth: It was a tributary state and society. At its apex was a ruling dynasty: the House of Osman (or Othman). Like many other dynastic states, it started out modestly, as one competitive war venture

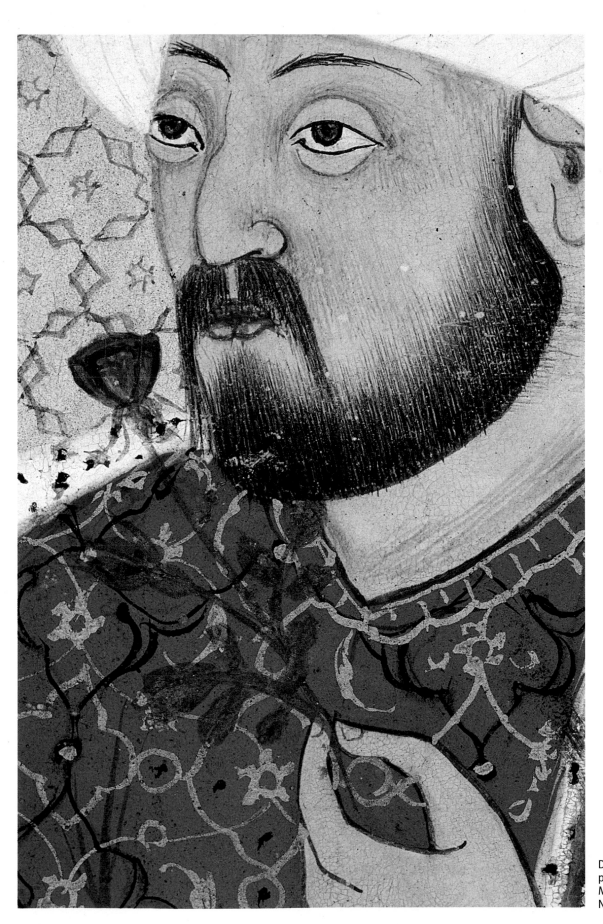

Detail of the
portrait of Sultan
Mehmed II by
Nakkaş Osman.

among many coming out of a major demographic movement, a migration or displacement of peoples (the Oghuz Turks' overrunning of the Middle East being comparable in this sense with the Germanic invasions). Because in history, as in business, nothing succeeds like success, the Ottoman war leadership, too, grew and developed into a state nucleus by attracting various coalitions and alliances to itself. Eventually it came to exercise power both over a whole military-bureaucratic elite, and, together with that elite, over a complex, advanced agrarian civilization comprising large masses of peasant producers together with developed towns serving as the loci not only for local and regional but also international trade.

So much is sociologically clear and understandable. What is (or was) unfamiliar, seen from the West, is the (Islamic) religion, the (Arabic) script, the (Ottoman Turkish) language, and together with them the costumes, the headgear, the music, the prayers – in short, the cultural idiom. But that element of "otherness", too, can be transcended, especially since it was not rigidly and unvaryingly maintained. Instead, for at least three or four centuries the Ottoman political organism showed great flexibility in undertaking successive reworkings of its original Turkish-Islamic tradition to cope with changing times, lands or requirements.

Actually, at the geographically unique juncture of three continents, it first expanded so much, and then proved so durable, that it came to be saddled with all kinds of ambiguities. Where did it really belong – spatially, with Europe or with Asia? Temporally, with the Middle Ages or with Early Modernity? In terms of its characteristic institutions, with a kind of feudalism or with modern, cash-based states? With its military fief system and its salaried royal guards army and artillery corps, it had in it a little of both; regarded from within Christendom, it looked incontrovertibly Oriental, but neither it did look typically Turkish when regarded from the opposed vantage points of West Asian Turkicity, nor for that matter traditionally Islamic when regarded from the vantage point of the lands of Classical Islam. From a very early stage onwards, indeed, it had come to occupy not only Near Eastern but also (southeast) European space. Thus, it began to draw on Byzantine and Balkan precedents, too, in fashioning its own combination of war leadership with bureaucratic management of landed revenue, and of military-charismatic with religious legitimation.

Then in the 15th century, it was the immense prestige resulting from the conquest of Constantinople that led to the "despotization" of the sultanate. Putting two famous Conquerors together – William of Normandy after 1066, Mehmed II after 1453 – it is tempting to speculate that in all ages, winners of unparalleled victories might have thereby obtained a relative autonomy from previous tradition – or, to put it the other way round, a greater capacity to invent tradition. Certainly Mehmed II appears to have capitalized on his great triumph to raise himself and his successors way above the rest of the ruling elite. From 1300 to the 1440s, the Ottoman sultan had been more like a "first among equals", a situation analogous in some ways to early Germanic kingship. Now, however, he came to inhabit an increasingly remote and inaccessible pinnacle. And it was the Topkapı Palace, which the Conqueror deliberately ordered to be built over the old Byzantine acropolis, that came to house these new mysteries of rulership. Mehmed II was not only a contemporary of the High Renaissance in Italy; though on the other side of the religio-cultural divide between Christendom and Islamdom, he was perhaps a better embodiment of the Renaissance Prince than any of the heads of the petty

Italian city-states, playing the game of Macchiavelli's new politics with far greater resources.

Three or four decades after his death, the Ottoman Empire advanced further into Central Europe to become part and parcel of the tangled rivalries, between competing and converging absolutisms, of the Early Modern Era. It was then, from the Süleymanic era onwards, that functional specialization set in, and the court, too, grew immensely large and complex. It loomed large not only within the state as a whole but also with respect to the production of a new artistic idiom of imperial solemnity. And what counted in this regard was not just the sheer weight and volume of its demand, but also, and very directly, the production of its own workshops. In order to keep its finances going, the state organized the regular taxation of sedentary agriculture (meaning millions of small peasant producers) as well as of international trade and commerce. The former, that is to say the land and produce taxes levied on the peasantry, were left to timariot sipahis, who were like petty knights in the context of a non-hereditary military fief system. The latter, that is to say the taxes levied on international trade, meant liquidity, and most of this revenue went into the war machine, with the court as a whole constituting the second largest "item" of expenditure. Included here was the maintenance of an enormous central plant for artistic production that labored to surround the apex and abode of power in an aura of splendor conforming to a unified aesthetic idiom. For Ibn Khaldun, the great historical theorist of political power in the late 14th century, inspiring fear and awe in one's subjects through displays of strength and magnificence was a *sine qua non* of successful rulership. (One might say that he had a Geertzian eye for seeing the substance of power in the trappings of power.)

In any case, it is this awesome orchestration of magnificence by the Ottoman palace artists and workshops that lies at the heart of the present exhibition, which proposes to take the visitor from (A) the Mehmedian redefinition and reorganization of the sultanate, through (B) the sources and rituals of Ottoman power, and (C) the more mundane "shop-keeping" aspects of government, to (D) aspects of the inner space and material culture of the abode of power, and (E) its huge investment in large numbers of skilled craftsmen as well as in out-sourcing when it came to artistic production. This, then, is our first innovation: the crispness of a well-structured narrative that proposes to make sense of the jumbled parts of the whole.

The second has to do with highlighting moments A-C-E of the five-part scheme outlined above. In some of the foregoing, we have tried to explain how Mehmed II (r. 1451-81) and Süleyman I (r. 1520-66) may be taken to represent two major stages in state-formation, the first taking the House of Osman into the transitional Renaissance threshold, as it were, and the second deeper into the Early Modern Era proper. Such sharp contexting is relatively new, being part of ongoing research at the leading edge of Ottoman studies; our exhibition will be not only using it, generally speaking, but also bringing it to bear on "the Conqueror and his court", thereby rectifying the balance vis-à-vis the Süleymanic era. And furthermore, no previous Ottoman exhibition, in the United States or elsewhere, has explicitly incorporated a major section on "running a bureaucratic state" (which is like descending into the bowels of the state) – or for that matter a separate section on the palace workshops (*ehl-i hiref*) organization; this will be the first time that precious objects will be presented not in isolation or as miraculously unique, but as social products, and hence by way of drawing attention to the administrative-economic system underlying and regulating their production.

The palace, power and the arts
Walter B. Denny

Who were the Ottomans?

In 1299 CE, according to Turkish tradition, a tiny principality in the vicinity of the modern-day town of Söğüt in northwest Asia Minor was ceded by the nominal Seljuk sultan of Konya to a semi-tribal Turkish warrior named Osman (chieftain from 1281 to 1324, called in Italian Ottomano, hence "Ottoman"), probably as reward for military services rendered or expected. Part tribal chief, part marcher lord, Osman was the war-leader of a fraction or grouping of the Kayığ tribe, one of several large nomadic groups whose members had migrated west from Central Asia, perhaps pushed in part by the Mongol tide, and had then been moved on by the Konya sultanate to western Anatolia in the 12th and 13th centuries to seek their fortunes on the frontier with Christendom. Osman's fief was in many ways indistinguishable from other small 13th-century Islamic principalities on the borderlands between the waning Byzantine Empire and Islamic domains, but unlike its neighbors, Osman's little territory survived and developed into a great empire. Osman's son Orhan (reigned 1324-1362) conquered for the new dynasty a respectable capital city, Brousa/Bursa in Bithynia, and his field commanders crossed the Dardanelles to establish an Ottoman foothold in Europe at Gallipoli. Orhan's son Murad I (r. 1362-1389) pressed the dynasty's fortunes in Europe, especially at the expense of the Serbs, and in the 1360s the military capital of the growing state was moved to Edirne (Adrianople) where today the borders of Greece, Bulgaria and Turkey meet on the Meriç river in eastern Thrace.

Murad's son Bayezid I, nicknamed Yıldırım – "the Thunderbolt" – because of his ability to move his well-trained army quickly and unexpectedly between Europe and Asia, continued to expand the empire. Ottoman conquests in the Balkans proceeded apace, and in 1396 Bayezid defeated a great army of Hungarian soldiers and French knights before Nicopolis on the Danube in Bulgaria. From this famous success Bayezid's star continued to rise until his sudden and cataclysmic defeat by the armies of the Central Asian ruler Timur (Tamerlane) before Ankara in 1402. After his capture, according to legend, he was carried around by the victor locked in an iron cage a tragic fall later recalled in European re-tellings by the Elizabethan playright Christopher Marlowe, the German composer George Frideric Handel, and the French dramatist Magnon.

With Bayezid dead in captivity in 1403 and his territories in disarray, it looked as if the Ottoman Empire might join the countless other dynastic military states that lived and then perished by the sword. But against all expectations, after a ten-year interregnum of conflict among the sons of Bayezid, Sultan Mehmed I (reigned 1413-1421) emerged as the winner and restored his father's empire. By the middle of the 15th century, under his son Murad II (r. 1421-1451) the lands of the Byzantine Emperor had been reduced by the Ottomans to the capital city of Constantinople, plus isolated provinces on the Black Sea and in the Peloponnessos. Behind its great double stone walls fronted by a moat, Orthodox Christian Constantinople nervously prayed for deliverance and pursued West European alliances, all the time plagued by internal divisions and strife that today give the adjective 'Byzantine'

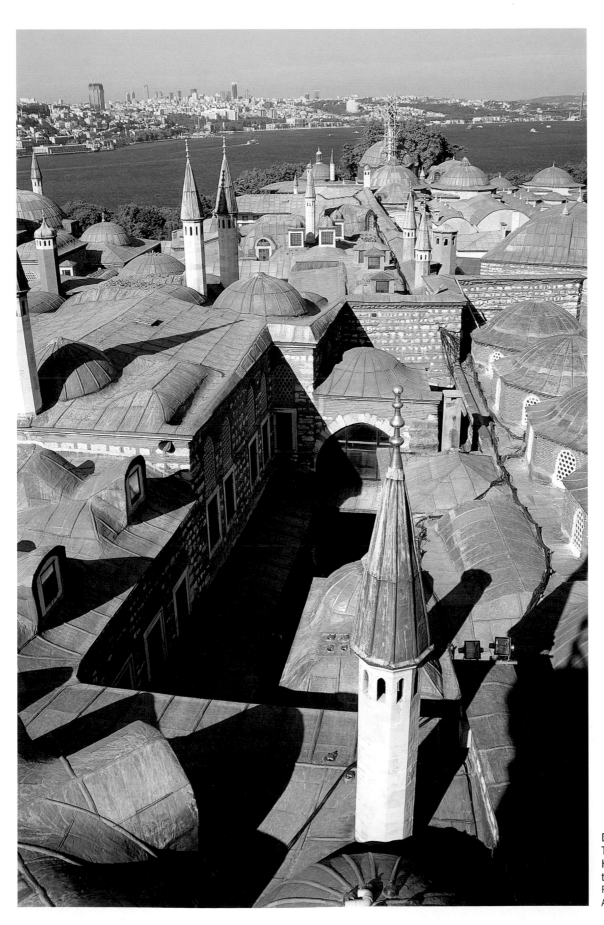

Domes of the
Topkapı Palace
Harem, toward
the Bosphorus.
Photographed by
Ali Konyalı.

its second dictionary meaning. Meanwhile, the Ottomans' Asian capital city of Bursa, the linchpin of east-west commerce in the precious commodity of silk, became one of the richest cities in the world, and their European capital, Edirne, was embellished by beautiful monuments of religious and secular architecture.

Mehmed II (r. 1451-1481) is known in Turkish history as *Fatih* – the Conqueror. Like his grandfather, he bore the Turkish version of the name of Islam's Messenger and founder, the sixth and seventh-century Prophet Muhammad. In many respects Mehmed the Conqueror reminds us today of some of his energetic contemporaries in Renaissance Italy. A brilliant and energetic military strategist, a speaker of several languages, possessed of a tremendous intellectual curiosity and an apparently very sophisticated interest in art and architecture, Mehmed was to earn the blessings that the Prophet Muhammad was traditionally said to have promised the Muslim conqueror of the City of Constantine. In May 1453, after a protracted siege in which huge bronze bombards firing gigantic stone cannon-balls were the major attack weapons, Mehmed's troops broke through the battered walls, and Constantinople, eventually to be known as İstanbul, became the new capital of the Ottoman Empire.

The palace and the capital

While his armies continued to expand the Ottoman Empire both in Europe and in Asia, Mehmed now began to apply some of his energy and intellect to the repopulation and rebuilding of his new capital. From towns and cities all over the Empire came a great wave of urban migration, the settlers occasionally giving the names of their former towns to new quarters in the capital. In the center of the city he built two great market-halls that today form the nucleus of

İstanbul's famous Grand Bazaar. On the highest hill he constructed a vast complex of buildings that included a mosque, several colleges, a hospital, and other social-service institutions. And on the very tip of the seven-hilled triangular peninsula comprising the city, on a magnificent site symbolically facing east across the Bosporus to Asia, south-west to the Marmara Sea and Europe, and northward toward the Black Sea, Russia, and Transcaucasia, he began the construction of the huge palace complex initially called the New Palace and today known as the Topkapı Sarayı: the Palace of the Cannon Gate.

Unlike the European palaces most familiar in the West today, the traditional Islamic palace was not a single house-like building of many rooms built with imposing facades and meant to be viewed from all sides. Rather, like the Alhambra in Granada, Spain, which is our earliest surviving Islamic palace, it was conceived as a series of ceremonial pavilions, living quarters, government offices and service buildings, arranged around a succession of open courtyards and set in a large park surrounded by protective walls. Mehmed's first structure in his New Palace was a two-domed pavilion on the edge of a cliff overlooking the sea; today it houses the Treasury. He also commissioned for the park three more pavilions, one each in the Turkish, the Persian and the "Frankish" or European styles, a symbolic indication of his vision of the reach of Ottoman power; he was thus responsible for the first appearance of "exotic" park architecture that would have a long lineage in Europe in later times.

As it grew over the centuries, the Topkapı Palace became a city within a city, serving not only as the residence of the Sultan and his family, but as a seat of government, a site of dynastic ceremonies and diplomatic contacts with other countries, a store-house of Islamic holy relics, and a

repository of collections of art, costumes, luxury objects, weapons, books, documents, and symbols of rulership that today make up the contents of the Republic of Turkey's most famous museum, situated in the second, third and fourth courts of Mehmed's palace complex. The plan of the Palace developed not as a formal and symmetrical arrangement of symbolic buildings, such as we see in the Forbidden City of Beijing, but in a fashion at once symbolic and practical, where large numbers of buildings of surprisingly modest size served dozens of practical functions.

In former days, one passed through the Imperial Gate in the surrounding walls of the Topkapı Palace to enter the huge outer court and gardens. In this precinct were vast stables for the horses of the Sultan and a regiment of Palace cavalry, the barracks of the palace guard, the Imperial Mint, and a host of gardens and seaside pavilions. Also enclosed by the outside walls was the sixth-century Byzantine church of Hagia Eirene (Holy Peace), which today serves İstanbul as a distinguished concert hall. Much later, in the second half of the nineteenth century, the Archaeology Museum with its astounding collections was also built in this same first courtyard of the then-abandoned Topkapı Palace.

A few hundred meters from the Imperial Gate one comes to the Middle Gate or the Gate of Salutation, which with its twin pointed towers and crenellations guarded the more restricted access to the palace proper, and which today marks the entrance to the Topkapı Palace Museum. Beyond it lies the second court, the major ceremonial space of the Palace. To the left, under the Palace's tallest tower, is the meeting-room of the Divan or the governing Council of State, where major political and administrative decisions were made, presided over by the Sultan or by the Grand Vizier, his chief executive. To the right is the single largest

building in the Palace, the Imperial Kitchens, with their rows of domes and chimneys, where daily meals for over four thousand people were prepared by an army of cooks, and where today the Topkapı's world-famous collections of Chinese porcelain are on display. And in the center of the wall running across the far end of the courtyard is a smaller domed gateway, the Gate of Felicity, beyond which one enters the third court.

Directly beyond the Gate of Felicity and connected to it by a columned porch is the Ottoman equivalent of a throne room: the Imperial Audience Hall, where foreign ambassadors were received by the Sultan. Today the third court houses some of the Museum's most renowned collections: costumes, embroideries, seals, miniature paintings, calligraphy, and, in a former mosque, the Library, comprising the world's richest collection of Turkish and Islamic manuscripts of all types. Beyond the Imperial Audience Hall on the right is the Treasury, housed in Sultan Mehmed's original pavilion, and filled with a panoply of royal and ceremonial objects in gold and silver, agate and jade, rock crystal and jewels. Imperial thrones and weaponry, gifts from foreign rulers, and luxury objects made by the Palace craftsmen, fashioned with exquisite craftsmanship from the most precious materials, are today displayed within the halls of the Treasury under its two large domes. On the left is the Pavilion of the Holy Mantle, a chamber housing some of the Islamic world's most venerated relics, including a robe said to have been worn by the Prophet Muhammad; in Ottoman times, possession of these relics symbolized the Sultan's dual role as Ottoman sovereign and Commander of the Faithful, the caliph or leader of all the world's Muslims. And in the center of the third courtyard is perhaps the most charming of the Palace's many buildings, the small and

exquisite library in the Ottoman classical style built in the early 18th century by Sultan Ahmet III, in a period today known as the Tulip Era.

Beyond the third court, two passageways lead to the fourth and last court of the palace. Unlike the second and third courts, which are surrounded by buildings and porticos, the fourth court is in fact a garden, with various kiosks or pavilions that served the Sultan and his family as places of contemplation and repose, set among flowers, pools and fountains: a kind of earthly paradise. From the second through the third into the fourth courtyard, the Palace becomes progressively more and more private and restricted as one moves north-east along the length of the rectangular ground plan. Through the centuries, visitors to the Palace often wrote of their impressions of the first two courtyards, and of the events that they witnessed there, while knowledge of the third and fourth courtyards was rare and mostly based on hearsay.

Furthermore, there was one vast area of the Palace for which no travelers' impressions were recorded, no accurate descriptions made, and where no Ottoman state ceremonies were performed. This complex of courtyards, buildings, fountains and gardens formed the residence of the household of the Sultan himself, and is known in Turkish as *harem* – literally, "restricted area." Over the centuries no institution within the Ottoman Empire has elicited in Europe and the West as much fascination as the Sultan's harem in the Topkapı Palace, and, not surprisingly, no part of the Palace has been more completely misunderstood.

Constituted as a palace within the palace, the harem was ordinarily populated by two groups. First there was the royal household itself, centered on the Sultan (who for a long time was its only adult male member), his mother, his female con-

sorts, and his children, including his sons who had not yet come of age and been sent off to a provincial governorship. Later, from the end of the sixteenth century onwards, the male members of the royal household living in the harem came to include the reigning sultan's brothers and adult sons, who were no longer sent off to the provinces at adolescence. Second, there were their women servants, as well as an elite corps of male guardians, normally castrated slaves from Ethiopia known as eunuchs, who acted as administrators and servants. The real power figure within the harem was the Valide Sultan, mother of the reigning Sultan, while its chief administrator was the Kızlar Ağası, or Chief of the Black Eunuchs. This latter official was in many ways a sort of mayor of the Palace, whose responsibilities included, in addition to the administration of the harem itself, the overseeing of vast religious endowments, properties whose rents provided the funds for the upkeep of the Islamic Holy Cities of Mecca and Medina in Arabia.

What was life in the harem like in Ottoman times? For all of the feverish imagining of European poets, painters, and novelists (more often than not based on their own repressed fantasies rather than on any kind of fact), the harem functioned like any cloistered community, with its rules and rituals, and its internal hierarchy of favorite consorts, ordinary consorts, and servants, presided over by the Valide Sultan. Boredom and routine were almost certainly the major components of harem life, punctuated by festivals and excursions to other, lesser palaces on the Golden Horn or the Bosphorus aboard the graceful and many-oared royal caiques or long-boats. To be sure, dramatic events did occur there as well; dark memories of the execution of Grand Vizier İbrahim Pasha, favorite of Süleyman the Magnificent, strangled on a night when he had been

invited to sleep over at the Palace (1536), and the bloody intrigues of that period in the 17th century known today as the Reign of Women, permeate the shadows of the harem's labyrinthine corridors, where those with vivid imaginations can still hear the drunken laughter of Sultan Selim II (r. 1566-74) or the insane ravings of Sultan İbrahim (r. 1640-48). But despite the attempts of some guidebooks to drape it in a veil of sexual fantasy, today the harem reminds us, first and foremost, that the Topkapı Palace was the residence of a large extended family and its numerous servants, who lived in isolated luxury in a very large and sprawling house directly adjacent to the seat of government and symbols of religious sovereignty. As in Europe, the size of the royal household was a symbol of royal power, and the number of wives and consorts was a measure of wealth, not of appetite. Over the centuries the harem's inhabitants, like the inhabitants of any house, demonstrated the full spectrum of human strengths and weaknesses, from the demented mid-17th century Sultan İbrahim to the passionate and steadfast love of Süleyman the Magnificent (r. 1520-66) for his wife Hürrem Sultan.

An empire of many nations

Shortly after capturing Constantinople in 1453, Mehmed the Conqueror confirmed the Orthodox monk Gennadios as Patriarch of the Greek Orthodox Church, and gave him the Pantokrator monastery as his official residence. Not only did the Byzantine historian Critobolos (Kritovoulos) of Imbros write a famous history of Sultan Mehmed's reign, but other Ottoman subjects of Greek ethnicity occupied positions of importance in the Ottoman state hierarchy. Under Mehmed's son and successor Bayezid II (r. 1481-1512) the Ottoman Empire became a refuge for Sephardic Jews expelled from Spain after the

Catholic Reconquest in 1492, and İstanbul and Salonika, among other Ottoman cities, came to harbor large and flourishing Jewish communities. Responding to the growing Ottoman patronage of the arts, talented creators of beautiful things all over the Ottoman territories as well as the rest of the Islamic world came to İstanbul to join the royal workshops. The Iranian Shah Kulu became the chief of the Company of Designers in the 16th century, and under him worked Turks, Georgians, Hungarians, Bosnians, and Persians. The Empire was enriched by its policies of tolerance towards various religious communities, who in civic affairs were allowed to follow their own customary laws under their own leaders, as well as by the widespread, non-forced, socially motivated conversion of individuals of many different confessions to Islam. Simultaneously the *devshirme*, or child-levy system, in which talented youths of Christian parentage within the Empire were drafted into royal service and then trained and educated by the state as an Islamicized meritocracy, gave the Ottomans a rich pool of converted Muslims that formed not only the famous Janissaries, the superbly trained "royal guards army" core of the Ottoman armed forces, but also staffed its bureaucracy on all levels. Trained in the Palace school, cut off from local or family ties, promoted according to ability, and intended to be wholly devoted to the Sultan and his Empire without any factional allegiances, this *devshirme* bureaucracy produced over the centuries some of the Empire's most outstanding administrators and creative minds, such as the two outstanding grand viziers of the 16th century, Rüstem Pasha (by birth a Croat) and Sokollu Mehmed Pasha (a Serb from Bosnia), or the great Ottoman architect Sinan (a Christian, perhaps Greek from central Anatolia). Likewise many women with origins in non-Muslim communities

entered the harem, and some became Valide Sultans. So it was that in their variegated and complex bloodlines the occupants of the Ottoman throne reflected the richness and diversity of the peoples of their Empire, in which many nations from three continents lived side by side.

Art and power

Throughout history, art and power have always been closely associated. We have little in the way of a surviving material legacy from the first Ottoman century, the 14th, partially due to the fact that courtly splendor was a secondary priority in the early days of military expansion. Nevertheless, documents attest to the early Ottoman acquisition of beautiful things, such as the tapestries, silks, and rich objects sent by the Duke of Burgundy to Bayezid I in order to ransom his son the Count of Nevers after the battle of Nicopolis in 1396; various accounts also describe the lavish expenditures and luxurious trappings of royal Ottoman hunts and the public ceremonies celebrating the circumcision of heirs to the throne. From the early 15th century onward, the rich legacy of beautiful architectural monuments created under commission from the dynasty as well as from its high officials attests to the munificent royal patronage of the arts in the Ottoman realms. By the end of the 15th century, detailed registers of the contents of the Imperial Treasury begin to record beautiful Chinese porcelains, silks from Bursa, France, and Italy, and a growing collection of scientific, historical, and literary manuscripts, many with beautiful bindings, illuminations and illustrations.

The Ottoman acquisition of such works, which all carried connotations of power, prestige and wealth, quite obviously proceeded from a variety of motives. Although orthodox Islamic religious thinking frowned upon human and animal images, as well as upon the enjoyment of luxurious material possessions, the royal imperative dictated otherwise. Thus, Sultan Mehmed II arranged to have his portrait done by the Italian painters Costanza da Ferrara and Gentile Bellini in the late 15th century. Court custom decreed that every Ottoman sultan should practice a trade: Süleyman I the Magnificent, in addition to his talents as a ruler, diplomat, military leader, and poet, was trained as a goldsmith; his grandson Murad III (r. 1574-1595) was a devoted bibliophile who spent hours with his painters in the court designers' workshop. Long after the Empire had begun to wane the custom continued: Abdülhamid II (r. 1876-1909) was a carpenter and cabinet-maker some of whose works have survived, and his descendant Abdülmecid, the last Ottoman crown prince, who briefly and nominally served as Caliph from 1922 to 1924, was a talented painter in oils. The high culture of the Ottoman court and the availability of rich dynastic collections at close hand obviously encouraged among the sultans and their courts the love of beautiful things and the collecting impulse.

At the same time, the public display of wealth in the form of material possessions, what the American sociologist Veblen called "conspicuous consumpting" has always been an important way of projecting royal status and power. Unlike modern politicians, whose images and utterances clog the major information media and often breed the contempt associated with familiarity, the Ottoman Sultan was from the time of Mehmed II onward a remote figure of great mystery, with an almost mythical persona. His public appearances on special occasions were carefully arranged to have the maximum impact and to preserve the sense of public excitement and wonder. On the occasion of his weekly procession to Friday prayers at one of the capital's great Imperial mosques, he

rode on horseback in the middle of a long procession of representatives of the military, the palace bureaucracy, and the judiciary – a procession that served as a sort of visual summary and personification of governmental power. The often very large scale of the designs on the sultan's costumes, the huge gems that adorned his mace, his turban ornament, and his ceremonial water flask, the brilliance of the gold and silver workmanship on his sword, and the huge size of his white silk turban, not to mention the opulent costumes, weapons and trappings of his courtiers and servants, all served to project an image of royal power to the crowds who assembled to see him. Ottoman subjects and foreign envoys alike were often awestruck by the sultan's carefully orchestrated public appearances; Busbecq, the sophisticated ambassador sent by the Austrian Habsburgs, wrote in the mid-16th century that he had never witnessed a more beautiful or impressive sight in his entire life. Like Kremlinologists of a later era, foreign officials also scrutinized Ottoman ceremonial processions for indications of which officials were "in" and which were "out," and for information on the sovereign's health, sometimes paying hefty sums for the temporary rental of premises with a good view of the passing panoply of Ottoman might.

And what of the motivations of the artists who produced these beautiful things? Because talented artists sometimes signed their most important works, we know the names of great masters like Ahmed Tekelü the swordsmith, or Kara Memi the illuminator and painter; the assessments of outstanding artists by their contemporaries, reflected in the daily wages paid to the former in silver coins from the Imperial coffers, are borne out by art historians today. The Ottomans had high standards in everything from the training and etiquette of their servants or the quality of their drinking water to the beauty of their material possessions, and a knowledge of standards of beauty was probably a common and expected attribute for a gentleman of the higher Ottoman bureaucracy. The rigorous training of artists, who served long apprenticeships and spent years as journeymen before ascending to the rank of master, insured that the commonly accepted standards for beauty and craftsmanship were widely maintained, while leaving room for the acceptance of brilliant artistic innovation within an established canon.

Even the most martial of Ottoman sultans or officials appear to have had an eye and an ear for beauty. Mehmed the Conqueror and the legendary 16th century Ottoman admiral Hayreddin Barbarossa both had their portraits painted in the act of smelling a rose; Süleyman I, the conqueror of Rhodes and Belgrade, wrote passionate love poetry, and paid a princely salary to his talented chief designer and painter, Shah Kulu. The warlike Murad IV (1623-1640), although usually depicted in armor, commissioned two of the most beautiful garden kiosks in the Topkapı Palace, and even the obsessively militaristic Selim I (r. 1512-1520), conqueror of Tabriz, Damascus and Cairo, brought back to İstanbul whole groups of artists from his newly conquered territories.

Court patronage of art had one other purpose in the Ottoman realms, one that has not always been adequately noted by historians. Like all Renaissance powers, the Ottoman Empire in the fifteenth and sixteenth centuries followed an economic policy of bullionism, seeking to maximize the flow of gold and silver into the Empire, and attempting to curtail its flow out of the Empire. The voracious European appetite for Ottoman commercial luxury goods, such as the silk velvets of Bursa, the carpets of Ushak, and the famous Ottoman ceramic wares of İznik (not to mention

such items as tulip bulbs, for which there was in the 17th century a virtual mania in Europe) made the production and export of such goods an important economic pillar of the Ottoman state. And while the sultans themselves were often connoisseurs of imported Asian and European luxury goods such as porcelain from China and silk cloth from Italy, at various times in Ottoman history the production of artistic goods for export and for court consumption was clearly encouraged by the state bureaucracy as an element of economic policy, while at the same time imports were discouraged. Many ateliers producing luxury goods were owned or controlled directly by the court itself, which seems at times to have pursued ambivalent policies in regard to how widely across the social spectrum such luxury goods should be distributed; but especially after the flow into Western Europe of vast quantities of gold and silver from Spanish mines in South America, the export of luxury goods to Europe was generally encouraged. Further, in much the same way that British royalty or American presidential families have served as style-setters and advertisements for the fashion industries in their own countries, the Ottoman sultans, through public display of luxury goods, lent their cachet of status and good taste to the products made by the silk-weavers, tile-makers, carpet-weavers and armorers of the Ottoman Empire.

Art, empire and history

Aside from a brief occupation by the British at the end of the First World War, since 1453 İstanbul was never conquered by any foreign power, and the Topkapı was never subjected to the looting and pillage of foreign armies or domestic revolutionaries. To be sure, natural disasters – chiefly devastating earthquakes and fires – have taken their toll over the centuries, while the Empire's decline is known to have repeatedly caused precious metal objects to be melted down and struck as coinage in order to cover financial needs; but the Topkapı Palace has never suffered the depredations that Versailles underwent after 1789, or the Tuileries in 1870, or which the art collections of Charles I suffered under the Commonwealth in England. The Ottomans' sense of themselves as a dynasty was always very strong, and the preservation, cataloguing, and augmentation of royal collections seems to have been undertaken as an affirmation of dynastic continuity for a royal house that saw an unbroken succession of Ottoman rulers from before 1281 to 1922.

It is for this reason that the Topkapı collections are not only a delight to the eye, but a window into the history of one of the mightiest of complex pre-modern empires –the first great "gunpowder empire" of fifteenth century vintage, and by far the most durable. Coupled with this unparalleled material legacy is a remarkable documentary record. The highly trained Ottoman bureaucracy was skilled in the making of lists: census and taxation registers, inventories, catalogues, payrolls, rosters, and market regulations all chronicle, sometimes in excruciating detail, the salaries of artistic workers, the cost of different kinds of cloth, the price paid per tile for architectural decoration, or the hoards of gifts both given and received in the Imperial court. Court officials received, in addition to their salaries, a particular number of silk garments every year, according to a very meticulous and complex hierarchy of values, and it was all written down. During the building of Süleyman the Magnificent's huge mosque in İstanbul from 1552 to 1559, construction notebooks recorded the prices of materials, the salaries of workers, and the progress of the entire enterprise. On Fridays, the Muslim equivalent of the sabbath, all the Mehmeds and

Alis, Murads and Mustafas took the day off. On Sunday it was the turn of the Yannis, Yorgis, Bedroses and Hagops of the Greek and Armenian communities. In the court rosters we see the progress of Keyvan the Hungarian, Mustafa the Georgian, Mehmed the Bosnian and Ali from Tabriz as they make their way up the hierarchy of the royal ateliers. From the chroniclers of royal ceremonies we learn who wore what, which presents were given by which Sultan to which bureaucrats, and, in immense detail, not only the nature of diplomatic gifts received from foreign ambassadors, but the appraised value of each item. History is big events; it is major personalities; it is the interplay of power, economics, culture, and society in the hands of rulers and generals. It is also the lives, cares, and activities of the ordinary people who grew the crops, produced the goods, staffed the army, sailed the boats and drove the wagons that made the big events possible. History is grand chronicles and heroic epics, but it is also the price of a loaf of bread and the salary of a stone-cutter. We are indeed fortunate that Ottoman chroniclers preserved records of history in both of these levels, a happy circumstance that allows us a fuller, if always imperfect, understanding of "how it really was."

But for many if not for most of us, that part of history that comes down to us in the most tangible form consists of significant things – buildings, clothing, autographed documents, contemporary pictures, and beautiful possessions that we can associate directly with specific personalities, places, or eras. In *Palace of Gold & Light* the curator and organizers hope to bring to audiences across the United States a wide variety of such significant things, together with a notion of the context and civilization in which they were created. In so doing, our aim is not only to celebrate the creative gifts of the Ottoman Empire that for so many centuries were focused with dazzling brilliance on the Topkapı Palace in İstanbul, but also to remind all of us that these significant things were created by people whose strengths and failings, aspirations and disappointments, were probably very much like our own. Members of a multi-ethnic and multi-religious society, who experienced the creative and corrosive tensions common to all such complex societies, the Ottomans, rulers and subjects alike, have left a fascinating record of beauty and power, a gift and a challenge for us to enjoy and understand.

Periods, functions, messages
Tülay Artan

Three thunderclaps: 1453, 1492, 1517. The fall of Constantinople was truly an earth-shaking, epoch-making event; it is not for nothing that (together with Columbus and the outbreak of the Protestant Reformation, as well as the advent of printing) it is usually cited as one of a group of events around the year 1500 that are conventionally used by historians to designate the close of the Middle Ages and the opening of the Modern Era. Beyond bringing the Byzantine millennium to an end, there were at least two ways in which the Ottoman conquest of Constaninople, this most coveted "city of the world's desire" as Philip Mansell has called it, pointed to the future: Its walls came tumbling down, blasted not by Joshua's trumpet but by huge bronze bombards, which heralded a new age of firearms; the huge fiscal and organizational capacity to concentrate the resources needed for a siege of this sort heralded the means and methods that would come to characterize the modern state.

What's in a conquest?

The mastermind [A4] behind this cataclysmic event was all of 19 years old when he started planning for it in earnest, and still only 21 when he rode triumphantly into the defeated city. By capturing the obvious hinge between the European and the Asiatic wings of the Ottoman Empire, Sultan Mehmed II assured himself of quick and easy passage across the Bosphorus, and eventually mastery of the Eastern Mediterranean and Balkans. He was one of the best-educated minds of his age, with formidable powers of concentration, and geostrategic principles were well within the reach of his grasping intellect.

The prestige and power acquired by the young Sultan as a result of the conquest also led to victory in domestic politics. He was able to break with the traditional pattern of power-sharing that had prevailed between the Ottoman dynasty and the old Turkish warrior nobility for more than a hundred years. After the conquest top posts in the empire came to be filled with new men, produced by the *devshirme* system, who, as upstarts with the same lean and hungry look as the sultan, had flocked to his "war party".

Subsequently the Conqueror moved to sap the economic power of the old noble families by confiscating their landed properties. Simultaneously he issued the famous law codes known by his name (*Fatih Kanunnâmesi*), cleverly mixing orderly compilation with radical re-editing to come up with a much more centralized administration and palace protocol that ultimately reduced his top officials to mere functionaries, "servitors of the Porte". He also ordered that henceforth he and his successors should not associate with their inferiors. Sultans should eat alone; should appear in public only infrequently; and then in as carefully regulated a manner as possible; should preserve a hieratic silence; and might even refrain from participating in meetings of the Imperial Council, preferring to watch and listen in secret from behind a latticed window high up on the end wall of the Council Hall. These were not mere formalities; through the daily habits and mentalities they imposed, they changed Ottoman political culture, which in turn affected all alignments of social power. As that most famous of all Ottoman historians, Halil İnalcık, has insisted all along, the Conqueror was, in

Ivory belt piece
5,5 x 5,5 cm
Topkapı Palace
Museum 2/630

28

truth, the second and definitive founder of the Ottoman Empire.

Manipulating tradition, controlling social memory

Shrouded in mystery, the Conqueror cultivated his reputation and stage-managed his image. Crucial for understanding how his mind may have worked in this regard are his collecting habits, as reflected in the Topkapı Museum's "Treasury of Mehmed II" collections. The first striking thing about them is that they are mostly books, including both priceless Ottoman, Persian, Arabic, Greek and Latin manuscripts, and items printed in Europe. They bear direct witness to his insatiable curiosity and his voracious reading in several languages. Understandably, many deal with geography or warfare, revealing not only his interest in ancient authors but also how closely he was following the course of modern knowledge, watching, scouting, and gathering intelligence. The map of Europe displayed here [A20], for example, is from a special compilation combining the *Geographike Hyphegesis II* (fol. 1-88) of Claudius Ptolemaios (90-168 AD) with Dionysios Periegesis' account of his travels (fol. 89-106); said to have been donated to the Hagia Sophia in 1421, it came to the attention of Mehmed II in 1465, and upon his request it was translated into Arabic that same year by Georges Amirutzes of Trebizond. A copy of a famous medical treatise in Arabic that he acquired, known in the West as Avicenna's *Canones*, is represented by its Italian velvet bookbinding [A17]. Within a decade of the Conquest, the sultan had asked Sigismondo Malatesta, lord of Rimini, to supply him with a good artist, whereupon Matteo de' Pasti set sail for İstanbul in October 1461. Among the presents that he carried for the sultan were a map or maps of Italy and the Adriatic and a copy of a military treatise by Rober-

to Valturio [A19]. The whole incident attests to Mehmed II's interest in Italy, which his army invaded toward the end of his reign, briefly occupying Otranto in 1479-80.

But beyond such practical books, in Mehmed's library there are other works that hint at his own imperial self-consciousness. Mehmed was fascinated with Alexander the Great and collected Alexander romances, represented in the exhibition by a miniature called "Alexander's Journey to the Land of Darkness", [A8] that has been taken from a 15th-century-manuscript from Timurid Herat. He also collected copies of the Persian epic known as the *Shahnâme*, "Book of Kings", that told stories of royal conquests, romances, and heroic exploits. Later the Ottomans employed official historians, called *şehnâmeci*, who now put the achivements of the Ottoman sultans and their predecessors in glorified literary form and also provided them through their illustrations with a visual repertoire. In a way, this whole development is foreshadowed by the histories of Mehmed II's own reign, centered on the momentous events of 1453, that were either directly commissioned by him or else presented to him in the hope of winning his favor. For example Kritovoulos, a Greek nobleman of Imbros who went over to the Ottomans at the time of the Conquest and was rewarded with the governorship of his native island, was personally asked by the sultan to weave something of a new Alexander romance around his life and times. Mir Seyyid Ali bin Muzaffer Tûsi, using the pen-name Ma'âli, is also recorded as having authored his *Hünkârnâme* in verse specifically for the Conqueror's library. Tursun Beg, an Ottoman fief-holder and commander, composed his history largely as an eyewitness account of the many 15th century campaigns in which he had personally participated. Significantly, these works were written in three different lan-

guages: the History of Kritovoulos of Imbros in Greek [A1], Ma'âli's *Hünkârname* in Persian [A2], and Tursun Beg's *Tarih-i Ebu'l-Feth* in Turkish [A3]. All are being shown outside Turkey for the first time.

Legends about Mehmed II grew in his own time, extolling the intensity of his burning, brooding passion, his habit of working late into the night, studying, drawing, planning for his great projects, and his tactical and organizational genius. Anecdotes portrayed him supervising his cannon foundry and the artillery trials at Edirne; riding his horse into the sea in anger at his admiral's failure to prevent four Genoese ships from supplying the besieged city of Constantinople, then promptly moving his own galleys over land into the Golden Horn; seizing the opportunity to honor learning when his tutor's horse happened to splash mud on his kaftan; calmly confronting defeat and death as he retreated, wounded, while commanding from the front lines outside Belgrade in 1456.

Mehmed also used architecture to symbolize both continuity with and triumph over Byzantium by deciding to relocate his palace and court to the vicinity of what had been the religious and political center of Constantinople. Three marble capitals within the Topkapı Palace grounds have been included in the present exhibition reflecting the historical layering and and continuity of the palace site [A12, A13, A14]. At the same time he acquired both Western and Eastern art, and then promoted subtly nuanced propaganda by sending visual messages to Europe in European style and to the Turkish-Islamic world in Turkish-Islamic style. In short, his real cosmopolitanism appeared to know no bounds.

The enigma of Mehmed Fatih: unique genius, sultanic archetype

Images and metaphors pile up and overlap, so that it becomes difficult to see the real man behind his representations. Several portraits of Mehmed II have come down to us; done in different styles or visual idioms, ranging from Gentile Bellini's sober Renaissance portrait in oils to the more contrived poses and flat surfaces of the opaque watercolor portrayals by Ottoman miniaturists. What they have in common is a likeness with an aquiline nose, his lips tightened, the eyes staring into the distance, the body full of tension and alertness. In a much later Ottoman manuscript the court painter Nakkaş Osman has posthumously depicted him in a similar vein [A4], wearing a blue kaftan.

When we look at the Conqueror's personal belongings, or at objects that are likely to have belonged to him, we are also reminded that each such object is both unique and part of a genre, a whole category of similar items that used to mark out a definite aspect or dimension of the sultan's role. Such is the relationship between the kaftan [A5], talismanic shirt [A7], sword [A6], horse armor [A10] and quiver [A11] shown in the first section, and the other kaftans [B10-18] or arms and armor [B27, B33-34, B35-36, B37, E12, E14-15, E20] shown in subsequent sections of the present exhibition. The kaftan, for example, was the traditional Ottoman royal robe or outer garment up to the first quarter of the 19th century, and on ceremonial occasions the sultans would wear kaftans of luxurious fabrics that were often preserved for posterity in the Palace Treasury [see below for B10-B18]. Of the many kaftans in the Topkapı collections that have been attributed to the Conqueror at various times, some, upon closer examination, have been re-dated to later periods. The plain blue kaftan [A5] exhibited here, however, is very likely to have been worn and kept in the late 15th century palace.

Personal items like clothes or shoes are always poignant reminders of mortality, and there is a very powerful link with history when we see royal Ottoman kaftans at

an exhibition. Even more intimate were the talismanic shirts that sultans used to wear next to their bodies, of which there are numerous examples in the Topkapı collections. On the talismanic shirt of Mehmed II displayed here [A7] there are inscriptions meant to preserve the health and safety of the wearer. The band with four lines that frames the front contains various verses from the Koran, while the squares in front near the neck are inscribed with the various titles and epithets of the Prophet, additional Koranic verses, and magical letters and numbers used in divination.

Along with medieval Europe and Japan, the Ottomans had a great sword cult, which was eventually built into their equivalent of Christendom's coronation rituals. Both ancient Turkish and many Middle Eastern rulers had worn crowns; the Ottomans never adopted this usage, developing instead a system of distinctive turbans to go with each rank and position. The sultans' ceremonial turbans were often decorated with jeweled aigrettes [B24, B25] so as to reflect the sovereign's magnificence.

But if there is no such thing as an Ottoman crown, neither can we speak of an Ottoman act of coronation. Instead, at least from the early 17th century onward (acording to Cemal Kafadar's research), soon after his accession to the throne each new sultan would go out in solemn procession from the Topkapı Palace to the local pilgrimage grounds in İstanbul's Eyüp district, there to be formally girded with a ceremonial sword. The swords used on such occasions were ancient weapons, held to be either sacred or ancestral in nature; these were kept in the Treasury of the Topkapı Palace. Mehmed's swords joined the palace collections on his death; they are represented here by an extraordinary early example of gold-inlaid metalwork [A6], with its slightly curved blade, extending in long sinuous lines from a creamy bone handle capped with silver,

decorated with protective inscriptions. Holding such a sword, and wearing chain mail over his talismanic shirt, the sultan took his ceremonial place at the center of the Ottoman battle line, mounted on a horse whose head was protected by a steel frontal with a magnificent floral scroll at the center [A10]. Various types of quivers were used by the Ottoman mounted archers, whose military ancestry can be traced back to the horse-nomadic cultures of Central Asia. Open quivers allowed fast shooting, while closed quivers protected arrows from the elements. The walnut box quiver shown here [A11], decorated with geometric panels inlaid with ebony, ivory and gold, is a fine piece of 15th century military equipment.

Facing east, facing west: the many worlds of Ottoman art

When Mehmed II died in 1481, the empire that he had built and consolidated in a brilliant reign of three decades comprised two compact, rather evenly balanced blocks of territory in Europe and Asia, hinging like two wings on an imaginary butterfly's body running between Europe and Asia along the Dardanelles and the Bosphorus. In the east it rested on a line running southwest-northeast at a 45-degree angle from modern Silifke on the Mediterranean to modern Rize on the Black Sea coast. In the west and north it abutted on the Danube, which at this latitude cuts across the Balkan peninsula from east to west. The Hungarians managed to hold the Danube line until the capture of Belgrade by Süleyman I in 1521 finally unlocked the gates of central Europe.

The Ottomans' success in straddling two worlds is reflected in a striking manner in the collections of the Topkapı Palace. These clearly point to the diverse origins, backgrounds and linkages of Ottoman art: a Turcoman vein, heavily overlaid with a

Chinese/Far Eastern connection, a Timurid/West Asian connection, a Mamluk/Classical Islam connection, and a Venetian/Italian connection rooted in the 13th and 14th centuries, when Venice and Genoa extended their economic influence and power in the Black Sea, the Aegean and the Eastern Mediterranean. It was through these new Italian zones of control that the Turcoman lords of Anatolia started learning about the sea. After 1453 it was with Venice that Mehmed II had to contend for hegemony. For centuries thereafter, Venice had a finger in virtually every anti-Ottoman alliance; Sultan and Doge kept clashing again and again: at Preveza (1538) or Lepanto (1571), over Cyprus or Crete, and indirectly in central Europe.

At the same time, they inevitably kept learning from and influencing one another. Fighting, trading, spying — it was all part of the game, made all the more complicated by the fact that early modern societies were so permeable that it was impossible to prevent contraband traffic in strategic materials, even when they were at war with one another. As for the luxury goods demanded for upper class consumption, they, as well as the craftsmen skilled in producing them, flowed back and forth across frontiers in more or less uninterrupted fashion.

Many leading members of the Ottoman elite placed a premium on Renaissance artists and artisans. This was clearly the attitude of the Conqueror himself who, to judge from the numerous drawings in his childhood sketchbook, seems to have been quite taken with Western art from an early age onward. From 1461, when work on the Topkapı Palace started, to Mehmed's death in 1481, invitations went out from İstanbul to numerous painters, decorators and bronze workers, as well as specialists in the minor arts, including clock-makers, scabbard-makers, and workers in glass. Although for sixteen of those twenty years,

from 1463 to 1479, the Otomans were at war with Venice, at the same time artists from Rimini, Ragusa (Dubrovnik), Milan, Florence, and Venice found their way to the Ottoman capital. Unfortunately, very little of what they brought with them or produced on site has survived. Hence it is a rare pleasure when research in the Palace collections reveals three dazzling pieces of Italian velvet [A16, A17, A18], or three hitherto neglected Burgundian rock-crystal jugs, very rare examples of their kind, one of which [A15] – complete with a metal base, lid, and a dragon spout – has been included in this exhibition for the very first time.

When they crossed over to Europe and started expanding in the Balkans, the Ottomans left many things behind, including the kinship-based political culture and the traditional Turkish tribal divisions of West Asia, instead building a more strongly centralized state. But we must be careful not to read too much into this "Europeanization" of political structure, for while the Ottomans changed, they never entirely disconnected from the eastern Turkish world in art. This legacy was an enduring one, but was especially strong in the 15th-century, including the aftermath of the conflict between the Ottomans and the Turkic conqueror Timur, who invaded Anatolia in 1402. The Tiled Kiosk that Mehmed Fatih ordered built in the outer precinct of the Topkapı Palace, completed in 1472, takes the form of a traditional Timurid palace then popular in the Turkic east. Just as meaningfully, a carved sandalwood box of matchless quality, generally referred to as "Uluğ Bey's wooden casket" [A25] because it is known to have been crafted at the Samarkand court of Timur's grandson Uluğ Bey (r. 1447-49), has come to be part of the Topkapı collections. A carved filigree of lacy arabesque is woven tightly across its surface; a meticulously inlaid polychrome geometric strip around the cover's edge recalls Timurid mosaic

tile architectural decoration; the interior is lined with a rare example of Timurid silk that recalls the material used for Mehmed's kaftan [A5]. Other examples of Timurid art in the Topkapı Treasury include two brass jugs [A26, A27], one of which [A26] bears a handle in the shape of a dragon. These belong to a group of signed and dated metalwork which seems to have originated in eastern Iran. In both cases, the floral and vegetal decorations covering the body are inlaid gold and silver. Similar interlocking and overlapping cartouches are to be found in Timurid manuscripts from contemporary Herat.

After the ebbing of the Timurid tide, Eastern Anatolia gradually came under the control of the Akkoyunlu (White Sheep) Turcoman clan, whose rise began to conflict with the Ottomans' eastward drive, especially after 1461, when Mehmed II conquered Trebizond. When the two sides finally gathered their full strength for a major showdown in 1473, the Ottomans won. The Akkoyunlus never really recovered from this blow, but their court was still able to produce artistic masterpieces, including a supreme example of bookbinding [A21] for a 1483 copy by the calligrapher Şeyh Mehmed of the *Cam u Cem*, the famous *mesnevi* or long poem of Rukn al-Din Evhadi (d. 1337).

Another source of the new Ottoman artistic synthesis was to be found in the culture of Mamluk Egypt. Slaves of Turkic origin, who created a praetorian state the Mamluks ruled Egypt and Syria from 1250 to 1517. Early in the 16th century, they found themselves caught between the Portuguese in the Indian Ocean and the Red Sea to the south and the Ottomans in the north. At the battle of Mercidabık in 1516, they were decisively defeated by the cart artillery of the Ottoman Sultan Selim I ("the Grim"), who was able to march into Cairo the next year. Proclaiming Ottoman sovereignty over the entire Middle East,

he returned to İstanbul with the Holy Relics of Islam, along with sizable groups of scholars, jurists and craftsmen, who were settled in İstanbul.

Selim captured the bulk of the Mamluk treasury, too, which includes a wide, shallow brass bowl [A23], from the time of Sultan Qayt-bay (r. 1468-96), inlaid with gold and silver on its outer surface. Significant for cultural history is an incomplete set of Mamluk tarot cards [A24] that are reminiscent of Mamluk book illuminations. Near the top of each of four suits of 13 cards are a king (*melik*) and then his regent or viceroy (*naib-i melik*); this is the only set where the word *naib* is actually written on the cards. Playing cards in Renaissance Italy were called *naibi*, in Southern France *nahipi*, and in Spain *naips* or *naipes*. The almost complete deck in our exhibition, therefore, captures an intermediate stage in the introduction of tarot cards from the Middle East through Italy to Europe.

Yet another dimension of the commercial and cultural contacts of the Ottoman Empire at the juncture of three continents is reflected in the magnificent Topkapı collections of Chinese porcelains. From the 14th century onward, Chinese porcelains were regularly exported to the Near East. Unmatched in quality and design, they found favor in royal palaces and wealthy households alike, and in order to maintain their hold on the market, Chinese craftsmen took care to study and adopt those metal or ceramic forms that would be most familiar to their customers. In an age when special Chief Tasters were employed in most courts to prevent assassination through poisoning, the belief that the light green type of Chinese porcelain called celadon would change color if it came into contact with any poisonous substance stimulated an exceptionally high demand for such wares so that celadon ewers, dishes, plates and bowls were purchased for the Topkapı Palace in large quantities [A28, A29,

A30]. One of them [A28] features an curved spout capped with a dragon's head, added in İstanbul. Blue-and-white dishes, plates and bowls [A31, A32, A33], as well as ewers, pitchers and canteens [A34, A35, A36] of all sizes, bring the Topkapı Chinese porcelain collections to some 9000 pieces, making them one of the largest in the world.

From collecting to creating: the birth of an Ottoman idiom

It would have been unthinkable for collections of Chinese, Timurid and Mamluk art such as this not to have made a strong impact on local taste. As with most cases of cultural reception, the Ottoman reaction to Chinese ceramics went from simple purchase and consumption, to copying, emulation, then to reworking the original inspiration, and finally to a new creative synthesis. With one foot in Europe and another in Asia, surrounded by a collection of art objects from both worlds, the Ottoman court and the ruling elite began to evolve a particular taste of their own which was ultimately built into a uniquely Ottoman aesthetics of power.

Thus, already in the 15th century the Ottoman decorative arts had begun to display a significant degree of stylistic consistency. Scrolling branches bearing *hatayis* – stylized composite blossoms of Far Eastern origin – and *rumis* – split-leaves with pointed tips – were making their appearance on all kinds of surfaces. Initially, they were either used alone or superimposed on one another. Somewhat later, they came to be combined with palmettes and lotus blossoms. Then towards the end of the same century, "Chinese" clouds or cloud bands were also added to this repertoire. A distinctive kind of abstract floral-natural patterning took shape, coming to dominate metalwork, woodwork, ceramics, ivory carving, and the arts of the book.

It is important to understand the central importance of the arts of the book – calligraphy, illumunation, miniature painting, binding and line drawing – in the Ottoman visual idiom, whereby the same kinds of designs were transmitted to a whole spectrum of techniques and materials. In a literate but non-print society, where books were made by hand in a slow, costly, and labor-intensive process, and where therefore there were always relatively few books in circulation, the production of large-size, illustrated manuscripts – each a treasure onto itself in its combination of calligraphy, illumination, miniatures and binding – was an exceptionally expensive prestige industry that produced books for the wealthiest and most powerful of the ruling elite, headed of course by the sultan. The site for such production was the imperial design studio, or *nakkaşhane*, that was established by Mehmed II shortly after the conquest. The design studio developed a wide range of specialties to the point where it required separate staffs for ruling margins, for drawing individuals, for group portraits, for depicting architecture, or for wall decorations. Over time the *nakkaşhane* acquired responsibility not only for the execution of books but, by virtue of all the experts on its staff, for creating designs to be utilized by artists working with ceramics, tiles, woodwork, carved stone, jade, metals, textiles and carpets. Thus new stylistic developments, as the art historian Esin Atıl has noted, first appeared in the *nakkaşhane* and were then disseminated through the other arts. Clearly, this also meant that through its imperial design studio, as through its guild of imperial architects, or indeed through its imperial kitchens, the court exercised enormous leverage in setting fashion in all spheres of Ottoman culture.

This mid-15th century emergence of an Ottoman court style is clearly traceable in the arts of calligraphy and book-binding. Calligraphy is a peculiarly Islamic branch

34

of art, playing as it does on the formal qualities of the Arabic alphabet, including the possibility of writing the same letter in different ways at the beginning, the middle, and the end of a word, so as to stack words and phrases in intricate patterns, creating a kaleidoscope of both somber and delicate images. During his tenure as the governor of Amasya, Mehmed II's son Bayezid (the future Bayezid II, r. 1481-1512) became acquainted with the great calligrapher Sheikh Hamdullah (1436-1520), who was invited to come to İstanbul to serve as both court secretary and teacher of calligraphy at the imperial studio. Under his tutelage, a distinctly Ottoman style of calligraphy, illumination and book-binding developed. The bindings for the *Gurar al-Ahkâm*, a book on Hanafite jurisprudence [A37]; for the *Al-Lama'at* of Fakr al-din al-Iraqi, a book on mystic poetry [A38]; and for a single-volume Koran [A39] are among the earliest and finest examples of this tradition. A Koran from the hand of Sheikh Hamdullah himself [A40] has double pages of illumination at the beginning and the end and beautifully decorated chapter headings. In the *Şerh es-Selâhiye* or "Book on Arithmetics" [A41] there are double pages of illumination at the beginning in the form of elongated medallions.

This medallion form, widely used on book-bindings, also influenced the design of Ottoman carpets. Carpet-weaving was a traditional nomadic Turkish art form. From the 12th or 13th centuries onward it put down new roots in the Aegean hinterland of west Anatolia with its summer and winter pastures for sheep, clean fast-flowing streams, and ready supply of the plants used to make traditional dyes. Initially, production was in part stimulated and controlled by Italian merchant capital operating through local Greek and Armenian intermediaries from the Aegean islands. After the conquest of Constantinople, the imperial court and its

workshops gained importance as an alternative center of patronage. Unlike the arts of the book, the actual production of carpets could not be uprooted and carried off to the palace. But some production was undertaken at the court, and the *nakkaşhane* also influenced designs through orders placed with provincial weavers. Hence by the middle of the 15th century, Anatolian carpet design was shifting to patterns showing the Ottoman preference for greater stylization and geometrical motifs. Uşak, in west-central Anatolia, was the most important center of production.

The fine example of a West Anatolian "medallion" carpet [A52] that has been included in the present exhibition comes from a shrine tomb in Konya. The field is red, and pointing inward from the four corners are arabesque-enriched quarter-star medallions. An early "star" carpet [A53] shows densely patterned eight-pointed stars in dark blue that contrast with the plainer red field. Centrally aligned on the long axis are three stars alternating with two squares, symmetrically flanked by squares and stars on both long sides.

In the Topkapı collections of Chinese ceramics, some items may be seen to have been redecorated by court artists, adding extra sparkle [A28, A35]. At the same time, The Ottoman potters of İznik (ancient Nicaea), not far from İstanbul, began to experiment with ideas they first encountered through imports from China. In some Ottoman ceramic dishes from the late-15th century, both the shape and the decorations take after Chinese porcelains [A51]. In others, while the overall shape of a dish or plate is still reminiscent of Chinese ware, the decorative repertoire already bears a markedly Ottoman 15th century character. If we look at metal work, two mosque lanterns, one of silver [A42] and one that is gold-plated [A43], show the same design features. The silver lantern is known to have been made for the Con-

queror's own mosque. On each panel, framed by sacred calligraphy at the top and bottom, is an oval medallion surrounded by branches, *hatayi* blossoms, and leaves [A42]. On the sides of the gold-plated lantern [A43] are medallions decorated with with pendants and quadrants, and pierced with *rumi* and *hatayi* motifs. Around the top and the bottom are engraved inscriptions in Persian offering prayers in praise of the Conqueror's son and successor Bayezid II (r. 1481-1512). Again, this entire decorative repertoire clearly echoes those found on many 15th century book-bindings, manuscript illuminations, ceramics and tiles.

In another example of metalwork, the four legs of a gilt candlestick [A44] terminate in dragon heads, recalling a Burgundian rock-crystal jug [A15], a Timurid jug [A26], and an Ottoman addition to the spout of a Chinese celadon ewer [A28]. The dragon motif was eventually adopted into the Ottoman style, for example on the curved *yataghan* sword of Süleyman I [B 35, see below] from the first quarter of the 16th century.

Many of the same visual elements are found in five ivory plaques [A45-A49], which are all that remain of two fabric or leather belts. The surface of a 15th-century mirror [A50] is similarly covered with carved *rumi* and *hatayi* patterns.

Royal emblems, rites and ceremonies

From the reign of Mehmed II onward, the Ottoman state was centered on the person of the sultan as war-leader, dynast, protector of the faithful, and provider of largesse, particularly for the urban masses of the capital. While he had a birth-right to the throne, he still had to fulfill all these functions, or at least not appear to neglect or violate them too much, in order to assure of the continued support of the ruling elite and the people of İstanbul.

Well into the 17th century, the sultan's legitimacy depended first and foremost upon his acceptance by the military. Like many other tributary states and societies born of a successful war venture, the Ottoman Empire was ruled by an elite that bore a decidedly military character at the outset. Over time, it acquired civilian elements, dimensions and practices without which it could not have survived. Tradition continued to command that both the sultan and his princes should engage frequently in symbolic ceremonial manifestations of power before their commanders and troops – in the palace or near the actual theaters of war.

Here it becomes interesting to compare the procedures they followed in İstanbul, at their permanent seat of power, with their field arrangements. Normally it was the Chamber of Petitions or the Imperial Audience Hall, located just beyond the threshold of the third gate, at the point of transition between the public and the private zones of the palace, that served the sultans as their principal throne room. This building was magnificently rebuilt under Süleyman I, when precious materials and spectacular gilt decorations were lavished on the columns, marble revetments, fireplace, wall tiles and fountain which contemporaries claimed to be studded with jewels. From the accounts of observers in the retinues of Western ambassadors, we learn that the sultan would sit cross-legged on a slightly elevated throne platform, richly furnished with leopard skins (which were associated with power), as well as carpets, brocades and "cloth of gold" cushions. The wooden dome inside the chamber was decorated with gold stars over an ultramarine background. Jewelled pendants or globes, made of gold or rock-crystal, ornamented and tasseled [B26], were omnipresent symbols of power in all major halls or chambers, hanging from chains fixed to the center of a dome, or above the sultan's seat,

or from the top of a canopied throne. Arranged near or around the throne were other royal insignia: two strategically placed sultanic turbans with aigrettes, water flasks or canteens, and pen cases [B30-B32]. The flasks in question were reserved for the sultan's drinking water, which was always tightly guarded; they are represented here by an example [B29] carved out of solid rock-crystal in the shape of a leather water-skin that would have been carried on horseback by a nomadic Turkish warrior. Similar flasks made of other precious materials and over-laid with jewels are depicted in Ottoman miniature paintings as being carried by the *Çukadar Agha*, who was in charge of the sultan's garments and, together with the *Silahdar Agha* who carried his sword, was one of two courtiers closest to the sultan.

During the heyday of the Empire, when sultans personally led their armies out of İstanbul, no effort was spared to reproduce this palace atmospere in the staging of military reviews, ambassadorial receptions, or even enthronements that took place during military campaigns. At various stages in the process of sedentarization, Turkish houses in West Asia or Anatolia had been modeled on nomadic tents, and perhaps it was by retracing that connection that the Ottomans found it easy to go on campaign with tents or pavilions that closely corresponded in size and splendor to the rank of the holder, and which in terms of their elaborate arrangements were truly the portable equivalent of the ruling elite's mansions or palaces.

Portable wooden thrones were carried along to be used on such occasions. Made of walnut but faced with ebony, Süleyman the Magnificent's field throne [B2] was also taken by Murad IV (r. 1623-40) on his Baghdad campaign in 1638. Under military conditions the royal insignia surrounding the throne included: maces [B27], shields [E20], swords [B33-B34, E12], helmets [B37],

bows [E14-E15)] and quivers [E16]. The sultan would appear in dazzling military attire, wearing a helmet [B37] embellished with jewels. Nine horse-hair standards would be planted in the ground outside the entrance.

The horse-hair standard or *tuğ*, of Central Asian tribal origins, was explicitly an emblem of rank and power [B3]. The Ottomans developed an elaborate system of heraldry in which every high post or office came to be represented by a certain number of these standards – five for grand viziers, three for lesser viziers, two for *beylerbeyis*, and one for a *sancakbey*. In peacetime they would mark each dignitary's residence. Raised on tall poles, they were used to signal the presence of the sultan as well as the positions taken up by his leading commanders in the battle order. When the army was on the march, each leader was preceded by his appropriate set of standards, indicating his position in the column to his own contingents as well as the entire chain of command. When the army camped, the standards would be planted vertically in the ground before the tents of the same officers and officials.

On campaign, living in these tents, thick floor coverings were functionally much more important, not only to maintain a setting of magnificence, but also to keep the cold and damp out of these portable pavilions. But since carpets do not exhibit any connection between production and ultimate destination, there is no telling what functions two large 16th century carpets [B55, B56] may have served before coming to rest in places of worship or burial, from which they were eventually taken to the Museum of Turkish and Islamic Arts in İstanbul.

The field of an Uşak carpet found in the Sultan Selim Mosque in Konya [B56] is covered with a repeating group of three circular forms and two stripes that is known as the *çintemani* pattern. This pattern reflects Ottoman art's Asian/Far East-

ern connection, for the *çintemani* is believed to be of Buddhist origin, probably symbolizing domination over sky, water and earth. Its pearls (the circles) and waves (the bands) were in Ottoman times also associated with leopard spots and tiger stripes. A floral pattern of tulips and leaves that runs around the border has close parallels in contemporary ceramic tiles and other works of art.

The same kind of intricacy of design is carried over into other emblems of power, with the foremost among them, the *tughra* or imperial monogram, most emphatically embodying calligraphy's ability to convey both Islamic and imperial messages. The *tughra* was employed as an impressive heading for imperial documents. As soon as a new ruler was enthroned, a *tughra* was created for him, combining the names of the sultan, his father and his grandfather in a stylized, cleverly compressed manner. As the 16th-century progressed, the illumination of *tughras* became more and more elaborate, and often several different artists – calligraphers, gilders, and illuminators – would collaborate in creating them. By the end of the 16th century, decoration was no longer confined within the *tughra*; an even more impressive effect was achieved through further decoration spreading upwards from the *tughra*'s left and right-hand extremities in the form of a high triangle. In this way *tughras* gradually emerged as artistic masterpieces conforming to a definite formal pattern of their own. A special member of the Imperial Chancery, appropriately called the *Nişancı* (literally: signer or mark-maker), was charged with affixing this *tughra* to all documents issued in the name of the sultan.

Illuminated *tughras* on a grand scale were probably meant to be hung in ceremonial halls. The earliest of such oversized monograms to come down to us is an illuminated *tughra* of Süleyman I the Magnificent [B1]. Drawn in cobalt blue and outlined in gold, it features superimposed layers of scrolls, *rumis* and *hatayis*, cloud-bands, and naturalistic flowers. One of the glories of 16th century palace workshops, it is likely to have come from the hands of the master designer Kara Memi and his assistants. Closely related to the *tughra* were the special banners and seals of the sultan. Simultaneously with the crafting of a new sultan's monogram, it was customary to prepare imperial banners bearing his name, while four seals, three of gold and one of emerald, were also made for him [B4-B6] as those of his predecessors were removed to the Treasury. The sultan kept the emerald ring-seal for himself, and entrusted the golden ring-seal to his grand vizier, who carried it in a leather purse strung around his neck and hidden under his arm. Another gold seal was kept by the Head of the Privy Chamber, and the fourth by the Lady in charge of the Treasury of the Imperial Harem. In this connection it is worth noting that leading female members of the imperial family often had seals of their own [B7-B9].

As already indicated, kaftans were among a sultan's most important belongings. After a sultan's death, his costumes would be bundled up in wrappers and saved, while several of them – together with his ceremonial belt [B28], which also symbolized sovereignty – would be laid out on the *sanduka* or symbolic coffin placed above the grave in his tomb. Carefully preserved, these royal robes bear further witness both to costume's capacity to dazzle, and to the stylistic unity of the Ottoman visual idiom.

On a kaftan [B10] of quilted, brocaded silk (*serenk*) in black and yellow attributed to Selim I "the Grim" (r. 1512-20), the *çintemani*, that is the triple-ball-and-double-stripe pattern, is set in variously shaped medallions. Another long-sleeved ceremonial kaftan [B11], made of cloth-of-gold with voided velvet crimson tulips and feathery leaves in relief that are typical of

38

16th century taste, is associated with Süleyman I (r. 1520-66). The baggy trousers (*şalvar*) worn under the kaftans were also made of rich materials. A silk pair [B12] that once belonged to Selim II (r. 1566-74) is decorated with hyacinth motifs complete with roots and bulbs, and with stars and crescents in between. Yet another kaftan [B13] of silk-brocaded satin (*serenk*), with bright yellow triple balls placed on a ruby-red ground, has matching sleeves meant to be buttoned to the shoulders. Just how popular the *çintemani* pattern was throughout the 16th century may be judged from the fact there is another kaftan of precisely the same fabric and design in the Topkapı collections. This makes it rather difficult to date the present sample [B13], though because of its cut it has been attributed to the young Selim (II), who is known to have been on the stout side. Other detachable sleeves exhibited here [B19-B23] add variety to our knowledge of favored patterns. These include a distinctively 16th century style, known as *saz*. This elegant form of decoration featured curving, twisting, overlapping serrated feathery leaves, lotus (*hatayi*) blossoms and buds, sometimes enhanced by birds perched on branches and other, fantastic creatures, all rendered in a harmonious combination of bold, dynamic brush strokes and delicate, smooth lines, that were freely composed on the surface without any dependence on the strict rules of an underlying geometric pattern.

17th century kaftans are similarly decorated. Thus of two kaftans [B14, B15] obtained from the tomb of Ahmed I (r. 1603-17), the short-sleeved and collarless example [B14] is made from a high-quality, brocaded crimson silk cloth (*kemha*) that carries a pattern of two vertically twisting and overlapping branches bearing narcissus flowers, tulips, roses and bold serrate leaves that curve and intersect the branches. The popularity of this design with undulating stems is attested by its frequent appearance in various media, including wall tiles. The second kaftan attributed to Ahmed I [B15] is also short-sleeved, child-size, and of brocaded crimson silk, but this time bears an ogival medallion pattern in the form of pomegranates, that includes serrated feathery leaves, with leafy pendants, triple spots, and adaptations of Venetian crowns. Yet another short-sleeved silk brocade kaftan on crimson ground [B16], attributed to Osman II (r. 1618-22), displays heavy undulating stems bearing stylized pomegranates and stylized artichokes or pine-cones. A long-sleeved ceremonial kaftan [B17], attributed to İbrahim I (r. 1640-48), is of heavy white satin with a large-scale *çintemani* pattern consisting of crescent-like satin appliqué triple circles and single tiger stripes in crimson.

While no women's garments from before the 18th century have survived, there are numerous gowns of princesses which are datable to the 18th century, which may reflect the enhanced status of the female members of the ruling house. In any case, a loose gown [B18], attributed to a certain Fatma Sultan, of silver-thread fabric with embroidered appliqué of floral motifs, looks very different from the male costumes in both cut and pattern. We do not really know if female robes were always like this, or whether we can assume changes in fashion to have made a parallel impact on the fabrics, patterns, colors and cut of 18th and 19th century costumes for both men and women.

Legitimation through war, through faith, and through munificence

On the Central Asian steppes, the Turks were part of a whole family of peoples who lived on their horses and fought by drawing the bow. They shared an ecology of sparse, semi-arid grasslands, a lifestyle of

nomadic pastoralism or long-distance nomadism, and a mode of warfare based on mounted archery with Mongols, Tatars, Avars, Bulgars, Magyars and many other peoples, who interacted, borrowed and learned from one another. In time, however, the Turkish Oghuz tribes stepped outside this niche, establishing their overlordship in the Middle East and undergoing a much more complex social evolution. But while they developed stable political institutions and an integrated army comprising cavalry, infantry, artillery, an engineer corps and an efficient commissariat, they perpetuated certain symbolic connections with their past even if in modified form. Thus, horses were always important for them, as were swords, bows and arrows, and tribal insignia.

In Ottoman tradition, a horse was said to be among those symbols of recognition bestowed on the dynasty's founder Osman Gazi by the Seljuk sultan in the 1280s. Thus, in Ottoman culture a good horse with a richly ornamented saddle and trappings was among the most desired gifts, and sultans' horses from the imperial stables were a sensational part of all parades. Medieval knighthood was a thing of the past; in an age of firearms, full horse armor impeded movement in battle without really providing protection. So the use of metal horse frontals was symbolic, restricted mainly to special guard regiments and to the mounts of high ranking officers. In the exhibition we show a 16th century gold-plated copper horse frontal that is complete with its cheek guards [B38], while another [B39] bears the *tamga* or brand mark of the Kayığ clan near its right eye socket. The House of Osman claimed to be descended from the Kayığ clan, and all weapons in the Palace Armory were stamped with the same mark. A circular cartouche contains a Koranic inscription promising victory to believers. Some frontals had an aigrette socket for decorative plumes (such as egret pheasant, peacock, white crane, heron, ostrich or eagle feathers) that could be symbolically "read" for the rider's rank or previous acts of heroism. Also kept in the Imperial Stables were elaborately decorated saddles [B40], saddle covers and harness sets that were decorated with jewels.

The Ottomans, descendants of nomadic bowmen, trained their princes as able archers; on the darker side, the bowstring became their instrument of royal execution. Composite recurved bows made and decorated at the palace workshops emerged as genuine works of art [E14-E15].

Less than a hundred years after a palace armorer forged Mehmed II's long sword [A6], the kind of austere artistry embodied in it reached a peak of ornate but still exquisitely balanced elegance in the *yataghan* of Süleyman I [B35]. The *yataghan* is a distinctive bladed weapon without guards or quillons on the hilt, with the sharpened edge on the concave side of the blade. In this extraordinary weapon, a gold-inlaid inscription praises the sultan himself; the ivory handle is decorated with two superimposed scrolls, the lower, rendered in mastic, bearing *hatayi* blossoms, while the upper, executed in gold, displays *hatayis* as well as cloudbands. The same type of superimposed scrolls appear on the incised gold guard. High up on the single-edged blade on both sides are a confronted dragon and phoenix, executed in high relief, with tiny rubies for eyes. The weapon is dated to the 933rd year of the Hegirah, which was AD 1526, the same year as the famous battle of Mohacs in Hungary. Was it presented to the sultan in honor of his greatest victory? We do not know. But the name of the swordsmith, Ahmed Tekelü, is written along the spine of the blade.

Such care and craftsmanship tells many tales. In a warrior society, men develop a culture that prides itself on the

very close, ready-to-hand possession of cutting and thrusting weapons, so much so that they are absorbed into the fighting man's innermost sphere of existence, assuming the same status of intimacy among his personal effects as our more mundane electric shavers. Neither is it strictly limited to men, for Ottoman women of higher ranks are also known to have carried daggers in their sashes.

The internationally famous Topkapı dagger [B36] was intended as a gift to the Shah of Persia. It was never delivered because news of the Shah's assassination reached the envoy of Sultan Mahmud I (r. 1730-54) in 1747 just as he was crossing the border into Iran. The gold hilt is set with diamonds and three huge emeralds. Another big emerald covers a small English watch in the pommel, and the sheath is covered with rose-cut diamonds. A polychrome enamel panel with stylized fruits in a basket adds further interest.

Swords and horses belonged to the sphere of military legitimation, which however went hand in hand with religious leadership and justification. The Ottoman Empire arose from the union of a Turkic warrior culture with an Islamic tradition. The juxtaposition of military and religious authority recurred in the 16th century when Süleyman the Magnificent, as the ruler of a vast empire dominating the Eastern Mediterranean, laid claim to the role of protector of the Holy Places of Islam, including Jerusalem as well as Mecca and Medina. Within the Islamic world, the Ottoman sultans used their control of the annual *hajj* or pilgrimage to remind other Muslim rulers of Ottoman preeminence. Every year the sultan sent a large subsidy to Mecca and Medina, along with new curtains and covers [B42-B43] for the Kaaba, the small cubical building in Mecca that marks the center of the Islamic world. From time to time locks and keys [B44], symbolically asserting Ottoman control,

were also sent to Mecca. When replaced, the older covers and locks were brought back to the Topkapı Palace; they now constitute a rich collection of textiles, locks and keys that are often dated or signed by their makers.

Within the Empire, Islam was the dominant religion, and the culture and profession of Islam was the fundamental prerequisite for entry into the ruling establishment. Sultans were from an early age trained and educated to be good Muslims, leaders and protectors of the faithful.

A Koran [B49] from the hand of Ahmed Karahisari (d. 1556), generally acknowledged as the greatest calligrapher of the Süleymanic era, bears silent witness to the immense labor of love involved in an artist's maintaining the same beauty of line and curve from beginning to end, day in and day out, over more than 6200 verses. Small Korans written on scrolls in minuscule script [B41] were carried on battle standards during military campaigns to inspire and fortify the Ottoman soldiery. To evoke spiritual enthusiasm back home in İstanbul, images of the Kaaba [B47-B48] were reproduced in different media, such as paper, ceramics or carpets; they were easy to circulate or to use in decorating interiors. Ottoman Muslims also venerated relics such as the teeth, hair or nails of holy personages, and beautiful boxes were crafted as reliquaries [B45-B46].

The Islamic community had strong egalitarian aspirations at the outset; as a result it became part of the ideal of good Muslim rulership to exercise generosity, to protect social welfare, to build public works, and to keep giving back to the community at least part of what was being taken in rents or taxes, dues and services from the community. All this added up to a redistributionist ideology, failure to observe which could result in loss of political legitimacy. Members of the ruling elite vied with one another in setting up pious

foundations, building mosques or fountains, commissioning schools, funding hospices or soup kitchens. A prominent role in this regard fell to female members of the royal house, whose patronage was highly visible to the public.

The *vakıfs* or pious foundations they set up are represented here by an endowment deed [B52] drawn up by Ahmed III's (r. 1703-30) daughter Zeynep Sultan. Hatice Sultan, one of the many daughters of Mustafa III (r. 1757-74), is known to have commissioned an incense burner and a rosewater flask [B50-B51] to be presented to the Islamic shrine-city of Medina. An 18th century map of the water supply system at Üsküdar [B53], an Asian suburb of İstanbul, reflects the extent to which the commissioning of public drinking fountains had become a major pious occupation among the elite. Among the hundreds of such fountains gracing İstanbul, the most striking is the one constructed by Ahmed III in front of the Topkapı Palace's Imperial Gate. Built in 1722, it is represented here by a 19th century model [B54].

Running a bureaucratic state

The Ottoman Empire was not just about beauty: elegant calligraphy, domes and minarets, vertical gardens of blue wall tiles, sultans smelling roses in the palace grounds, nightingales singing before dawn, the morning wind stirring the beloved's tresses. There is a lot to a tributary state, anywhere, that is much more ordinary than that: collecting and managing land revenue, assessing and levying taxes, regulating production, keeping cities well-supplied, controlling the price of bread, curbing fief-holders or dignitaries, imposing authority and maintaining loyalty. This is basic, routine, universal; nothing else happens without it.

Moreover there are guidelines, born of long practice, on how to go about all this.

Armies march on their stomachs, goes the old adage. Its equivalent in Near Eastern statecraft is a parable called the Cycle of Equity. A sovereign's power depends on his soldiery, it says. But you cannot have a strong army without a full treasury. You cannot have a full treasury without prosperous subjects. And you cannot keep your peasants going if you do not treat them justly. This is traditional wisdom; translated into a more theoretical kind of modern language, it means that if millions of small peasant households constitute your basic producing class, from year to year you must take from them only so much as will enable them, with what is left, to keep reproducing themselves, their families and their petty holdings. Furthermore it is not enough for the central state to abide by this rule; you must also make sure that your provincial governors or magnates behave the same way, not going in for more than their lot. Otherwise your peasant subjects are likely to suffer anything from creeping malnutrition to a combination of outright famine with epidemics. They could be losing their draft animals over the winter months; whole villages could become deserted in waves of flight from the land. Before or together with all this, they could also be rising in revolt. Any or all of that would mean that there are no peasants there, or perhaps not enough peasants, to tax over the next year or decade. So you have to try and strike some sort of balance between the peasantry and the ruling elite. You have to set limits and make sure that nobody exceeds them, at least not chronically. You have to control your territory; to learn about local conditions; to collect and store information; to consult, assess, negotiate. And for all this you need an instrument which is not easy to come by in pre-modern, non-print societies with all their difficulties of transport and communication, their local bonds, their heterogeneity: a writing, weighing, measuring, boundary-

making, recording, book-keeping, order-relaying bureaucracy.

How did the Ottomans go about their business of taxing and spending, of controlling learning and managing elite socialization, and of putting unchallengable authority behind long-distance verbal orders, written missives or deputized officials? Crucial in this regard was, first, the *devshirme* system, which regularly kept feeding new generations of talented young Christian-born children into overlapping phases of religious and cultural conversion, of basic education, and of on-hands training in a number of jobs, gradually moving them up through the hierarchy of palace functionaries, instilling in them more or less the same skills, languages, service ethos and world-view, and in time circulating them through a series of provincial postings but eventually bringing the most talented of them back to the capital. Secondly, Muslims who aspired to climb upward through faith and learning were eligible for the numerous religious colleges or *medreses* that systematically produced and reproduced the *ulema*, the caste of Islamic scholars and men of jurisprudence. This was the source of the *kadıs* or judges who staffed and operated the network of royally appointed district courts, which in turn were responsible for administering uniform justice. This legal bureaucracy eventually deprived the Empire's military fief-holders of juridical rights, and thereby curtailed the possibility of their developing any kind of local autonomy. The cultural habits fostered by the two bureaucracies spread outward from the *devshirme* and the *ulema* to other sectors of the Ottoman state. The administrative apparatus was further consolidated under Süleyman I, called "the Magnificent" in Europe but, significantly, "the Lawgiver" (*Kanuni*) at home. By the early 17th century, when the fortunes of war were becoming so uncertain that sultanic legitimacy could no longer be risked on protracted military campaigns, the 15th and 16th century mode of military-charismatic rule made way for a new mode of government by the increasingly complex bureaucracy.

Here we turn to look at things like imperial rescripts and property deeds; writing sets; examples of state records; and manuscripts from the collections of leading dignitaries, the products of a scribe bureaucracy, scribes who would go on taking disciplined dictation regardless of who sat on the throne. Beautiful wooden writing desks [C3] were crafted so as to be used with the scribe seated on the floor; they also contained writing tools and blank sheets of paper necessary for correspondence. In a calligrapher's set, the most basic instruments would have been reed-pens, a pen-knife for sharpening and a pen-rest for trimming them, steel shears used in book-making, and a letter opener. One set was decorated with floral designs inlaid in gold [C1]. Another set [C2], listed as having been given in gift by Ahmed Zülküf Paşa in 1879 (probably to the reigning sultan Abdülhamid II), also includes an inkpot, a pot to hold the sand used for drying the ink, scissors for cutting paper, as well as the usual pen-knives and a pen rest, all on a matching tray, in silver with painted enameling.

Spending years studying and practicing their art of writing using a reed pen and ink made of lampblack, not all calligraphers rose to become the supreme masters employed in the imperial studio; the vast majority ended up as secretaries serving in the Imperial Chancery or lesser households. Among what they wrote, imperial decrees called *fermans* are certainly the most impressive, as well as some of the most revealing state documents for Ottoman diplomacy, law, land tenure or economic history. They came in various forms, some granting a military fief or a piece of land in freehold, some settling boundaries, and still others formalizing the endowment of a pious foundation.

What was common to all was that they forced instantaneous recognition and obedience through the *tughra* that they bore, which seemed to extend the distant sultan's reach and power to wherever, whenever the document was delivered. The cases for these imperial decrees [C4] were equally exquisite, whether gilded, made of embroidered leather or of high-quality textiles. In later centuries, the decorative scheme of *tughras* became less refined, and finally the influence of the West, affecting as it did so many fields of Ottoman life, came to be reflected in multi-colored bunches of tulips, peonies, roses or irises, and in garlands and shells [C4-C5]. In two imperial decrees issued by Sultan Murad III (r. 1574-94) over the second half of the 16th century [C7, C8], however, the *tughras*, smaller versions of the monogram of Süleyman I [B1], still adhere to classical style; either drawn in gold and outlined in black [C7], or drawn in cobalt blue and outlined in gold [C8], they read: "Shah Murad, son of Selim Shah, Khan ever-victorious." The first document [C7] is a *sınırnâme* or boundary charter that sets out in detail the perimeter of a dairy farm in Thrace that appears to have been first improved and developed by the grand vizier Sokollu Mehmed Paşa, then made over to him in freehold, and finally incorporated into a pious foundation by him to provide income for the mosque and other public buildings he had commissioned in the nearby town of Lüleburgaz. The second [C8] is in the nature of a *mülkname* or deed that re-confirms Sultan Selim II's original grant of freehold status to certain lands held by the same Sokollu. These properties are said to have consisted of a village in the district of Rusokastro, now in eastern Bulgaria, as well as seven plots of wooded wasteland in the same area.

The grand vizier was the first in rank among the sultan's servants, second only to him in power. Of the many who held this exalted office, the most distinguished was the 16th century Sokollu Mehmed Paşa, who served three sultans: Süleyman I, Selim II, and Murad III. Born into a poor Serbian family in the Bosnian town of Sokol, the young boy was inducted into the imperial civil service with the new Muslim name of Mehmed, and rose through the ranks while his younger brother, who was not drafted – the Ottomans took only one child from any given household – became an Orthodox prelate. Sokollu Mehmed Paşa was one of the greatest Ottoman patrons of art and architecture in the 16th century, endowing his home province of Bosnia with roads, bridges and commercial inns while also (with sultanic permission) placing orders with artists attached to the palace workshops. The *Fütuhat-ı Cemile*, for example, is an illustrated manuscript with seven miniatures [C9] accompanying a lengthy poem or *mesnevi* describing the capture of the Hungarian fortresses of Temeşvar, Pecs, Lipva and Egri (Eger). It is identified as a 1558 gift to Süleyman I by Sokollu, who commissioned the court biographer Arifi for the *mesnevi*, while the illustrator remains anonymous. After strongpoints were conquered, it was the custom to symbolize Ottoman sovereignty over them by having gold fortress keys crafted and presented to the sultan to be kept in the Palace Treasury. These ceremonial keys bore an image of the fortress in question. After repairing a series of Danubian fortresses in the first quarter of the 19th century, Mahmud II (r. 1808-39) commissioned new keys for them that carried his *tughra* [C20–C23]. Two of the four are identifiable as the keys of Tolcu and Silistre.

Tradition required a distinctive costume for each group of palace attendants, whose portrayal in costume albums had both exotic and practical functions: it served to

identify the various ranks and posts of Ottoman officialdom. Two miniatures show a polo player and a falconer [C11-C12]. As already indicated, all turbans [C13-C14] were also specifically designed to correspond to office and status. The ceremonial costume of the Chief of the Water-Bearers [C15] is part of a rare set that has survived in its entirety. These were attendants responsible for serving drinking water at meetings of the Imperial Council, which had to be securely guarded by trusted servants. The tall headgear of the Chief Water-Bearer contains a metal socket decorated with a floral pattern. The upper part of the costume is made of black leather. Silver pieces bearing flower motifs are found throughout the ensemble. The leather belt has a three-piece yellow metal buckle decorated with floral patterns in repoussé. Under the belt is a leather apron which also features metal pieces. Hierarchy and protocol extended into everything. Like the sultans and the female members of the royal house, Ottoman dignitaries and palace attendants used seals [C17-C19], and there were "Books of Seals" [C16] that recorded all the seals in use at a particular time.

Hidden from the world's eyes

Deep inside the palace, behind the Chamber of Petitions, the sultan had his private apartments in the buildings ringing the third courtyard. This was still a world of men, although it bordered on the *harem*'s world of women. From the late-16th century onward, this was where Ottoman rulers came to spend more and more of their time. Superficially, this came to be seen as a sign of self-indulgence which was blamed for the failure to lead their armies in war, which in turn was blamed for the decline of Ottoman might.

Actually, it was the other way around. The vast size of the empire, and the growing power of its adversaries, caused the Ottoman establishment to stop risking sultanic fame and pride on costly expeditions into the unknown. This is why it eventually became common for the sultan to stay at home while the grand vizier or even lesser appointees took over battlefield command. At home, the public image of the sultan depended increasingly on public displays of splendor, and the Palace's role as royal residence began to eclipse its role as the center of government.

Through the centuries, many parts of the Topkapı Palace were being continually built, altered or restored. Particularly in the *harem*, changes ordered by each new sultan, comprising additional pavilions or renovations, were executed in the style and taste of the period. Ottoman architectural decoration depended to a very large extent on tiles [D3-D6] which were in great demand for wall revetments. Also featured strongly in "classical" interiors are wooden doors and window shutters, decorated either with geometric polygonal units inlaid with mother-of-pearl, ebony, ivory and tortoise shell, or else with carved *rumis* and *hatayis*, sometimes also containing inscription panels. All this is very much in evidence in the older sections of the *harem*. The early 18th century witnessed a major change, embodied above all in the famous Fruit Room commissioned by Ahmed III (r. 1703-30), where painted panels of flowers and fruit baskets replace tiled wall revetments, reflecting the transition to a lighter, more playful lifestyle. Similar in spirit are a pair of late-18th century cupboard doors [D1], brightly painted in warm colors. On each side, the long rectangle of the central panel bears an urn containing a single flower stem branching off into green, pink or red tones on a yellow ground. Visible on the two blue-and-white urns are painted landscapes of a distinctively Dutch character, while the small panels at the top and bottom of each door depict dishes of grapes,

figs, cherries and dates also reminiscent both of the Fruit Room and of European genre painting of the period. A 19th century hexagonal ceiling knob [D2] with a geometric design radiating outward from a ten-pointed star is another fine example of late Ottoman painted woodwork.

Textiles and carpets played a vital role in traditional Ottoman interiors, a striking aspect of which was the absence of large-size furniture. Instead low platforms running along the walls or set into alcoves were covered with exquisite satins or other silk and lined with bolsters and cushions. This left large central spaces relatively uncluttered, allowing a free view of the carpets [D10-D15] that covered the floors and the equally opulent wall hangings [D16]. Embroidered wrappers were used to bundle other fine textiles [D30]: sheets and spreads [D26]; towels [D23-D25] and napkins [D27-D29] were also part of the picture. Bright monochrome satins, embroidered in gold, silver or silk thread, were made into cushion covers [D18, D22], further ornamented on occasion with pearls or precious stones. Another cushion cover embellished with coral beads [D19], one of a set of ten, is made of loosely woven heavy linen, embroidered with gold- and silver-wrapped yellow and white thread, and separate strips of gold. In the center is a blossom encircled by knotted branches bearing leaves, tulips, roses and other blossoms.

The basic principles of embroidery are different from those of fabric design, though both incorporated the beloved stylized flowers. But embroidery also allows freer play for individual creativity, a wider variety of form and color, and a wider choice of patterns. Thus in the 18th century, making their appearance in embroidery are fruit motifs, arranged fruit plates or baskets, and architectural representations. In a bath towel [D28], for example, the two narrow edges are filled with landscapes using green, light blue, pink, coral red and light brown silks in conjunction with metallic threads and strips of gold and silver. Shown are various waterfront buildings, with tall willows, pines and small cypresses in the background. A rare example of a 19th century sofa skirt [D17] bears a realistic depiction, reflective of contemporary European engravings, of the summer palace complex at Beşiktaş on the Bosphorus. In this case accompanying cushions in the same style have also survived. Famous for centuries were the lustrous velvets that were tightly woven on Bursa looms [D20-D21]; they were used for the front panels of large cushions. While at first they all seem to be quite similar, on closer examination they turn out to constitute an almost endless spectrum of subtle variations.

Rounding out the decoration of the Palace's residential interiors is a group of lesser objects, which blended subtly into the overall scene: a lamp of Venetian glass [D31] decorated with gilded *hatayis*, lotus-blossoms, tulips and floral sprays; a pair of jewelled candlesticks [D32]; a flat, circular alarm clock [D33], its gilded silver dial decorated with pierced floral scrolls, and its identically engraved back bearing the name "Bulugat"; three prayer rugs [D7-D9] of uncertain provenance; finally a series of large calligraphic panels [D34-D39] with talismanic connotations, including a Koranic verse from the hand of Sultan Ahmed III [D34], the border illuminations of which reflect the taste of the early-18th century Tulip Era; a Koranic inscription written in the shape of a ship [D38]; a *Hilye-i Saadet* – an Arabic text devoted to the physical appearance, personality and behavior of the Prophet Mohammed [D35]; a poem celebrating the birth of a princess [D36]; two other panels with inscriptions containing religious and moral advice [D37, D39]. In the midst of all the splendor achieved primarily through tiles, carpets, fabrics and woodwork, these objects hint at the importance of rituals of the faith in regulating the flow of daily life.

Behind the Ottoman canon: The works of the imperial palace

Filiz Çağman

Ottoman art has a special place within Islamic art particularly where architecture, the decorative arts and miniature painting are concerned. Its earliest products date from soon after the appearance of the Ottoman principality on the political scene around 1300, growing into a truly imperial art with the expansion of Ottoman territory and economic power.

The attitude of Ottoman artists to proportion and the filling of the ground differs from that of decorative artists in other Islamic countries. This approach to decoration took greater account of the object being decorated so as to produce a striking, easily appreciable effect, due primarily to the preservation of a balance between motifs and ground, and to keeping decoration under control. The preference of Ottoman artists for larger motifs produced by areas of pure color without further detail achieved an eloquent effect which could be grasped by the observer at first glance.

Hence, Ottoman art came to diverge considerably in taste from other parts of the Islamic world, and particularly from the aesthetics of the Timurids, Turcomans and Safavids of 15th and 16th century Iran, with its *horror vacui* designs of extremely small and densely packed motifs, which sometimes result in no more than a display of skilled craftsmanship. A willingness to leave empty spaces and to search for balance in decoration, which can also be discerned in Mamluk art of the 14th and 15th centuries, achieved very different dimensions in Ottoman art, with its nearly six hundred years of continuity, diversity of motifs and composition, and expressiveness. The new style which it brought was unafraid of color, and powerful in conception.

The palace guild: The *Ehl–i Hiref*

Apart from the overall, political and economic strength of an empire which extended over three continents, the realistic and rational approach of the Ottoman state and court, too, had a lot to do with this path of artistic development.

The centers of Ottoman art were always the capital cities where the royal palaces were situated. During the early years of rapid expansion, the empire's capital was first Bursa and then Edirne, to be replaced after 1453 by İstanbul, which then remained the Ottoman capital for close to five centuries. The Ottoman palace was not only the residence of the sultan, but the administrative centre from which the empire was governed, as well as a training ground for soldiers, bureaucrats and statesmen. The employment of large numbers of artists and craftsmen by the palace meant that it was also the center of Ottoman art.

As with other imperial courts, the Ottoman sultans, too, gathered around them poets, musicians, and scholars. Beyond that, however, architects, artists and craftsmen engaged in all the various decorative arts were also employed in the palace. Rather than relying wholly or mostly on placing orders with independent masters, the Ottomans kept co-opting the best artists they could find into their own palace workshops. Furthermore, all such court artists and craftsmen were incorporated into a body known as the *Ehl-i Hiref*, carrying out their diverse activities within the various companies of this comprehensive organization.

Before the conquest of Istanbul, a similar body is known to have existed at the

Fairy by Veli Can
from Tabriz,
ca. 1550-75.

Ottoman palace in Edirne (Topkapı Palace Museum Archives D. 9306/3), and then to have kept growing and developing in Istanbul under Mehmed II (1451-81), Bayezid II (1481-1512) and Selim I (1512-20). But it was during the 46-year reign of Sultan Süleyman the Magnificent (1520-66) that the organization reached its creative pinnacle of achievement. What makes it possible for us to trace this evolution is a marvelous body of written evidence: inspection records and wage books for the *Ehl-i Hiref* over 1526-1796, as well as diverse other documents, all of which constitute a rich source of information not only about the types of artists who were employed, but also their names and just what they made or created, thereby throwing considerable light on both the demand and the supply side of the production of magnificence.

So basically, it is through these registers (*Ehl-i Hiref defteri*), a complete example of which [E64] is included in the present exhibition, that we know just how the Ottoman bureaucratic state organized, directed, and financed art. We know, for example, that all the different companies of artisans that constituted the *Ehl-i Hiref* were under the control of the chief treasurer, who was a leading palace official. The primary task of these companies was to produce articles for the palace, and the procedure for initiating new production was for the head of the relevant company would be summoned by a treasury official (*kethüda*), who would inform the master craftsman of the most recent orders and directions. As with the janissaries or royal guards, the members of the *Ehl-i Hiref* were paid every three months by the chief treasurer, who distributed their salaries in a building known as the Old Imperial Council Hall. From surviving documents it also appears that the craftsmen were paid additional sums for special orders (Topkapı Palace Museum Library R. 1224, f. 133r-133v).

The wage books provide the name of each company, followed by a list of its members, whose first names are given sometimes with those of their father, as in the case of Mehmed bin ("son of") Abdurrahman or of Abdi Şaban; sometimes with their nicknames, as in the case of Kara ("Black") Memi; and sometimes with their countries of origin, such as Pervane Macar ("from Hungary"), Mehmed Bosna (" from Bosnia"), or Haydar Arnavut ("from Albania"). Entered beside each name is the wage or salary that they received. Each company of craftsmen comprised masters and apprentices, and for the latter the books sometimes indicate which master they were working under. Also noted on occasion is the specific expertise of the artists in a given company. For example, beside the names of some of the *nakkaş* or decorators one may come across the additional information that they were either painters, miniature artists or illuminators, while among the *kündekâr* craftsmen (i.e. those who worked in ivory, gold or bone) some are sub-classified as makers of *zehgir*, that is the finger-rings used by archers.

One among the surviving wealth of documents in the Topkapı Palace archives is a list of orders placed with the *Ehl-i Hiref*, and drawn up by the chief treasurer Topkapı Palace Museum Archives D. 9618). This document corroborates other information about how the guild operated, as well as about the scale of orders that they received. Included here are orders for minor jobs such as having certain silver articles gilded; a request for the *kazzaz* (who normally produced silk braid and buttons) to make a strap for a sword; other requests for gold-embroidered slippers or for a brushwork picture. But of course palace artists also undertook large-scale projects involving many different specialists, perhaps the most typical being the production of large manuscripts known as *Shahnâmes* – Books of Kings – which were

copied by calligraphers, illustrated by miniature artists, decorated by illuminators, and bound by expert book-binders [A22]. The decoration of a new pavilion at the palace, involving fresco painting of a sort known as *kalemişi*, as well as tiling and stained glass, is another example of a grand project that would have consumed the time and energy of a large number of craftsmen.

On religious feast days, or on even more special occasions like circumcision ceremonies or wedding celebrations, it was customary for leading artists belonging to the *Ehl-i Hiref* companies to present gifts they themselves had made to the sultan. In return the ruler would reward them with substantial sums of money and valuable kaftans. Almost all gift registers for the reign of Süleyman the Magnificent have been published (Topkapı Palace Museum Archives D. 9602, D. 6503, D. 10009, D. 9605, D. 4104). In 1540, for example, no fewer than 149 *Ehl-i Hiref* craftsmen are recorded as having presented gifts to the sultan, receiving in return a total of 225,450 *akçes* and thirty-four kaftans.

The number of *Ehl-i Hiref* companies varied from forty to forty-nine at different times between the early-16th and the late-18th century. The number of artists and craftsmen in each company also varied. The earliest surviving register, which is undated but appears to be from the reign of Bayezid II, lists only the names of the companies and the number of artisans in each. Thus the palace appears to have employed 360 artisans at the beginning of the 16th century (Topkapı Palace Museum Archives D. 9585, f. 5r-7v). But by 1526, which is still early in the reign of Süleyman the Magnificent, their number had risen to 598, and to 636 by 1566, when he died during the siege of Szigetvar (Ottoman State Archives MAD 6196, pp. 153-177). Another register dated 1575 (which is a year after Murad III succeeded Selim II) gives only the total number of

artisans employed by the palace as 898. Then towards the very end of the 16th century, we find 1502 craftsmen on the palace payroll (Topkapı Palace Museum Archives D. 9613/2). In the 17th century, however, their numbers begin to decline: while there are around 900 palace artisans c. 1600, after 1650 this is found to be too many and too costly, so that some companies are abolished altogether, while in others the total number of craftsmen are considerably reduced 'Topkapı Palace Museum Library R. 1224, f. 133r-133v) — by two-thirds to 289 by 1688, and then to no more than 186 by the end of the 18th century (Topkapı Palace Museum Archives D. 9613/13).

One thing that is not very clear about the palace workshops is where they actually operated. Some are known to have been situated in the first courtyard of the Topkapı Palace, while for the rest we can only say that the most important among them are likely to have been in the vicinity of the palace. From the time of Süleyman I onwards, it became the custom for the wage books to list the *Ehl-i Hiref* companies always in the same order. It is this that we have taken as the basis for relating the principal companies as they stood in the mid-16th century to some of their most typical products.

The designer-decorators

First, of course, there were the arts of the book [E1-E5]. The text would be written out by the *katip* or scribe, whose long training as a calligrapher is attested to by a late-18th century exercise book [E3], where we can see the artist trying out his hand. Simultaneously members of two companies of *nakkaşân*, known as the *nakkaşân-ı Rum* and the *nakkaşân-ı Acem* (or the "Anatolian" and the "Persian" decorators) would be carrying out their work, which more frequently than for the others

becomes identifiable either stylistically or else through their signatures. In the production of large-size manuscripts, the specific processes that fell to them included both illuminating, as here for the pages of a 16th century Koran [E5], and illustrating, as in an ink-drawn fairy [E1], holding a jug and a bowl, seated beneath a fruit tree in blossom, with the ground and the clouds in watercolors (with a false signature of the celebrated 15th century Timurid painter Bihzad in the lower right corner), or as in a scene showing the Prophet's uncle Hamza flying on a phoenix, that is portrayed on a story-telling card [E2]. Finally it would be the turn of the *mücellid* or book-binder, who would take, for example, the finished pages and set them in a black leather binding decorated in relief and gilt with Chinese clouds and floral motifs such as *rumis*, scrolling branches and peonies [E4].

By far the most important artists within the *Ehl-i Hiref*, the designer-decorators' tasks extended considerably beyond the arts of the book to various other activities. They designed the tiles, fabrics and carpets used in the palace as well as in the tents that sultans took on campaign; they decorated caskets, chests and many other artefacts, as well as the royal barges (Topkapı Palace Museum Archives D. 9706/2, f. 2v); and as already indicated, they designed painted architectural decorations. For example, Osman, the most famous miniature painter of the second half of the 16th century, was commissioned to execute the frescoes in one of the pavilions at the painted decorations (Topkapı Palace Museum Library H. 1344, f. 432). As their tasks increased, so did the designers' numbers. In the reign of Bayezid II there were twenty-two court decorators, and this number had risen to forty-one (out of a total of 598) by 1526.

A budget register for the same year provides a list of those who were receiving wages on a *monthly* (instead of a quarterly) basis from the Imperial Treasury. Those cited as members of the *Ehl-i Hiref* were (in that order) the chief confectioner, chief architect, chief decorator, chief pot maker, chief boot maker, and chief furrier. We are told their names, as well as their daily and monthly wages. But what is this position of the chief decorator? To judge from the the fact that it is listed among a small group of top administrative posts, it is different from and higher than the working head of the company of decorators, who would himself be a decorator. The person cited as chief decorator, on the other hand, was a certain Hasan Çelebi bin Abdülcelil, who is not known as an artist, but who as a profezzional administrator appointed from above appears to have continued in this post until the mid-16th century. In the course of organizational changes made over the second half of the century, this higher post was abolished, although the number of *nakkaşân* kept rising to over a hundred by the end of the century before declining at an increasing rate during the 17th and 18th centuries.

Where did the *nakkaşân* actually work? This is debatable, but it would seem that first, at least some of them were normally allocated space in the building of the Imperial Warehouse (*Ambar-ı Âmire*) that was located on the road leading from the Imperial Mint to the Tiled Kiosk. When it came to major book projects, small task forces were brought together in special workshops; leading masters like Şahkulu or Nakkaş Osman had their own workshops which were probably situated in the first courtyard of the palace. On the other hand, during the 16th, 17th and 18th centuries there also seems to have been an Imperial Studio (*Hassa Nakkaşhânesi*) situated outside the Imperial Gate of the palace and just beyond the Hagia Sophia, next to the Byzantine church that was being used as a lion house.

The jewellers and goldsmiths

Second, there were the jewellers, who employed various techniques [E6-E11]. Those working in gold were not limited to the goldsmiths proper (zergerân, who also did niello work and enameling, and who like the nakkaşân were divided further, under Süleyman I, into two companies of the zergeran-ı Rum and the zergeran-ı Acem), but also comprised the engravers (hakkâk, who cut and set precious stones, and also engraved seals), the gold chasers (zernişân, who executed gold inlaying on metals, jade, ivory and similar materials), and the makers of dies for coins (sikkezân). Furthermore, their art was often carried over into other media in collaboration with different specialists. The Ottomans liked using multiple materals in combination. Fine examples of the craftsmanship displayed by the zergerân (goldsmiths) are a pear-shaped rosewater sprinkler [E7] the floral motifs on which are set with emeralds and rubies, as well as a jade mirror [E8] that could be interpreted as a stylized rose, and which also displays floral mounts, made of gold, for rubies. On the binding that belongs to an undated Koran [E6], what the zerger added is in evidence in the form of gold plates where the gold field is engraved with small blossoms, and leaves rendered in relief. Two jewelled jade cups [E9, E10] are inlaid in gold with engraved scrolling rumi bands outside the rim and the base. Around the body are rosettes that display rubies set in floral mounts of gold. A covered black hardstone jug [E11] with a dragon handle and enamelled gold mounts is decorated with a foliate gold tracery; on it, again, are the inevitable golden mounts bearing rubies, which together with emeralds were the favorite gemstones of the Ottomans.

This group of jewellers and goldsmiths, which existed right through the history of the Ehl-i Hiref, was also quite numerous, and comparable in size with the nakkaşân. Their and the die makers' workshops were situated in the first courtyard of the Top-kapı Palace, next to the Imperial Mint which lay (and still lies) behind the church of Hagia Eirene. Another company whose workshops were in the same area was that of the zerdüzân, who did embroidery in gold thread. It appears that the workshops of the carpenters who produced the joinery and fittings for buildings were also there, and that they worked under the Imperial Warehouse, which as already indicated was situated on the road leading downhill from the Mint to the Tiled Kiosk, and incorporated the workshops of artisans engaged in construction and repair work. The head of the lodge of royal architects also worked in this building, and it is thought that together with some of the designer-decorators as mentioned above, the glaziers and locksmiths, too, must have had their workshops in the same building.

The armorers and clothiers

Third, there were several companies of armorers, who produced weapons [E12-E25; also A6, B27, B33-B37] not only for war but also for ceremonial uses, sports and hunting. Foremost among them were the şimşirgerân (or swordsmiths) and the kâridgerân (dagger and knife makers), from whose hand came royal sabers [A6, B33-B34, E12], daggers [B36, E13] and yataghans [B35], together with the scabbards [B33-B34, B36] that were the work of the niyamgerân. The tirgerân made the arrows [E16], the kemangerân the composite recurved bows [E14, E15] that shot them, and the zehgirgerân the jade thumb stalls or rings [E17-E18] that, together with the leather gloves [E19] made by the destivancı, and sometimes embroidered in gold by the zerdüzân (see below), protected imperial hunters' hands. The bozdoğani crafted ceremonial maces [E21-E23] of deadly appearance but little worth

in actual fighting, constructed as they were of precious materials like rock-crystal (or even glass) and further ornamented with gemstones. Equally useless but wonderfully decorated with floral patterns, such as a saz design consisting of scrolling branches with large *hatayi* blossoms, were the *siperdüzân*'s ceremonial shields of wickerwork wrapped around with raw silk thread [E20]. Meanwhile the *dımışkıgerân* (literally: the damasceners) provided the top quality, already treated and patterned iron and steel that these various armorers needed, as well as the gunsmiths whose highly decorated pistols [E24] and muskets [E25] gradually took over from thrusting and cutting weapons in a long process of diffusion of fire-arms extending from the late-16th into the 19th century.

Textiles and costumes

Fourth came the makers of all kinds of clothing [E26-E33], comprising the *külâhdüzân* for a whole range of headgear [E26] that were so important in signaling rank and status; the *kürkçü* (furriers); the *mûzedüzân* or boot-makers [E27, E28]; the *kazzaz* who made buttons and wove silk braid as straps for swords and knives, pouches and similar items; the producers of *simkeş* or silver thread; and the *zerdüzân* who were responsible for all gold embroidery, including those on sashes [E29], underwear [E30], barber's aprons [E31] or women's dresses [E32]. Then there were the *kaliçebafân* who were carpet weavers (though whether or to what extent they actually did so constitutes a separate problem), as well as other weavers specializing in the heavy woollen cloth known as *aba*, in velvet, or in brocade and figured brocade (*kemha*), whose separate companies were apparently established during the reign of Süleyman I, and continued in existence until the end of the 18th century. They formed one of the largest groups of employees at the palace (Topkapı Palace Museum Archives D. 9612; Ottoman State Archives MAD 6196, MAD 7238). A sketch plan in the Topkapı Palace archives shows that each of these companies was housed in separate workshops in the palace. The *çameşuyân*, too, probably did some weaving — of fine linen for use as undergarments — while also performing the actual stitching on many types of clothing [E30, E31, E32].

Distinct from all these, however, were the tailors, who did not belong to any *Ehl-i Hiref* company; instead, they were part of a parallel organization which like the *Ehl-i Hiref* was under the direction of the chief treasurer and his steward. In charge of sewing ceremonial kaftans (*hil'at*), kaftans lined with fur [A5] and other clothes for the sultan and palace officials, they were divided into two groups known as the *hayyâtın-i hil'at* (hil'at tailors) and the *hassa terzis* (imperial tailors). Each of these groups consisted of several companies, while part of the same network were *hallaç* companies who prepared cotton wadding for padded clothing. Numbers of tailors were obliged to accompany the sultan on campaign. The workshops of the tailors were situated just outside the palace walls opposite the Processional Kiosk (Alay Köşkü). In 1478 during the reign of Mehmed II, only twenty-three palace tailors are recorded. In the 16th century, however, there were around 370 tailors and other artisans in this parallel organization, though this figure dropped to around a hundred in the 18th century. An indication of how palace patrons and tailors were following foreign fashions, at least in the late-19th century, comes from a page of the French magazine *La Saison. Journal illustré des Dames*, to which a strip of dark blue cloth has been attached together with a note asking for a similarly cut and sewn gown with the skirt with a long back but short in front [E33].

The puzzle of the carpet weavers and tile makers

As indicated above, the *kaliçebafân* or carpet weavers had a separate company of their own in the 15th and 16th centuries, and so did the pottery and tile makers (*kaşigerân*). Undoubtedly the most important change to occur in the *Ehl-i Hiref* organization, however, was the disappearance of the tile makers and carpet weavers as separate companies early in the 1600s. Little has been said by research specialists about the activities of these two companies, though they are of considerable importance for art history; by and large, scholars have also avoided commenting on what these palace craftsmen produced or might have produced.

It is clear that carpet weavers and tile makers employed by the palace were not sufficiently numerous to have been able to meet the full demand of the court for their products. Nevertheless, the fact that the palace employed these artists and craftsmen shows that the companies in question must have met some part of the need for high quality artefacts. It is difficult to suppose that the carpet weavers, whose company had been formed under Mehmed II (1451-81), and who are known to have numbered eighteen during the succeeding reign of Bayezid II (1481-1512), were occupied solely with drawing carpet designs. Julian Raby justifiably attributes the earliest examples of "star" and "medallion" Uşaks to the reign of sultan Mehmed II in terms of motifs and composition, and these at least must have been woven by palace craftsmen. Actually, a significant proportion of the court carpets widely held to have been woven in Bursa and Cairo must also have been the work of palace carpet makers in the 16th century. The fact that carpets woven according to designs prepared by palace artists, and in which the tastes and decorative styles of the 16th century Ottoman court predomi-nate, continued to be woven until the early 17th century, supports this premise. On the other hand, there is no reason why carpets of the same type with designs conforming to Ottoman court tastes should not have been woven in Cairo, from which city materials and weavers were from time to time brought to Istanbul.

A similar situation holds for the production of tiles in the court workshops. If we may assume that the materials needed would have been brought in from İznik, the empire's leading centre of pottery and tile production, then we can also conclude that the tiles for some of the palace buildings might have been produced by these craftsmen in Istanbul. A document dating from the reign of Sultan Süleyman I (1520-66), which has been transcribed and edited by Gülru Necipoğlu-Kafadar, provides clear evidence of cooperation between the *nakkaşân* or designer-decorators and the tile makers of the *Ehl-i Hiref*, and also gives a breakdown of expenditure on tiles for the court. Nevertheless, the İznik potteries were, of course, the main centre for the production of tiles both for the palace and for all public buildings constructed by the state. At the same time, we know from other documents that tiles kept being produced in İznik according to samples supplied by the palace. Now by "samples" they could have meant either drawings or designs, or actual tiles made in the workshops in Istanbul. That the latter is a feasible interpretation, is demonstrated by a reference to "a plate and a ceramic rose" (meaning, perhaps, a tile with a rose motif) presented to Süleyman I on the occasion of a religious festival, by one of the *Ehl-i Hiref* potters.

Metalworkers and silversmiths

After reviewing these top producers of luxury materials and artefacts, we move on to fifth category *Ehl-i Hiref* companies who

56

or hired on a permanent basis. Some craftsmen, moreover, were employed by other state sectors. Thus apart from the parallel organization of the tailors, already referred to, as well as the Aegean carpet weavers or the tile makers of İznik, the saddlers (*saraç*), numbering around 300 at the end of the 16th century, were affiliated with the Imperal Stables (*Istabl-ı Âmire*), as were the rein makers (*efsardüzân*), the makers of horse blankets and saddle cloths (*yapukcuyan-ı hassa*), the makers of soft saddles (*palan dikici*), the chain makers, felt makers and tanners. All these artisans were under the command of the Master of the Horse (*büyük mirahur*). Similarly, the tent pitchers were another and very large company of palace employees, whose quarters were near the İbrahim Paşa Palace in the Hippodrome. Their organisation was known as the *Mehteran-ı Hayme-i Hassa*, and they were composed of four principal companies responsible for all aspects of the pitching and care of royal tents and pavilions. In addition there were the makers of these royal pavilion tents (*otakgerân-ı hassa*), the tent embroiderers (*nakşdüzân*) and the tent and curtain makers (*haymedüzân*).

We can conclude from all this evidence that compared with some other contemporary (for example, Italian Renaissance) systems of artistic patronage, Ottoman art developed in a framework of relatively more centralized palace patronage, under a system where the state exerted close control over both resource allocation, and quality and design.

Catalogue

A 1 History of Mehmed the Conqueror by Kritovoulos of Imbros.
1451-1467. h. 22 cm; w. 14,8 cm; 310 folios. Topkapı Palace Museum, G.İ. 3

A 2 Book of the Sovereign/Hünkârname by Ma'âli (Mir Seyyid Ali b. Muzaffer Tusî).
15th century. h. 25,5 cm; w. 18 cm; 183 folios. Topkapı Palace Museum, H. 1417.

A 46

A 48 A 49

A 46 Ivory Belt Piece. ca. 1500. l. 3.9 cm; w. 3.9 cm. Topkapı Palace Museum, 2/633.
A 48 Ivory Belt Piece. ca. 1500. l. 4.2 cm; w. 3.5 cm. Topkapı Palace Museum, 2/631.
A 49 Ivory Belt Piece. ca. 1500. l. 1.7 cm; w. 4 cm. Topkapı Palace Museum, 2/632.

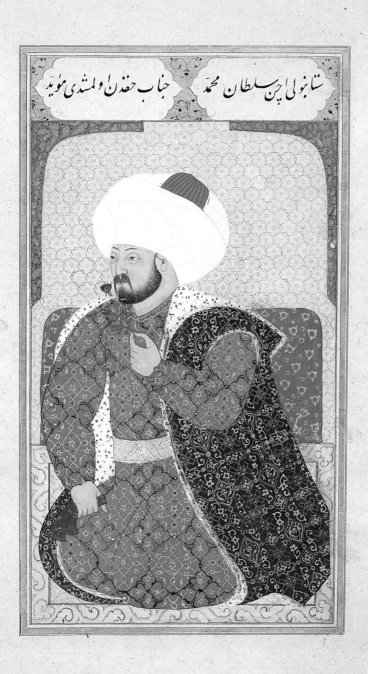

ستانبولی این سلطان محمد جناب حفذن اولمشدی مؤید

Portrait of the Conqueror, Mehmed II from Kıyafet al-İnsaniye fi Şemail al-Osmaniye by Nakkaş Os ca. 1579, h. 23 cm; w. 12.5 cm, Topkapı Palace Museum, H. 1563, fol. 47v,

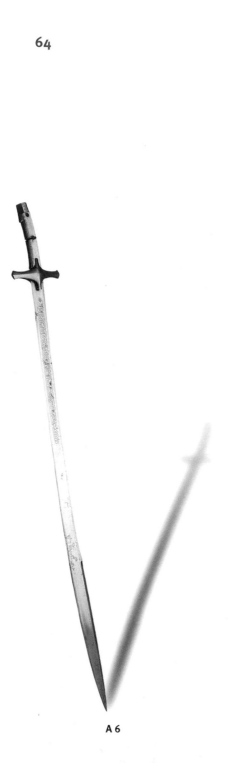

A 6

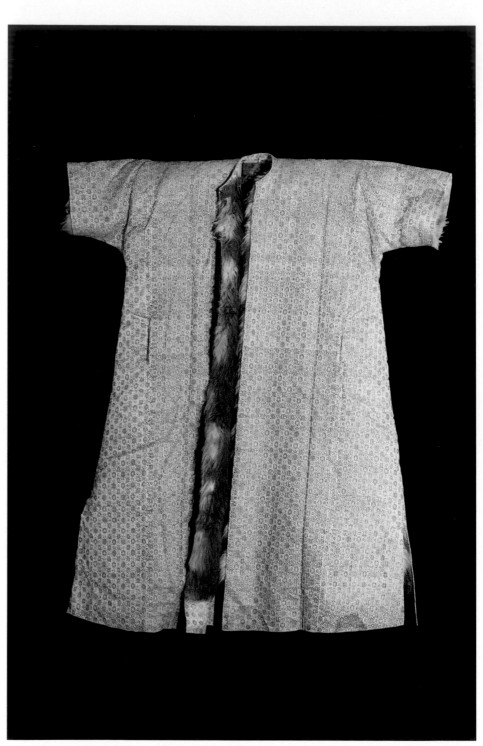

A 5

A 5 Kaftan of the Conqueror, Mehmed II. 15th century. l. 140 cm. Topkapı Palace Museum, 13/20.

A 6 Sword of the Conqueror, Mehmed II. l. 100 cm. Topkapı Palace Museum, 1/375.

A 8 A Portrait of Alexander the Great in "Alexander's Journey to the Land of Darkness" from Hamse-i Nizami (Timurid Herat). copied by Yusuf al-Jami; illustrated and illuminated by Khwaja Ali al-Tabrizi, 1445-6 (H. 849). l. 24,5 cm; w. 16,6 cm; 326 folios. Topkapı Palace Museum, H. 781, fol. 279b.

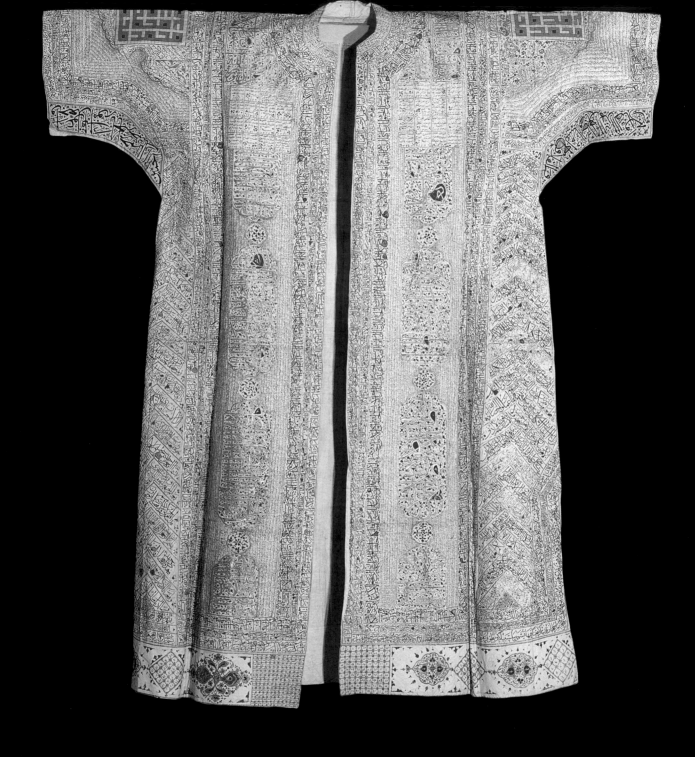

A 7 Talismanic Shirt of the Conqueror, Mehmed II. 15th century. l. 135,5 cm. Topkapı Palace Museum, 13/1408.
(Back, see p. 75; detail, see pp. 76-77)

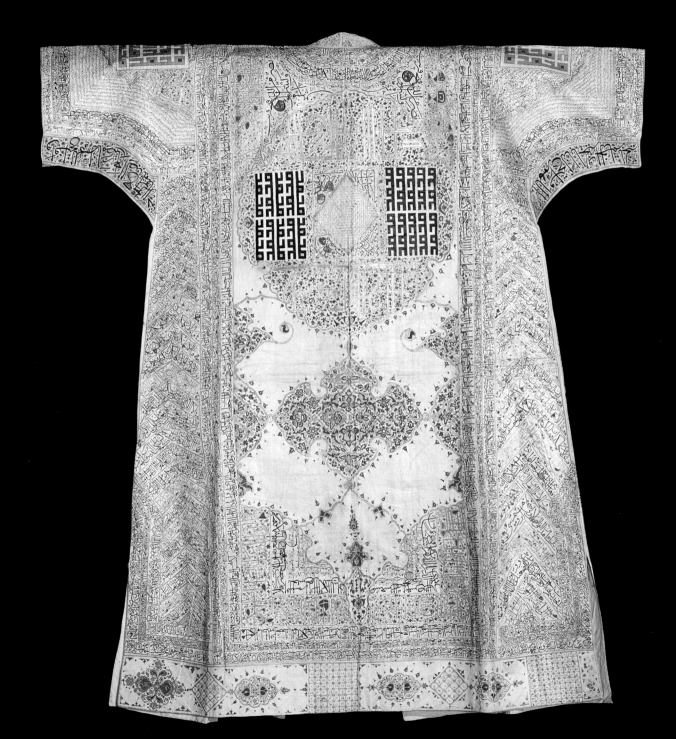

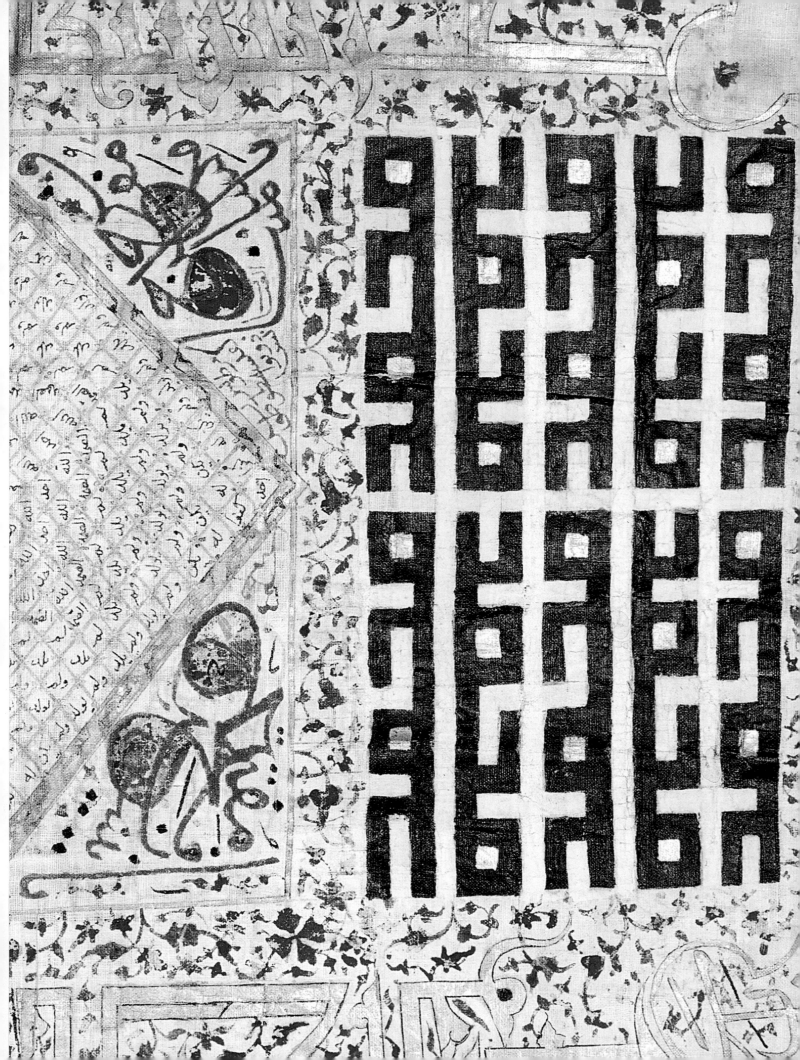

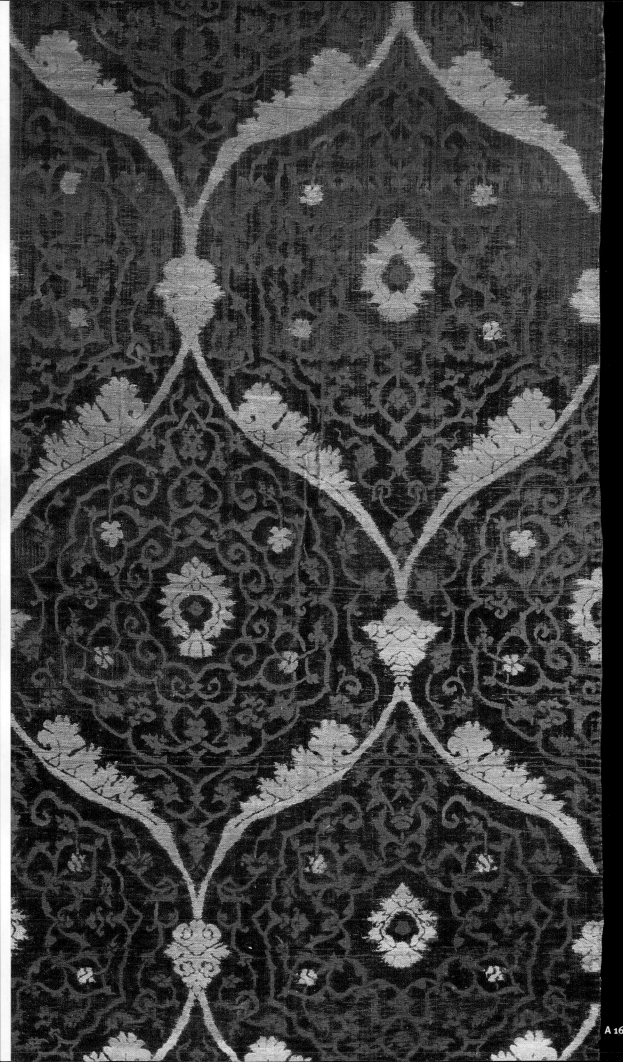

A 16

A 17

A 16 Italian Velvet. 15th century. l. 425 cm; w. 64 cm. Topkapı Palace Museum, 13/1915.

A 17 Italian-velvet Bookbinding for a Translation of Avicenna's Canones (el-kanun fi't-Tıbb "Book on Medicine"). ca. 1480, text dated 1323-5. l. 40 cm; w. 28,5 cm; 253 folios. Topkapı Palace Museum, A. 1939/1.

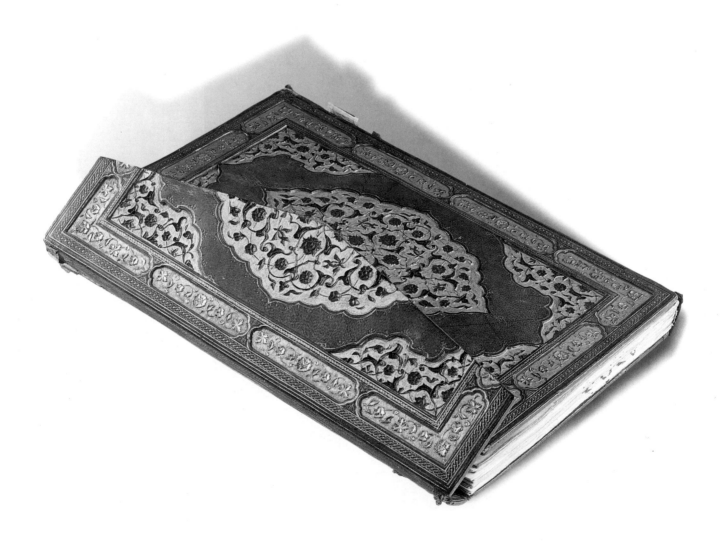

A 21 Bookbinding of Cam-u Cem (Book of Mesnevi poems) by Rukn al-Din Evhadi (d. 1337); copied by Şeyh Mehmed.
1483. l. 20,7 cm; w. 14 cm; 152 folios. Museum of Turkish and Islamic Arts, 2053.

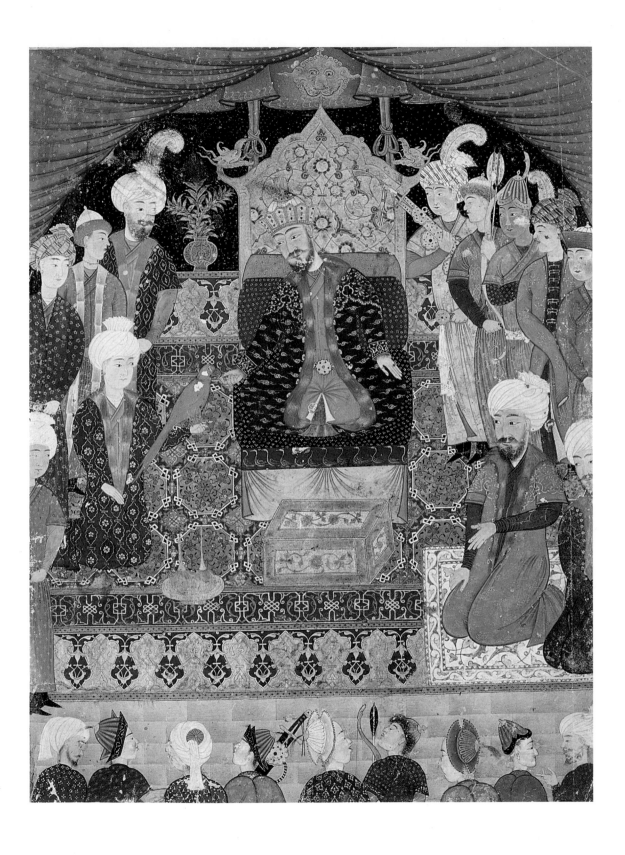

A 22 Enthronement Scene from Sultan Ali Mirza's Shahname (The Book of Kings) Firdausi, Ebul Kasım Mansur, 1494.
l. 35 cm; w. 24 cm. Museum of Turkish and Islamic Arts, 1978.

A 23 Mamluk Brass Bowl. 1470-1490. h. 16,5 cm; upper d. 35 cm. Museum of Turkish and Islamic Arts, 2959.

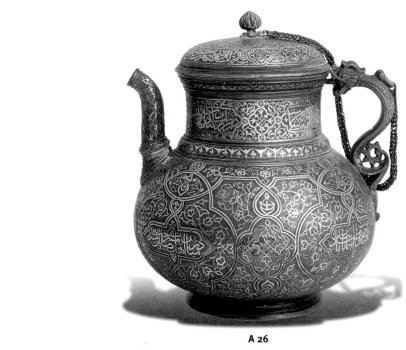

A 26

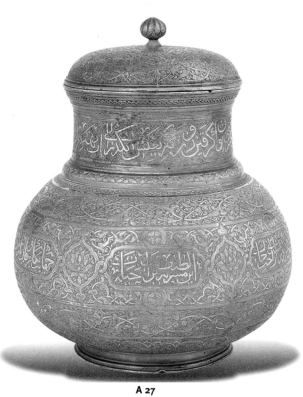

A 27

A 26 Timurid Brass Jug. Husaynuddin Shihabuddin al-Birjandi. Dated 871/AH 1467. h. 16,5 cm.
Museum of Turkish and Islamic Arts, 2961.

A 27 Timurid Brass Jug. Husaynuddin Shihabuddin al-Birjandi. Dated 871/AH 1467. h. 16,5 cm.
Museum of Turkish and Islamic Arts, 2963.

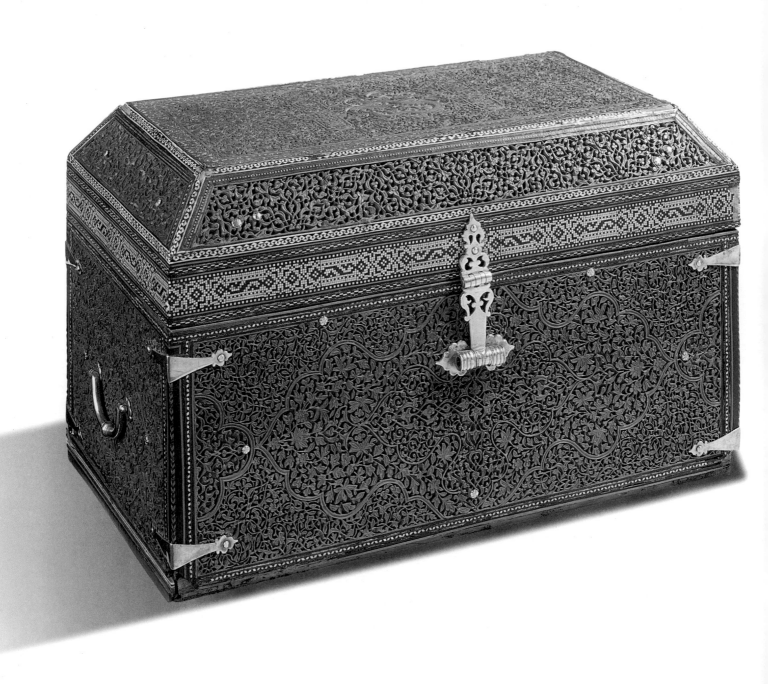

A 25 Timur's Grandson, Uluğ Bey's Wooden Casket. ca. 1420-49. h. 19,5 cm; l. 31,2 cm; w. 17 cm.
Topkapı Palace Museum, 2/1846.

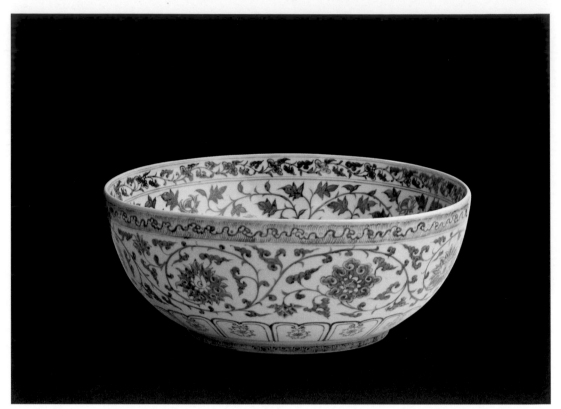

A 33

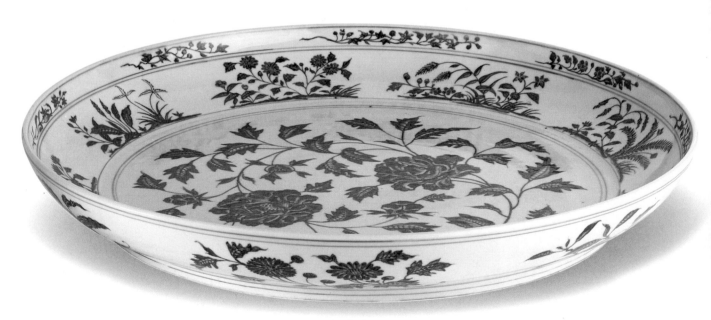

A 31

A 33 Blue-and-white Chinese Porcelain Bowl. Second half of 14th century to early 15th century.
d: 41,3 cm; h. 16,2 cm; d. 23,2 cm. Topkapı Palace Museum, 15/1369.

A 31 Blue-and-white Chinese Porcelain Dish. Early 15th century. d. 63,5 cm. Topkapı Palace Museum, 15/1372.

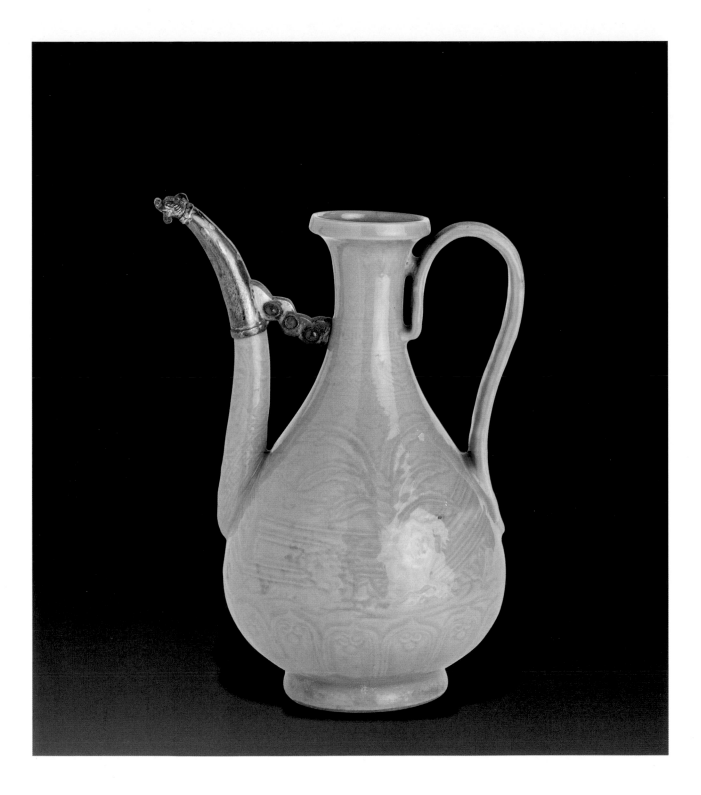

A 28 Chinese Celadon Ewer. ca. 1400. h. 34 cm. Topkapı Palace Museum, 15/40.

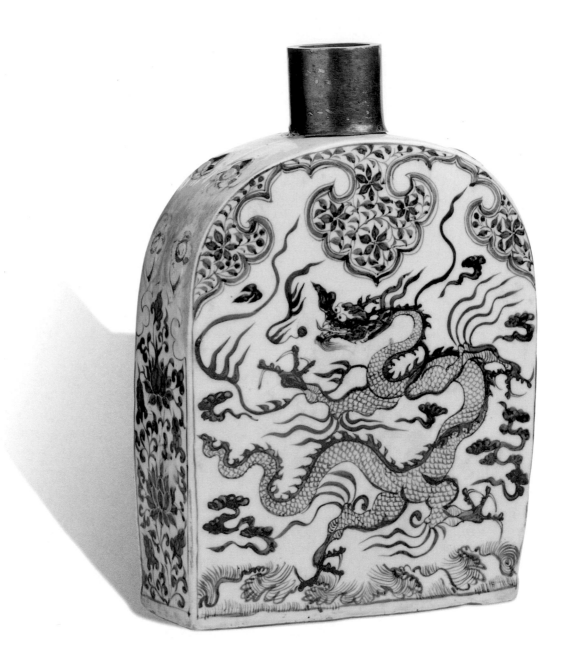

A 36 Blue-and-white Chinese Porcelain Canteen. Mid 14th century. w. 27 cm; h. 39,5 cm.
Topkapı Palace Museum, 15/1391. (Detail, see pp. 92-93)

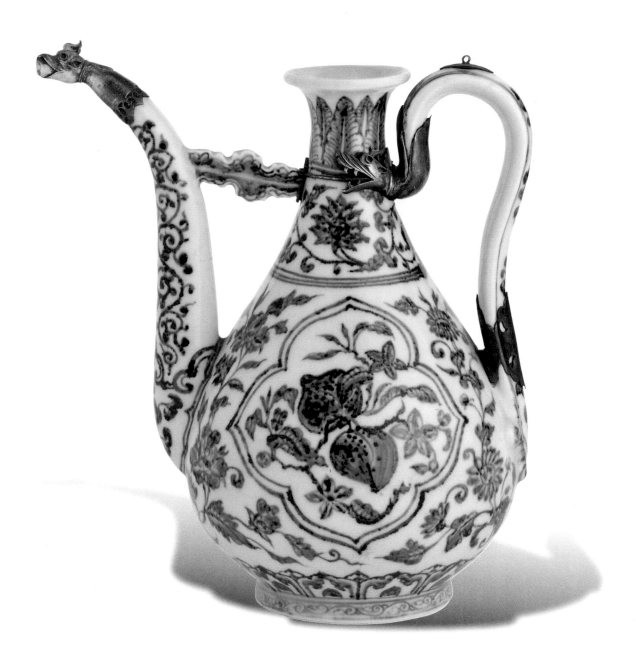

A 35 Blue-and-white Chinese Porcelain Pitcher. Early 15th century. h. 27 cm. Topkapı Palace Museum, 15/1410.

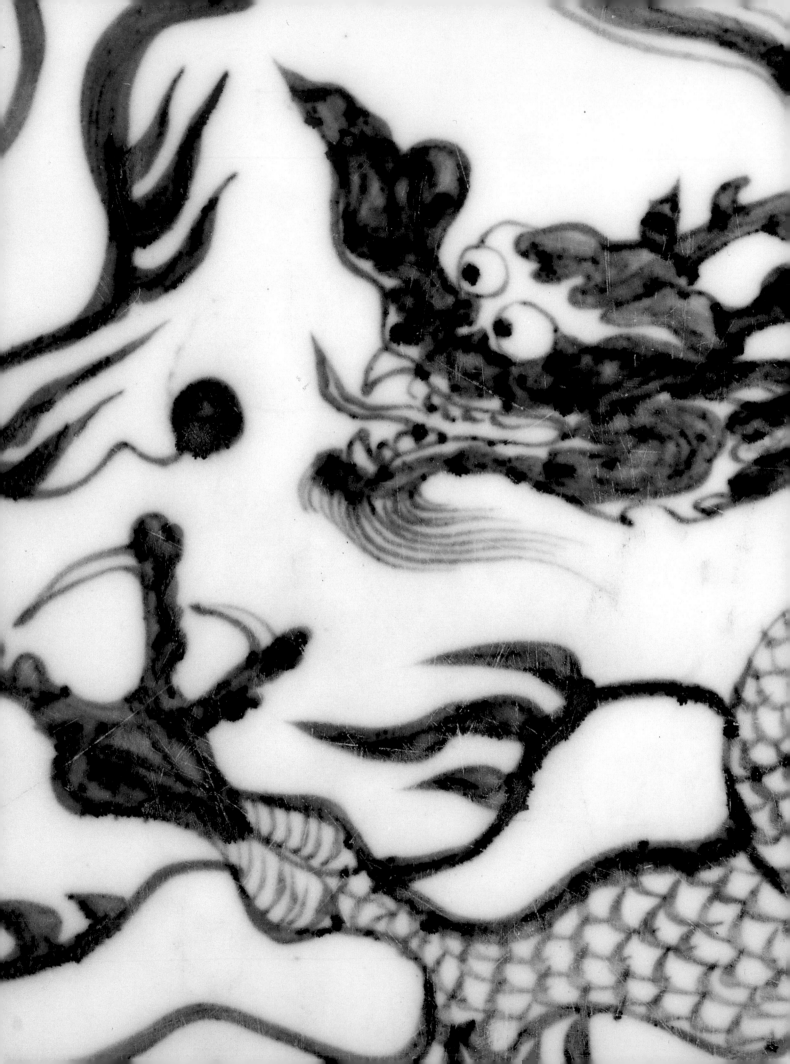

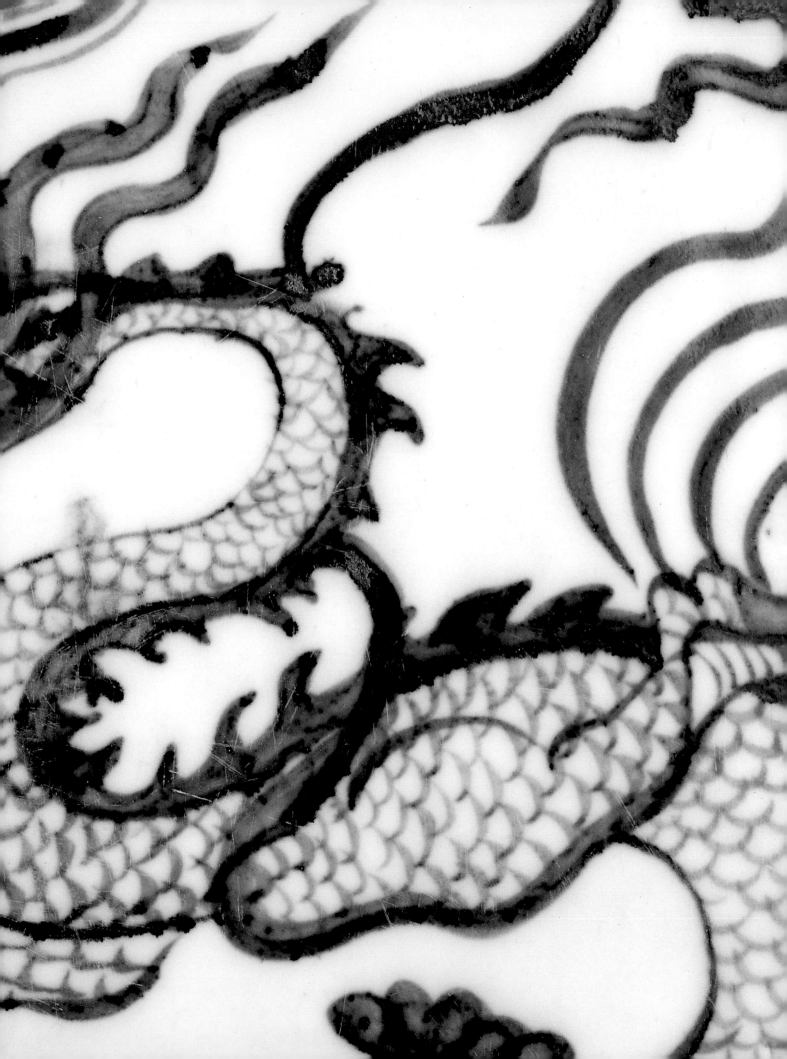

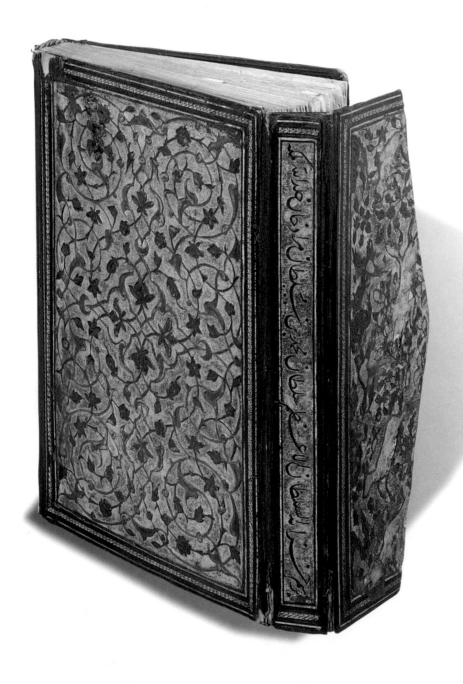

A 38 Bookbinding of Al-Lama'at of Fakhr al-din al-Iraqi (Book on Sufi Poems), copy made in İstanbul
by Ghiyath al-din al-Mujallid, text completed on 19 February 1477. l. 18,4 cm; w. 11,7 cm; 71 folios.
Museum of Turkish and Islamic Arts, 2031.

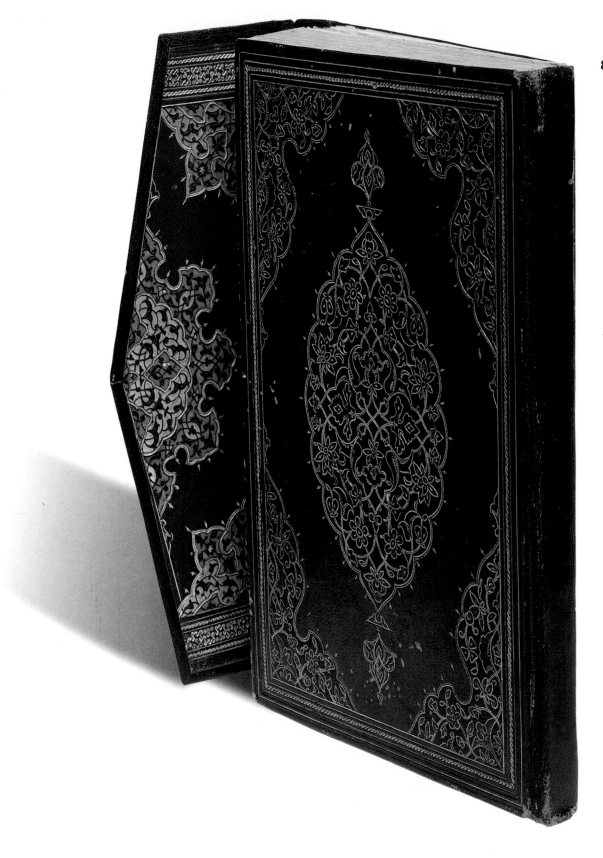

A 37 Bookbinding of Gurar al-Ahkâm (Book on Hanefi Jurisprudence), Muhamed b. Farâmuz b. Ali al-Tarsusî, commonly known as Molla Husrav, 1474 (by the author's hand writing). l. 25 cm; w. 17,5 cm; 152 folios. Topkapı Palace Museum, A. 1032.

A 39 Bookbinding of a Single-volume Koran. ca. 1465-70. l. 40,6 cm; w. 27,5 cm; 334 folios.
Museum of Turkish and Islamic Arts, 448.

A 40 Frontispiece of a **Koran by Calligrapher Şeyh Hamdullah.** 1495-6. l. 33 cm; w. 22,5 cm, 337 fols.
Topkapı Palace Museum, E.H. 72.

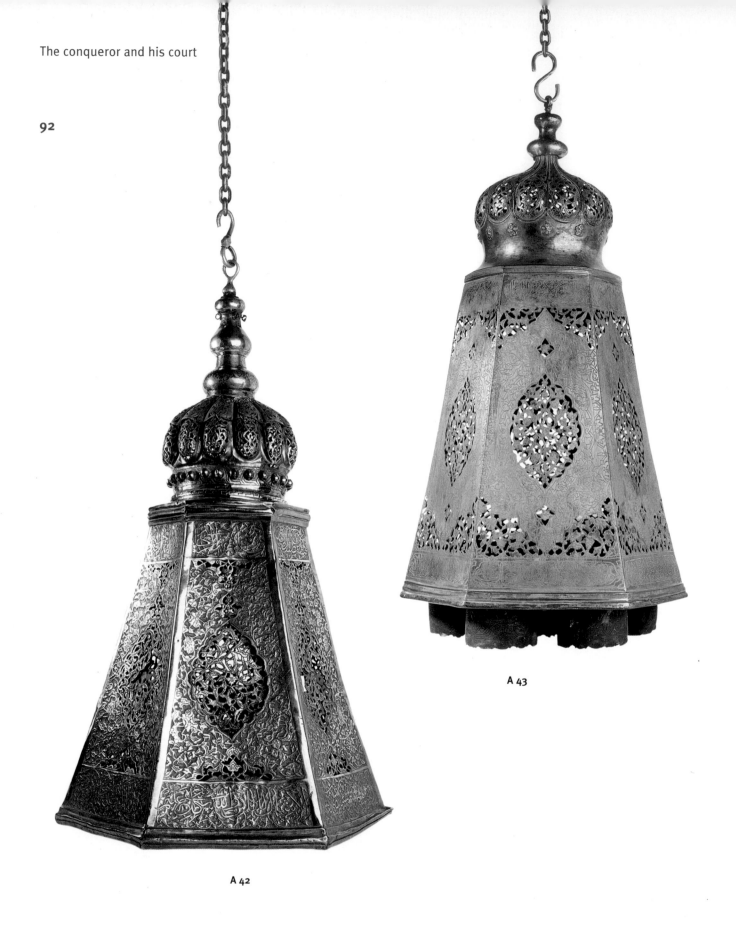

A 42

A 43

A 42 **Silver Lantern.** From the Mosque of the Conqueror, Fatih Cami, ca. 1450-60. d. 40 cm; h. 67 cm. Museum of Turkish and Islamic Arts, 167.

A 43 **Gilt Mosque Lamp.** 1481-1512. d. 40 cm; h. 70 cm. Museum of Turkish and Islamic Arts, 170.

A 41 Frontispiece of Şerh es-Selâhiye (Book on Arithmetics) by Salahi; expanded by Şams ad-Din Muhammed al-Hatibi.
Second half of 15th century. l. 25.2 cm; w. 15 cm; 129 folios. Topkapı Palace Museum. A. 3141.

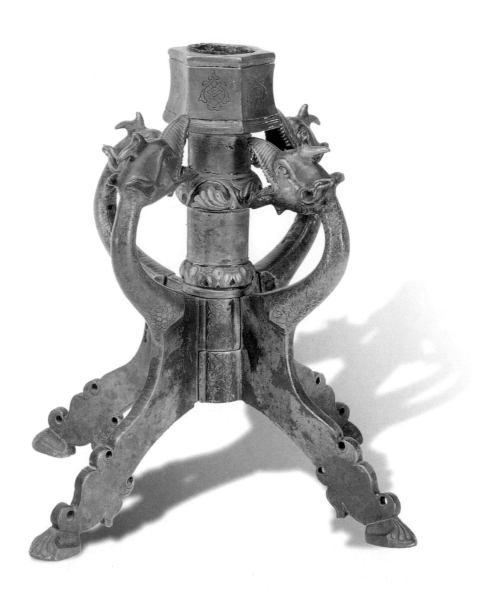

A 44 Gilt Candle Holder. 15th century. h. 22,5 cm. Museum of Turkish and Islamic Arts, 4017.

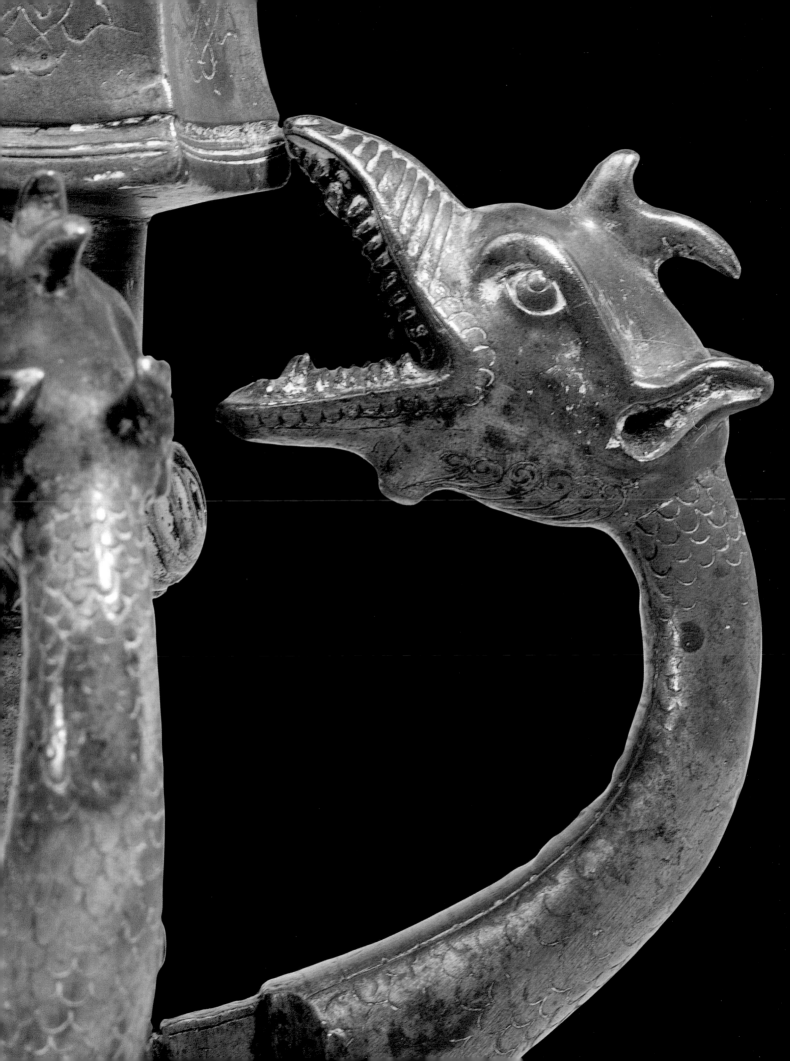

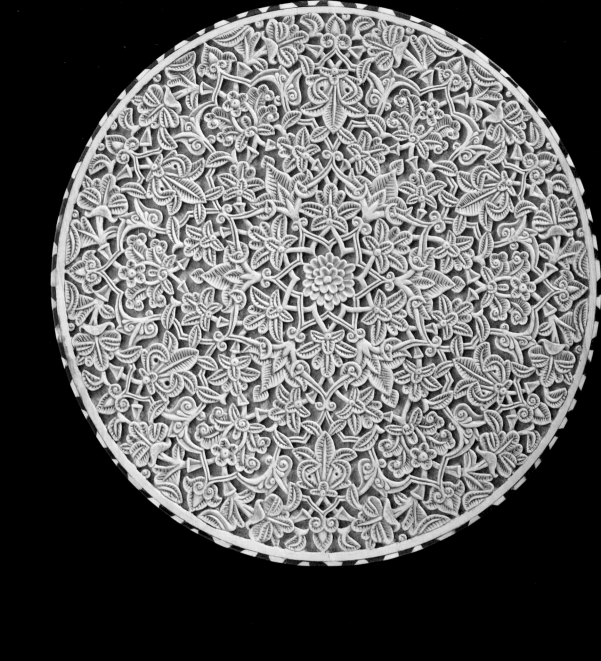

50 Ivory Mirror. Second half of 15th century, d. 14.4 cm, Topkapı Palace Museum, 2/1805.

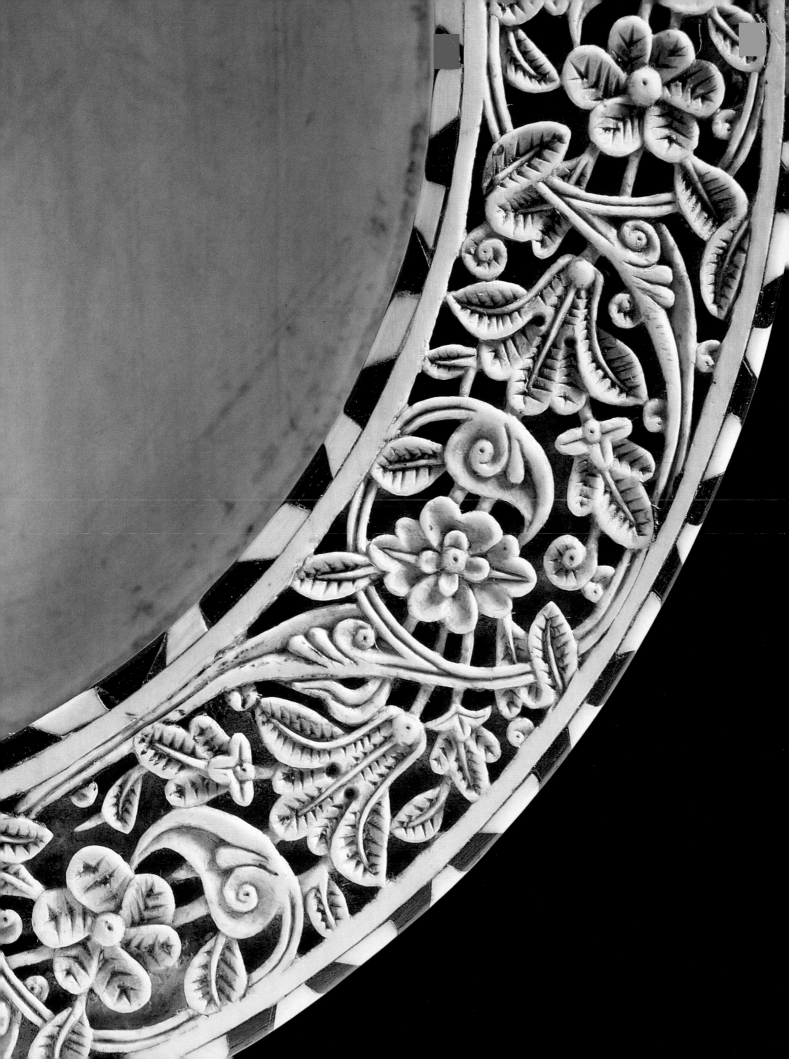

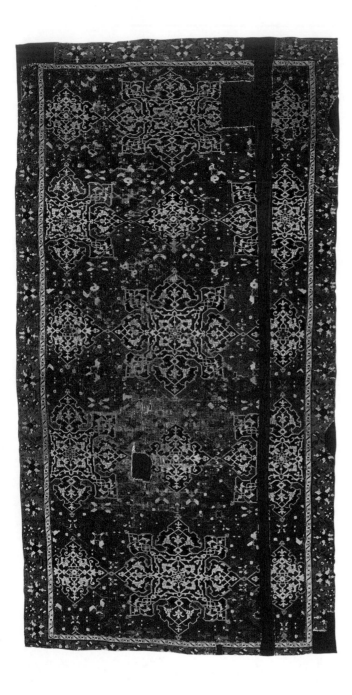

A 53 West Anatolian "Star Uşak" Carpet. Late 15th century or
early 16th century. l. 375 cm: w. 196 cm.
Museum of Turkish and Islamic Arts, 53

A 52 West Anatolian Medallion Uşak Carpet. Late 15th century. l. 285 cm; w. 161 cm.
Museum of Turkish and Islamic Arts, 765.

A 54 Blue and white Ceramic Mosque Lamp. Early 16th century. h. 21,5 cm; d.(at rim) 17,5 cm.
İstanbul Archaeological Museums, 41/1.

B 1

B1 Illuminated **Tuğra of Süleyman I.** By Kara Memi, ca. 1540-1550. h. 158 cm; w. 240 cm.
Topkapı Palace Museum, G.Y. 1400.

B3 **Tuğ.** 18th century. h. 346 cm. Topkapı Palace Museum, 1/1000.

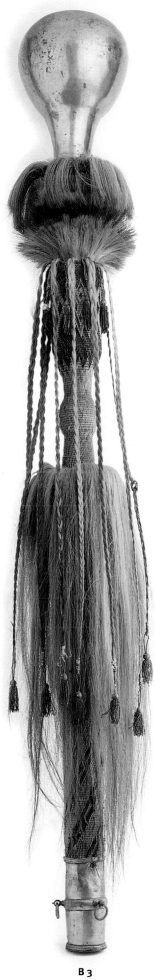

B 3

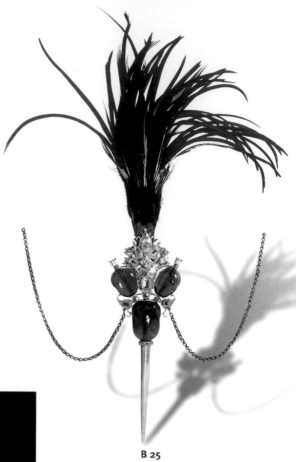

B 25

B 26

B 25 Aigrette. 17th century. l. (of the chain) 18,5 cm; d. 16,5 cm. Topkapı Palace Museum, 2/205.
B 26 Rock Crystal Pendant. 18th century. l. 16.5 cm, d. 18 cm. Topkapı Palace Museum, 2/469.

B2 **Campaign Throne.** Mid 16th century. h. 129 cm; l. 163,5 cm; w. 75 cm. Topkapı Palace Museum, 2/2879.

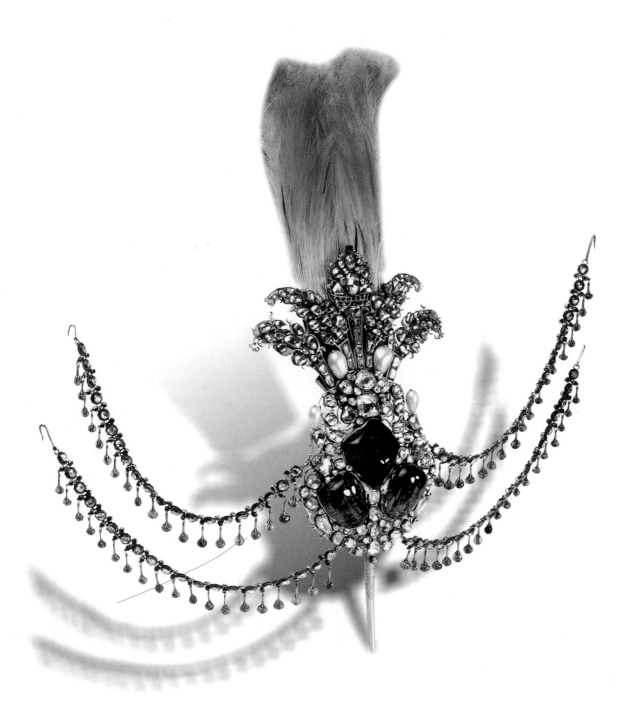

B 24 Aigrette. 18th century. h. (without plumes) 32 cm; l. 62 cm. Topkapı Palace Museum, 2/284.

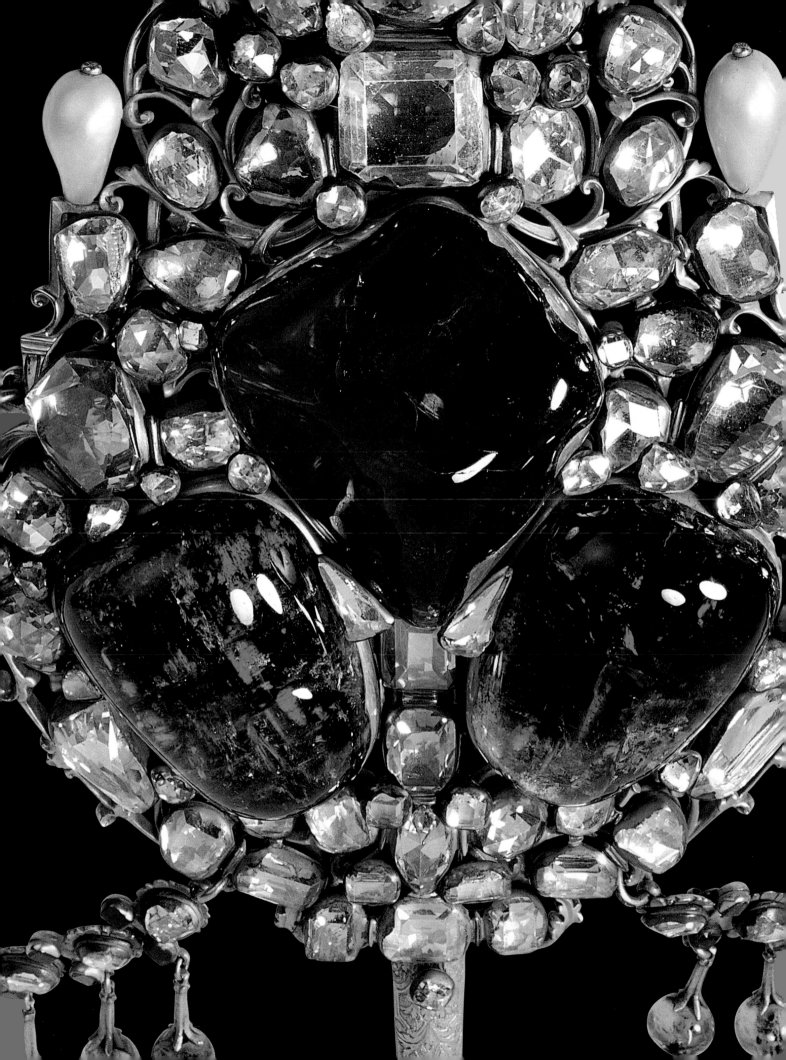

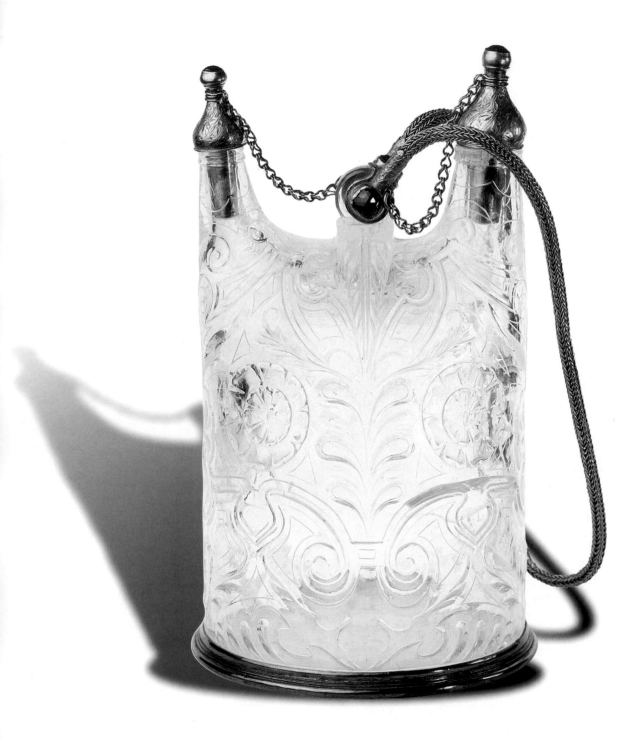

B 29 Rock Crystal Flask . 17th century. h. 28,5 cm; w. 15 cm. Topkapı Palace Museum, 2/474.

B 8

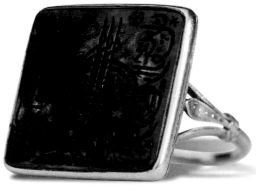

B 5

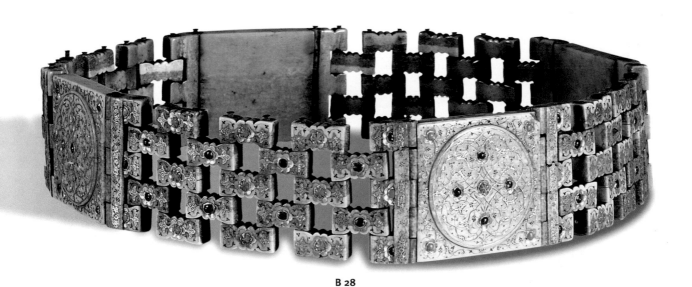

B 28

B 5 Seal of Abdülhamid I. r. 1757-1774 (H. 1187). square; l. 2,3 cm; w. 2,1 cm; h. 2,8 cm. Topkapı Palace Museum, 47/20.

B 8 Seal of Nazikeda Başkadın. 1879 (H. 1296). d. 2 cm; h. 2,7 cm. Topkapı Palace Museum, 47/102.

B 28 Ivory Belt. Mid 16th century. l. 65,5 cm; w. 4,5 cm. Museum of Turkish and Islamic Arts, 482.

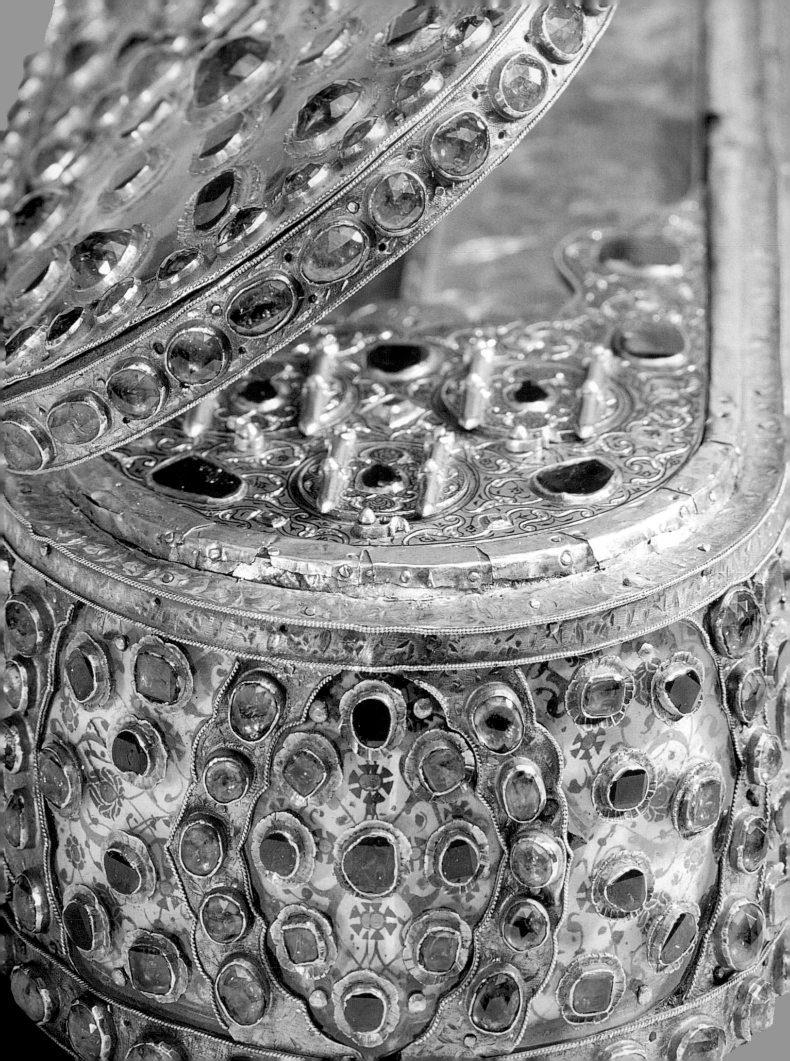

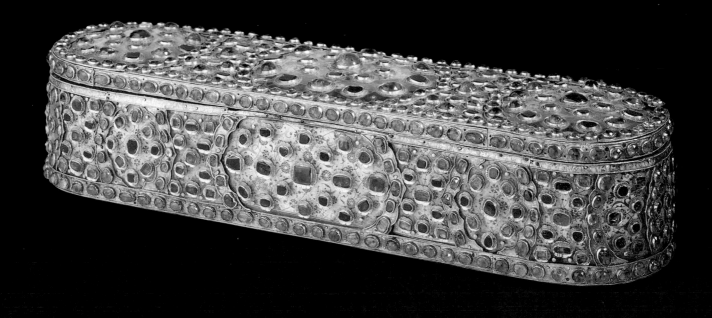

B 30 Jeweled Rock Crystal and Gold Pen Box. Late 16th century, w. 8,5 cm; l. 40 cm; h. 11 cm, Topkapı Palace Museum, 2/22.

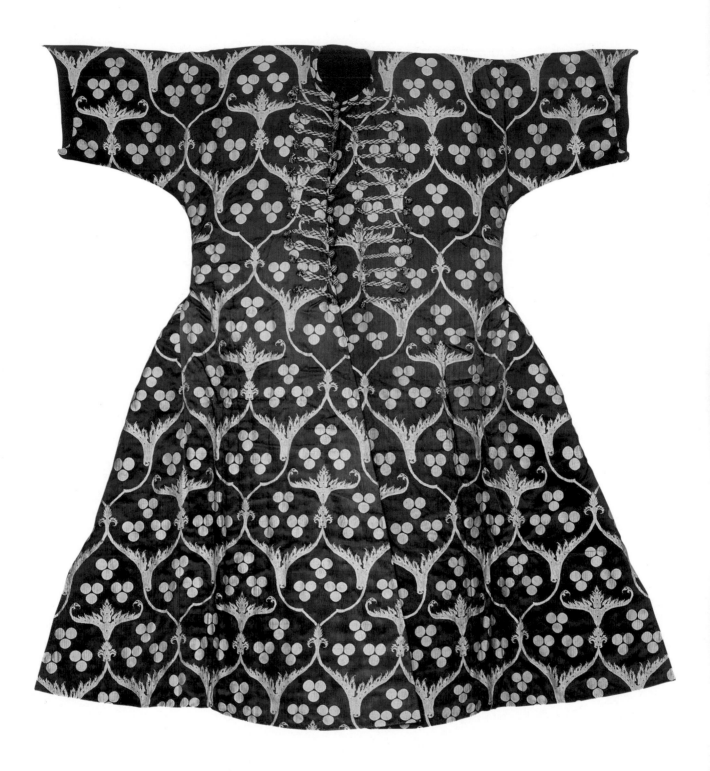

B 10 Short-sleeved Kaftan, associated with Selim I. 16th century. l. 140,5 cm. Topkapı Palace Museum, 13/42.

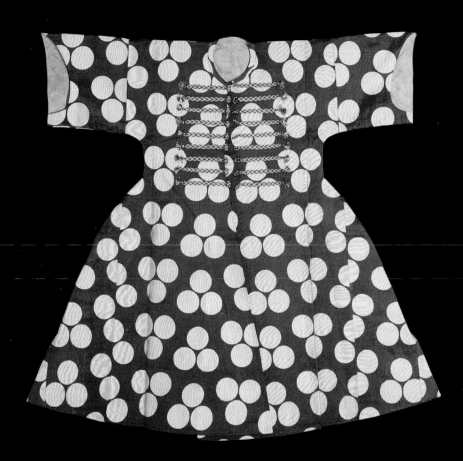

B 13 A Prince's Kemha Kaftan with Detachable Sleeves. 16th century. l. 73 cm; sleeve l. 47,3 cm.
Topkapı Palace Museum, 13/1015 and 13/927.

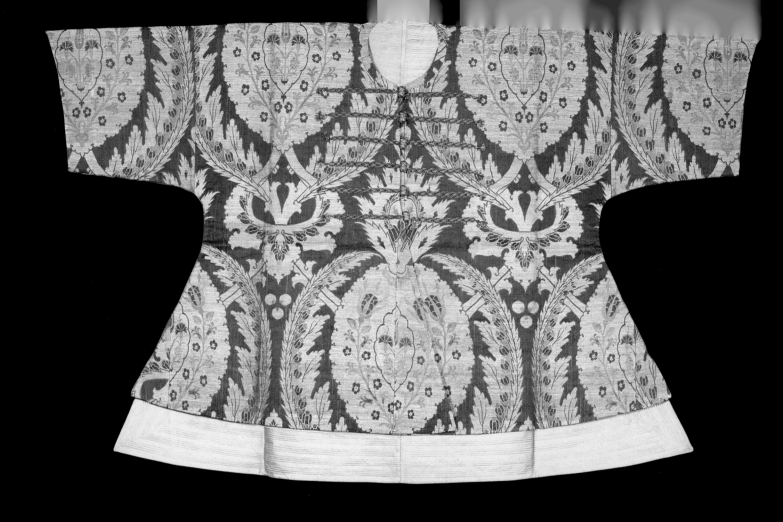

B 15 Princely Kaftan. Associated with Ahmed I. 17th century. L. 67.5 cm. Topkapı Palace Museum. 13/277

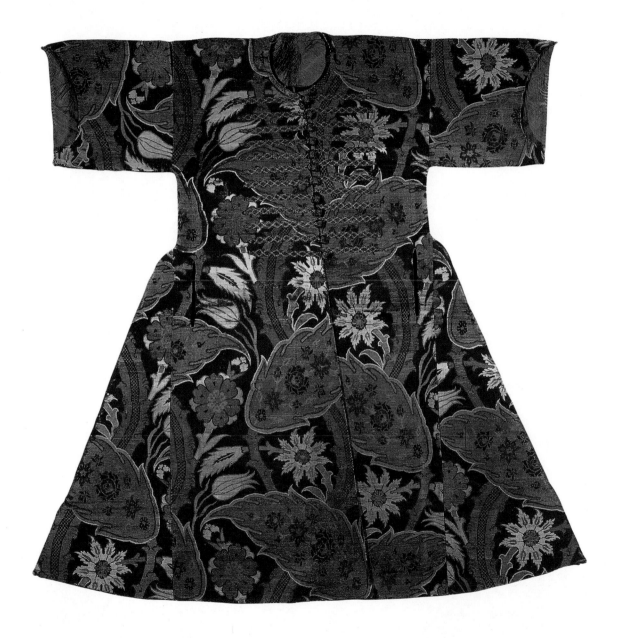

B 14 Princely Kaftan, Associated with Ahmed I. 17th century. l. 76.5 cm. Topkapı Palace Museum, 13/267.

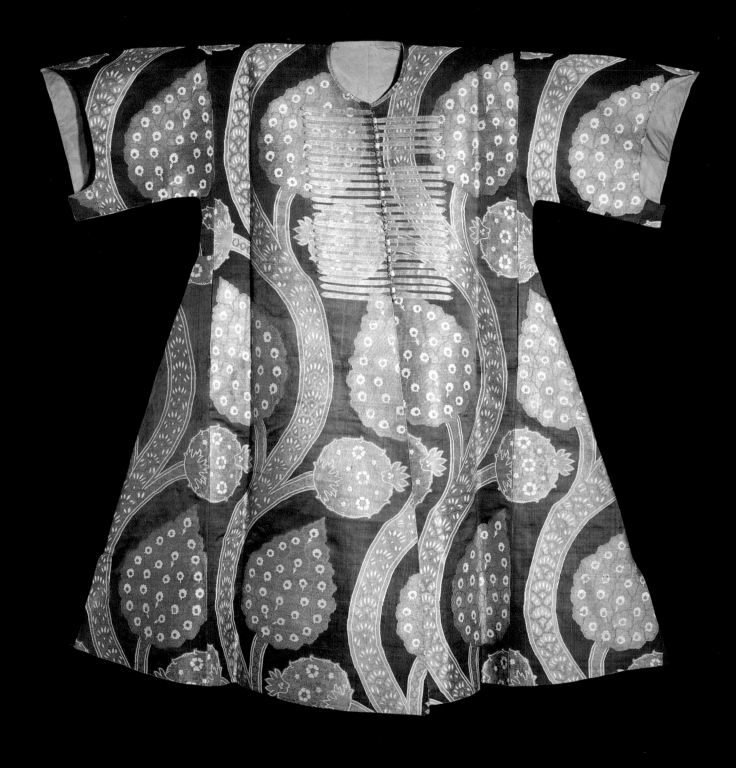

B 16 Kemha Kaftan of Osman II, ca. 1618-1622, l. 137.5 cm, Topkapı Palace Museum, 13/584.

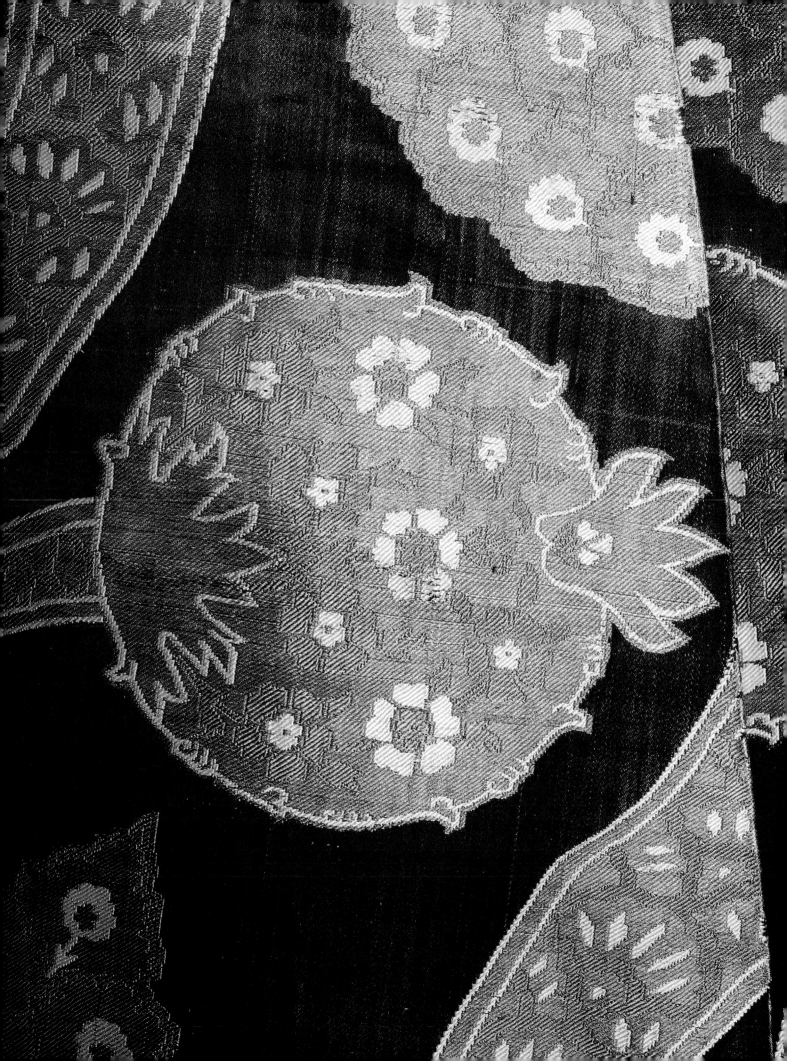

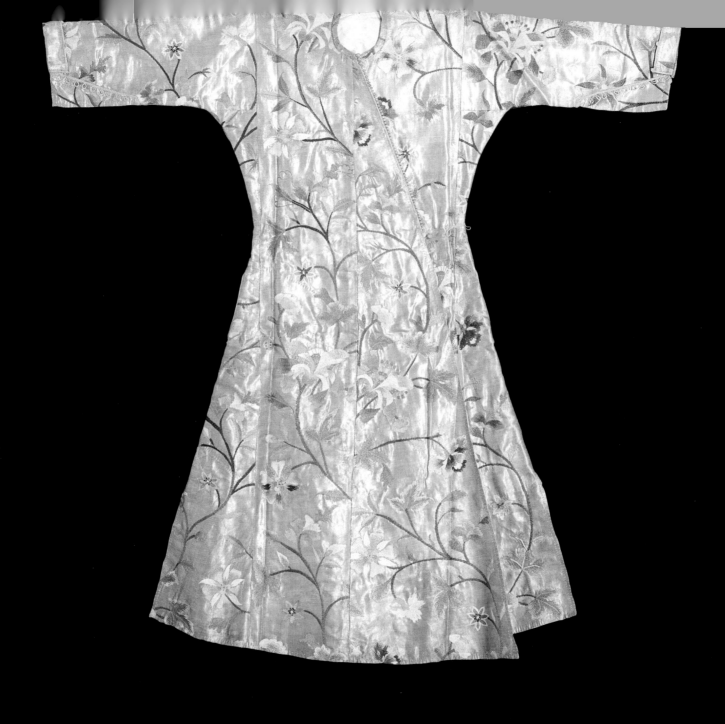

B 18　Luxury Garment of Fatma Sultan (?), Daughter of Mustafa III (r. 1757-74)
Mid 18th century, L 82 cm, Topkapı Palace Museum, 13/804

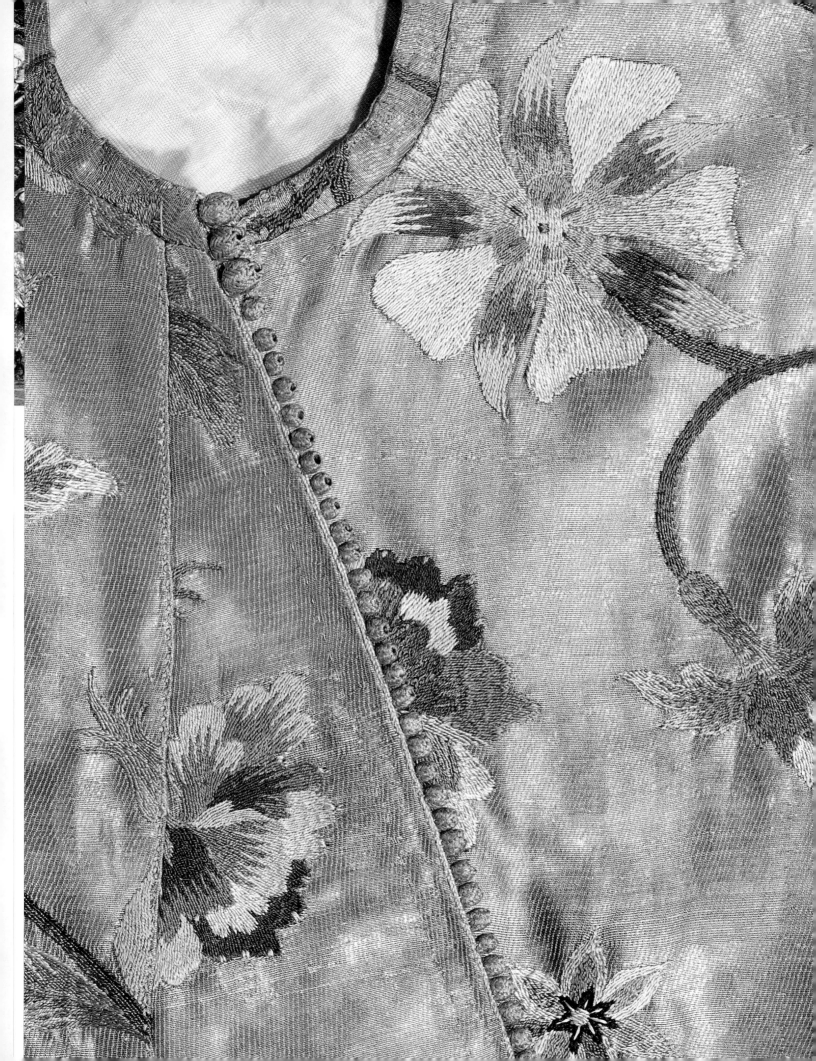

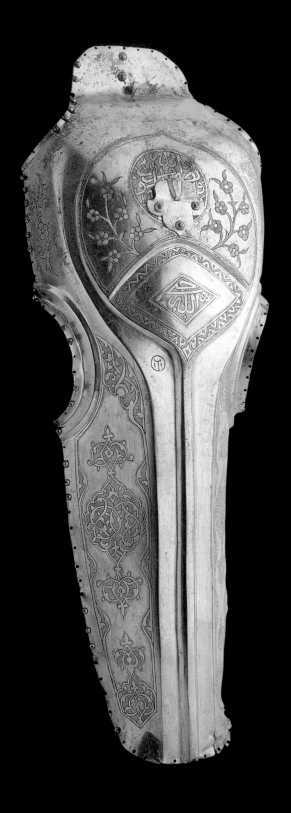

B 39 Horse Frontal. Late 16th century. h. 60 cm. Military Museum, 8359.

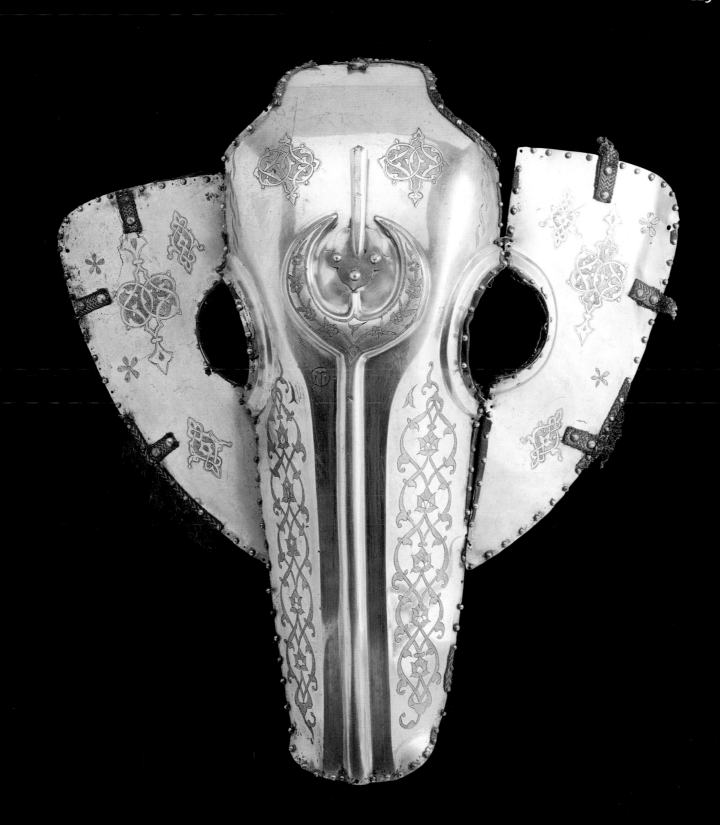

B 38 Horse Frontal. 2nd half of 16th century. h. 61 cm; w. 48 cm. Topkapı Palace Museum, 1/1446.

B 47 View of the Mescid-i Haram in Mecca from the Futûh el-Harameyn by Muhyî al-Dîn Lârî (d. 1526-7) ca. 1545. h. 18 cm; w. 12 cm; 58 folios. Topkapı Palace Museum, R. 917, fol. 14r.

B 42 Kaaba Curtain. 16th century. l. 42 cm; w. 79 cm. Topkapı Palace Museum, 24/362.

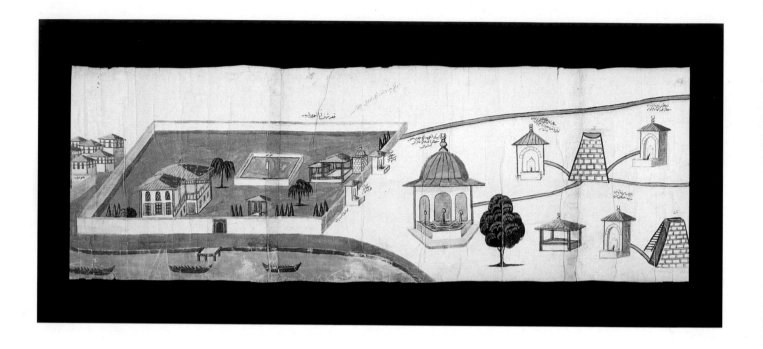

B 53 Map of Süleymaniye Waterways. 1753 (H.1166). l. 18 m; w. 30 cm. Museum of Turkish and Islamic Arts, 3336.

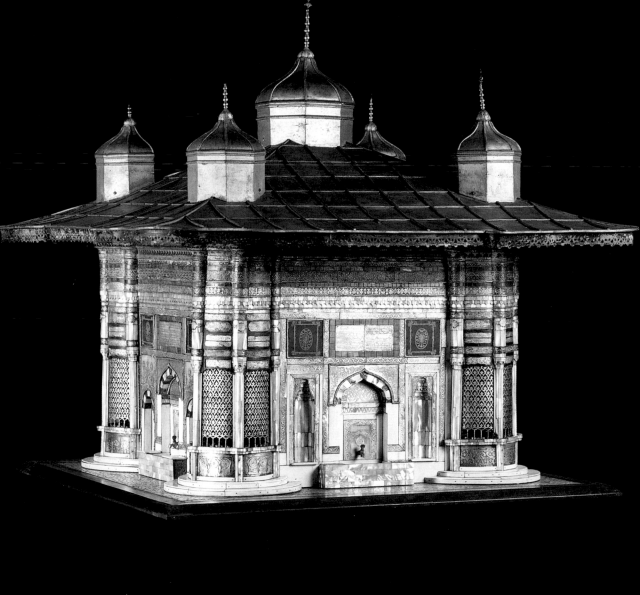

Model of the Fountain of Ahmed III. 1907. h. 65 cm; l. 68 cm; w. 68 cm. Yıldız Palace Museum, YSM/364.

C 8 Mülkname of Sultan Murad III. 20th-29th June 1575 (H. 983). l. 258 cm; w. 44 cm.
Museum of Turkish and Islamic Arts, 4126.

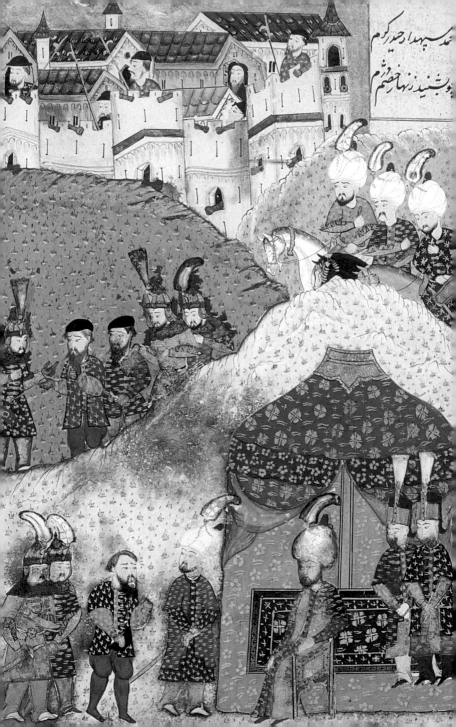

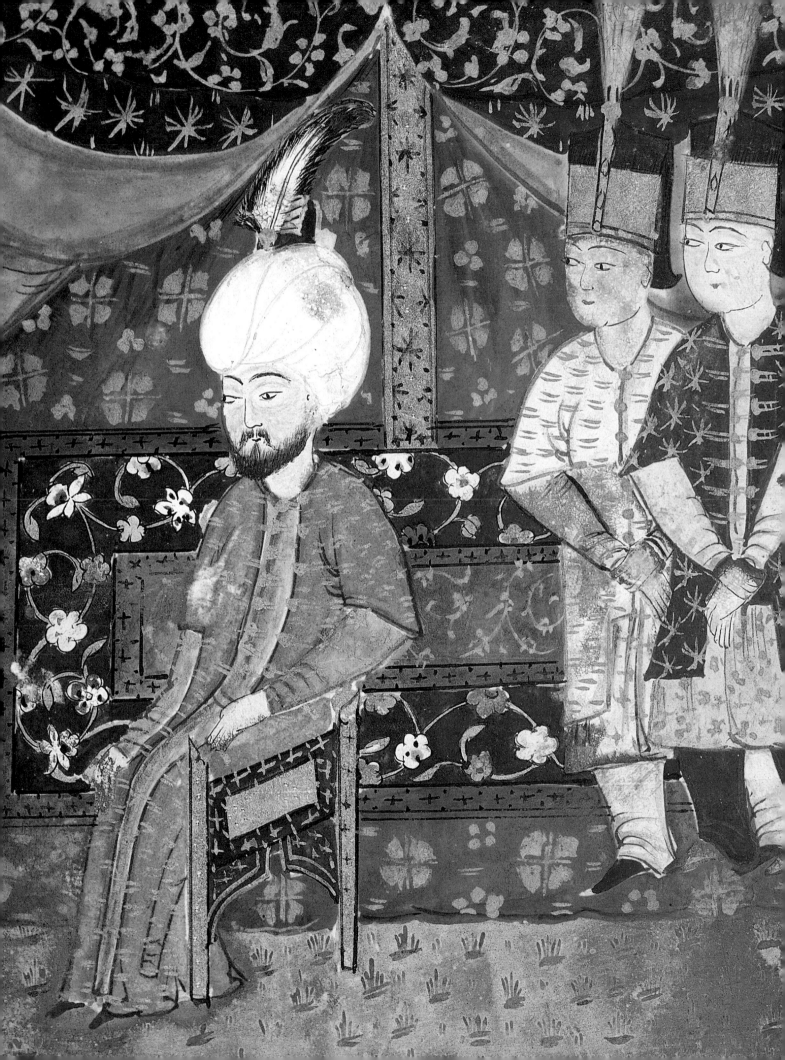

C 13

C 14

C 13 Headgear of a *Peyk*. 17th century. h. 30 cm; d. 18 cm. Topkapı Palace Museum, 1/1468.
C 14 Headgear. 18th century. h. 23 cm; d. 17 cm. Topkapı Palace Museum, 24/2113.

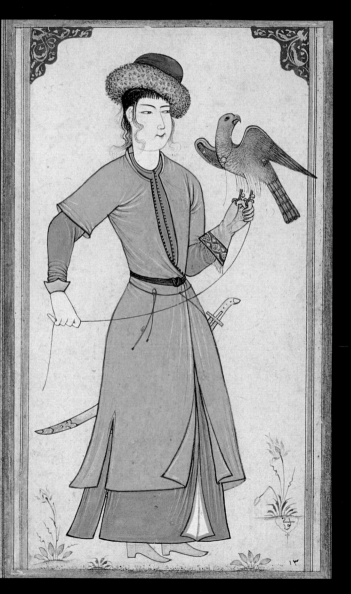

C 12

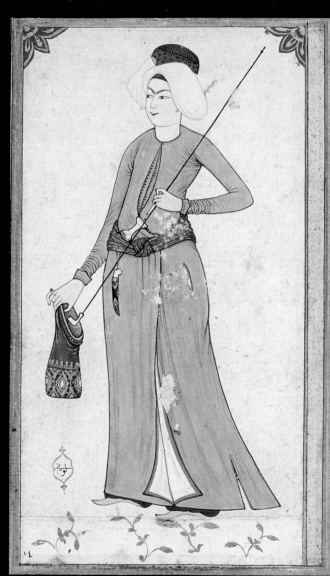

C 11

C 16

C 17

C 16 Book of Seals. 19th century. h. 16,4 cm; w. 10,8 cm, 23 folios. Topkapı Palace Museum, YY. 1116.

C 17 Silver Seal of Grandvizier Mahmud Şevket Paşa. 1912 (H. 1331). h. 3 cm; d. 2,8 cm. Topkapı Palace Museum, 47/141.

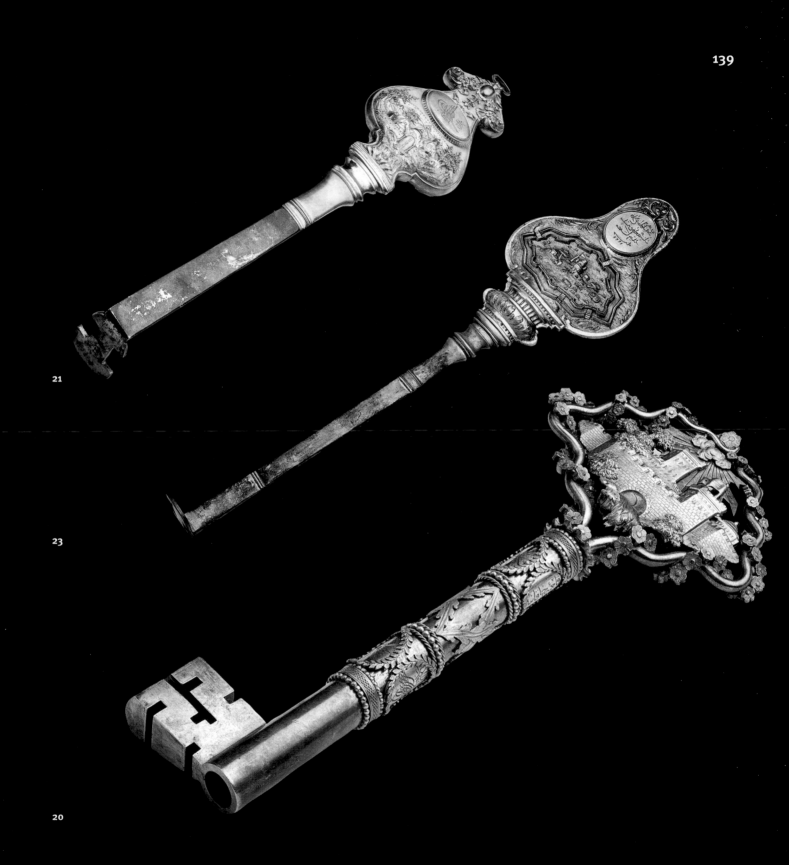

C 20 Fortress Key: Tolcu. 19th century. l. 30 cm. Topkapı Palace Museum. 2/2232.

C 21 Fortress Key: Unidentifed. 19th century. l. 45 cm. Topkapı Palace Museum. 2/2248

C 23 Fortress Key: Silistre. 19th century. 1818-9 (H. 1234). l. 55 cm. Topkapı Palace Museum. 2/2247.

140

D 1 Pair of Painted Wooden Cupboard Doors. Second half of 18th century. h. 182 cm; w. 119,5 cm.
Topkapı Palace Museum, 27/127.

D 3 Polychrome Tile, ca. 1530, d. 17.5 cm, İstanbul Archaeological Museums Çinili Kösk, 41/515.

D 17

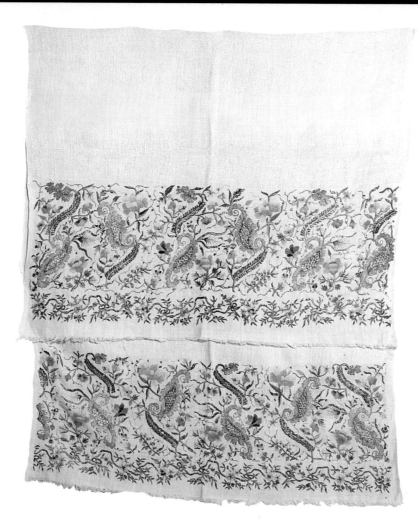

D 23

D 17 Embroidered Sofa Skirt. 19th century. l. 430 cm; w. 40 cm. Topkapı Palace Museum, 31/96.

D 23 Embroidered Towel. 18th century. l. 168 cm; w. 80 cm. E. and N. Akın, 2.

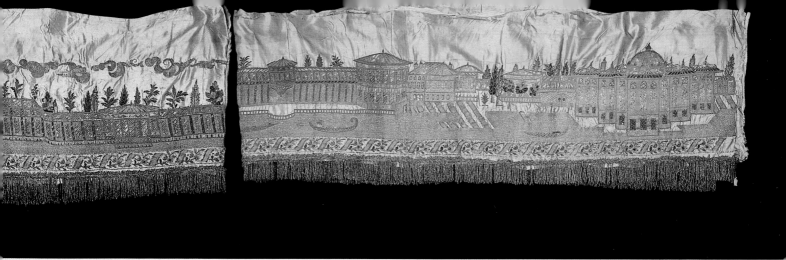

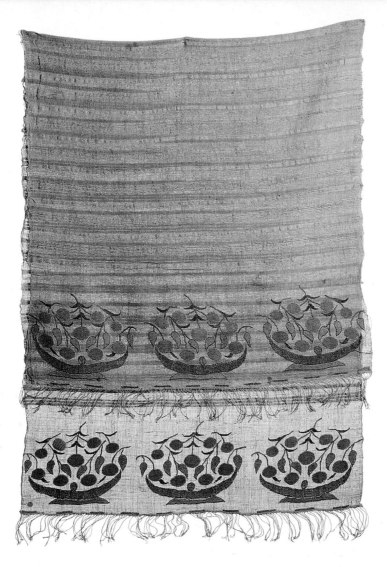

D 25　Embroidered Towel. 18th century. l. 106 cm; w. 47 cm. E. and N. Akın, 10.

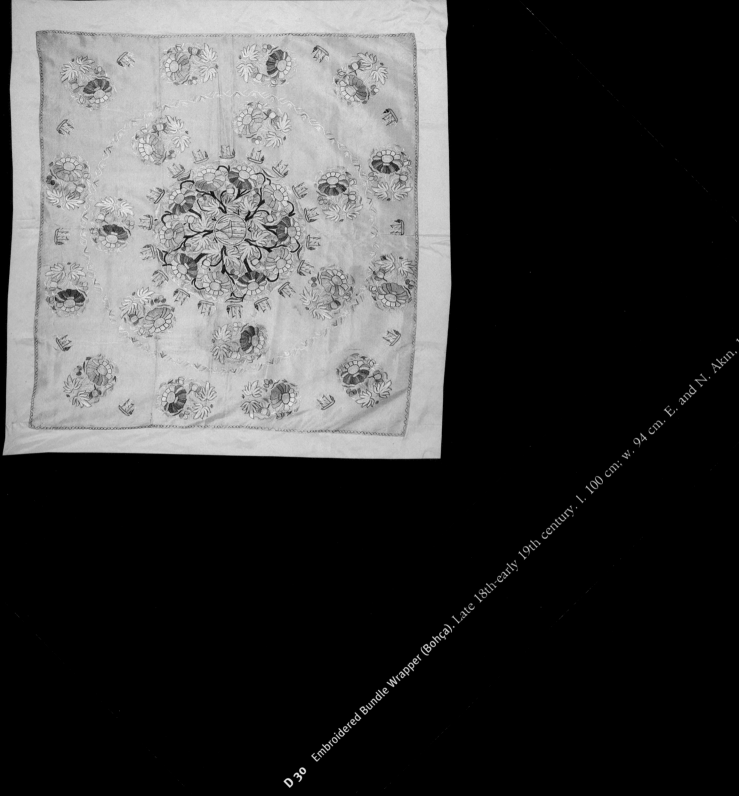

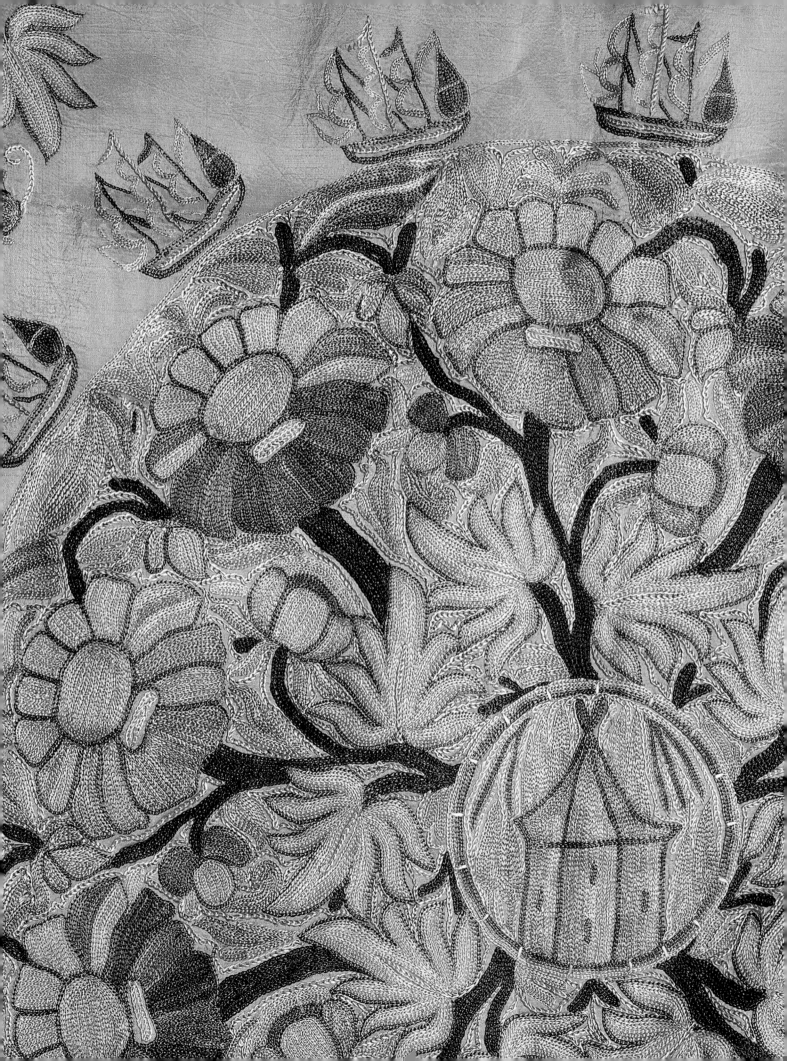

D 20 Velvet Cushion Cover, 17th century. l. 119 cm; w. 65 cm. Topkapı Palace Museum, 13/1440.

D 21 Velvet Cushion Cover. 17th century. l. 104 cm; w. 61 cm. Topkapı Palace Museum, 13/1442

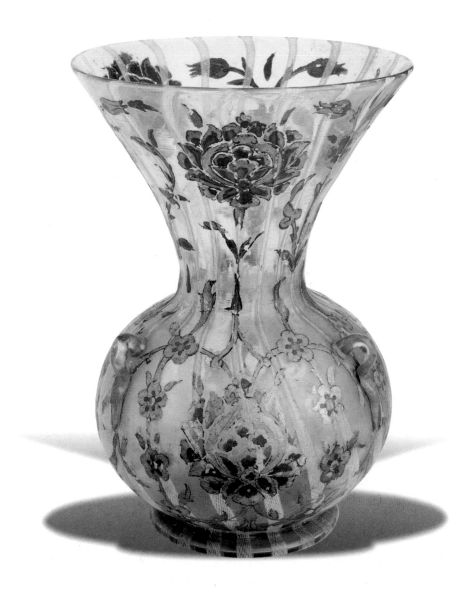

D 31 Venetian Glass Lamp in Turkish Style. 2nd half of 16th century. h. 28 cm; d. 20 cm. Topkapı Palace Museum, 34/468.

D 33 Clock. Mid 17th century. d. 18 cm. Topkapı Palace Museum, 53/86.

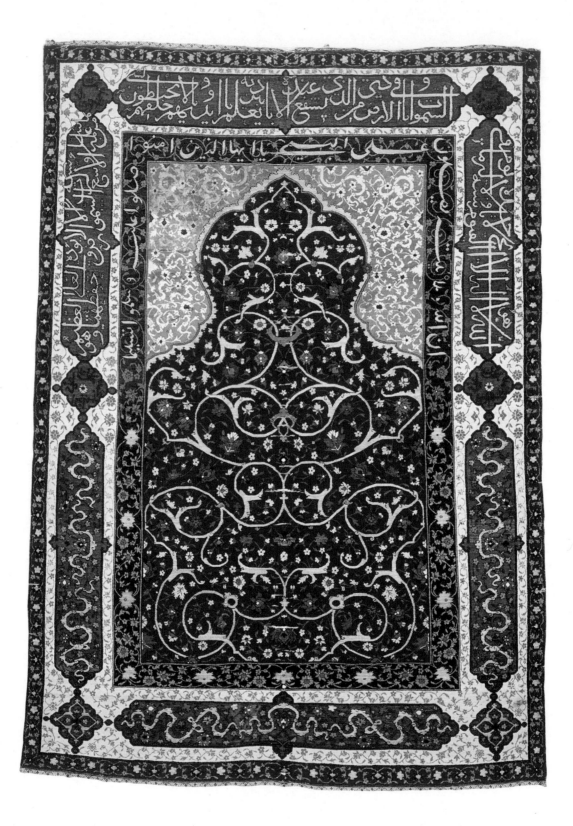

D 7 **Prayer Rug with Ayet al-Kursi and Rumi Field.** Probably 16th or 17th century. l. 153 cm; w. 110 cm. Topkapı Palace Museum, 13/2028

154

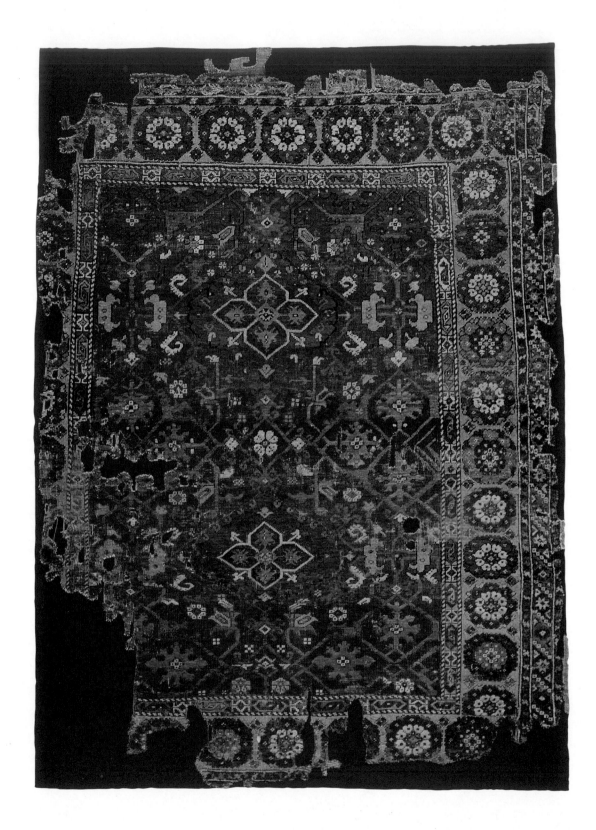

D 10 Medallion Uşak Carpet. 17th century. l. 304 cm; w. 180 cm. Museum of Turkish and Islamic Arts, 1599.

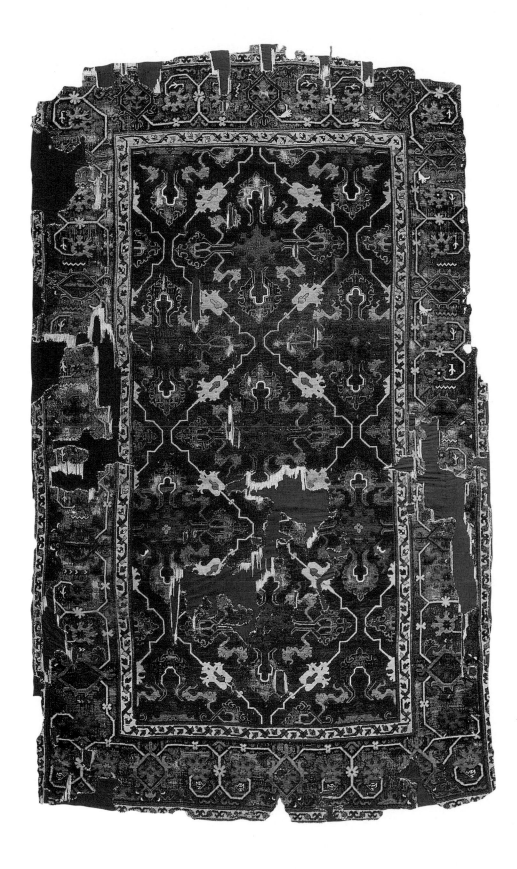

D 15 Uşak Carpet. Early 17th century. l. 295 cm; w. 172 cm. Museum of Turkish and Islamic Arts, 865.

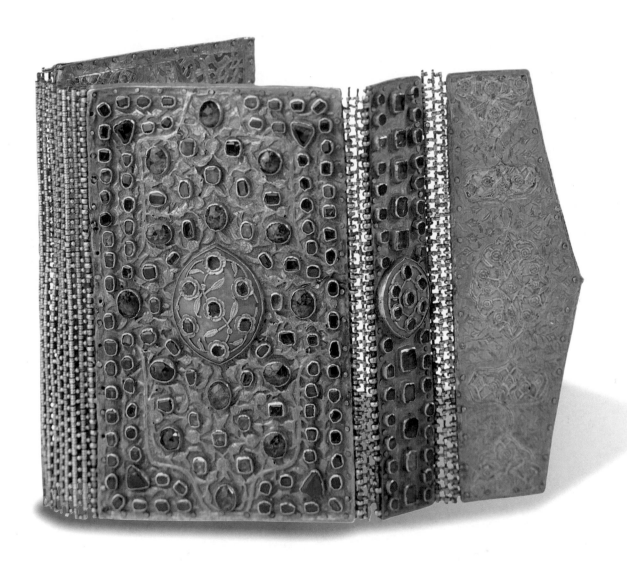

E 6 Jewelled Gold Bookbinding. Last quarter of 16th century. l. 12,9 cm; w. 7,7 cm. Topkapı Palace Museum, 2/2086.

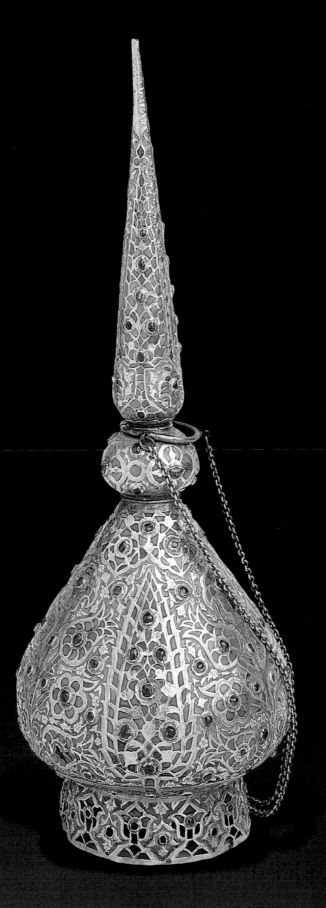

E 7 Golden Rosewater Sprinkler. End of 16th century. h. 32 cm. Museum of Turkish and Islamic Arts, 91.

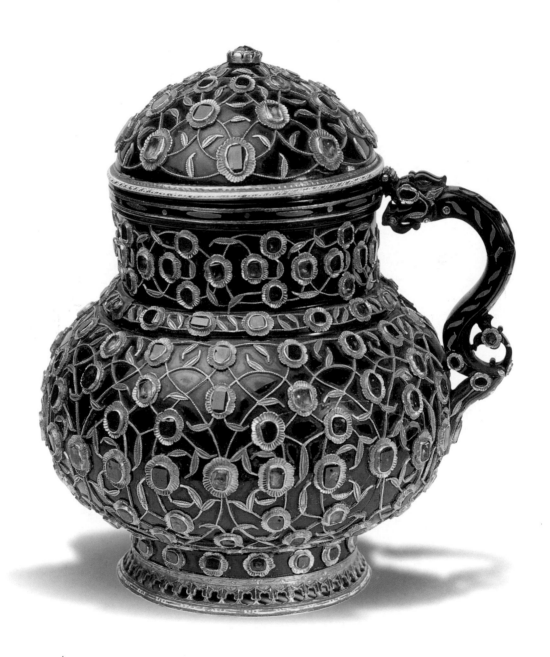

E 11 Jewelled Hardstone Jug. 16th century. l. 19 cm; d. 9 cm. Topkapı Palace Museum, 2/3831.

E 10

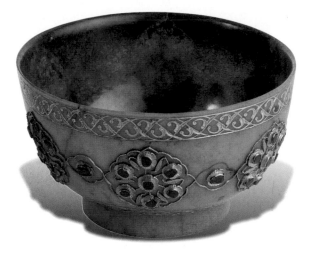

E 9

E 9 **Jewelled Jade Cup.** 18th century. h. 6 cm; d. 7 cm. Topkapı Palace Museum, 2/3787.
E 10 **Jewelled Jade Cup.** 18th century. h. 5,5 cm; d. 7 cm. Topkapı Palace Museum, 2/3793.

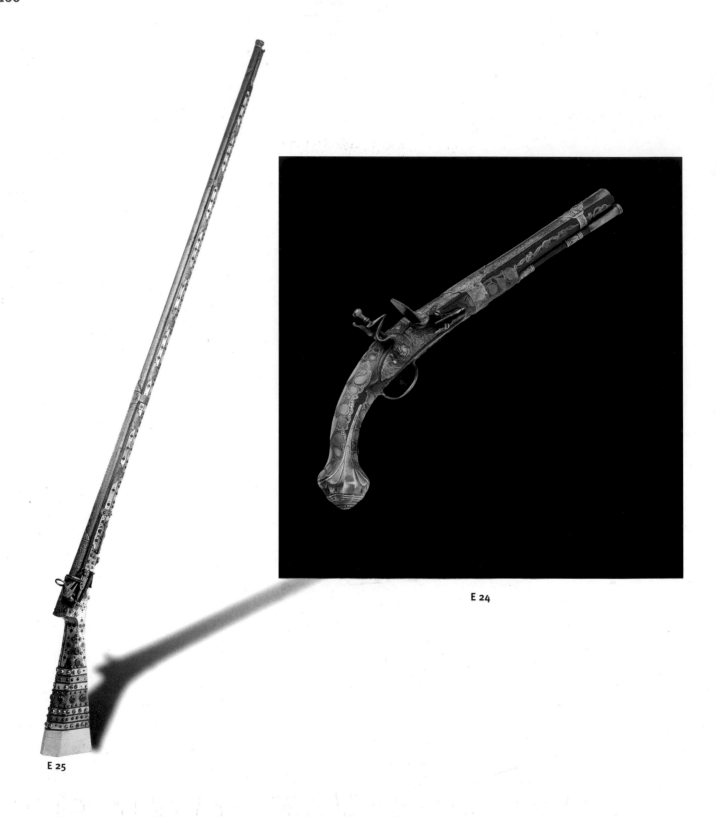

E 24

E 25

E 24 Flintlock Pistol. By Hacı Mustafa (in the barrel) and Ahmed (on the trigger). First quarter of the 18th century. l. 47 cm. Topkapı Palace Museum, 1/4090.

E 25 Flintlock Musket. 18th century. l. 155 cm. Military Museum, 1902.

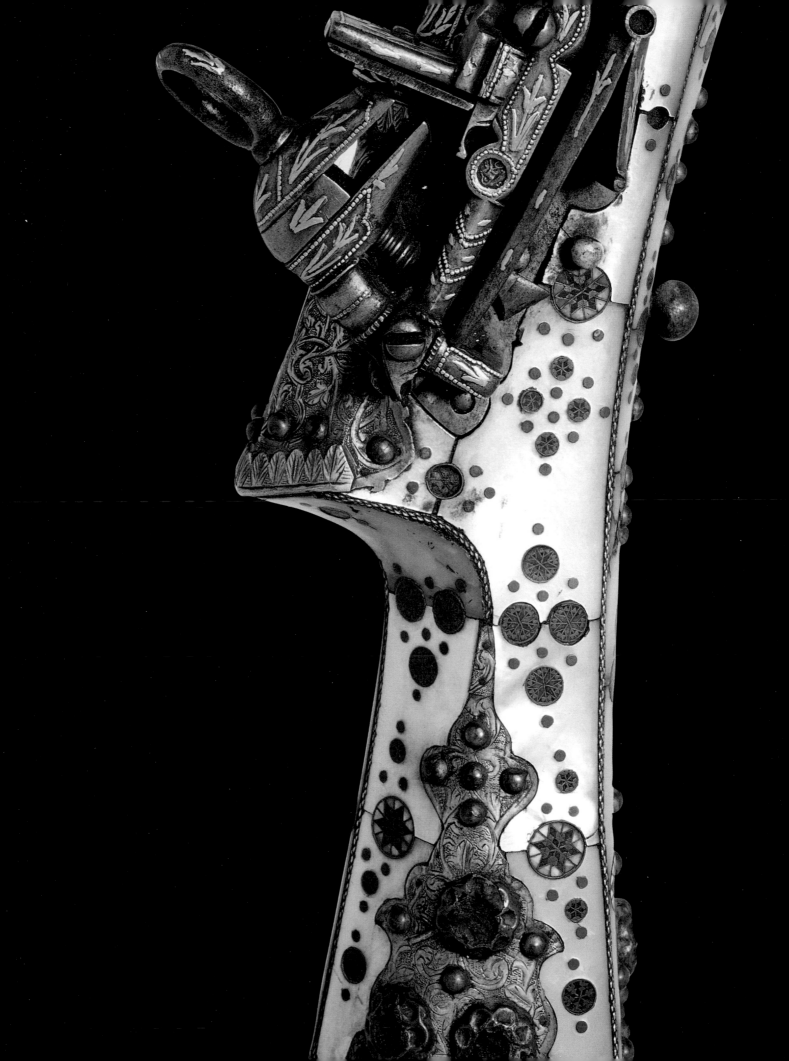

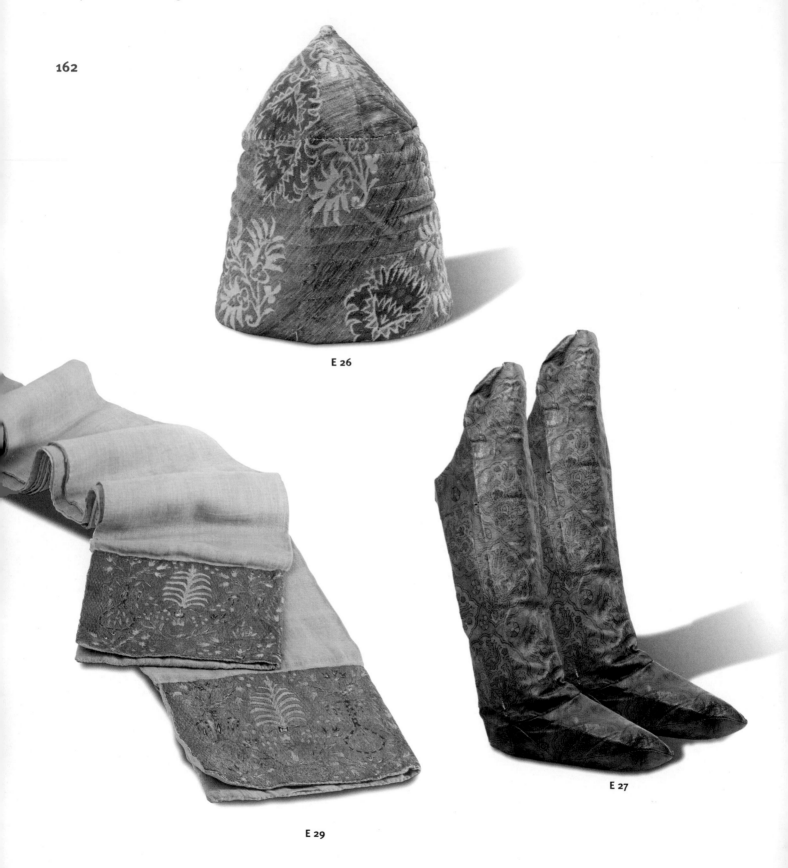

E 26

E 29

E 27

E 26 **Skullcap.** 18th century. h. 18 cm; d. 17 cm. Topkapı Palace Museum, 13/1950.

E 27 **Çizmeci** Leather Boot. ca 1566-74. h. 53 cm. Topkapı Palace Museum, 2/4440.

E 29 **Gold-thread Embroidered Sash.** Mid 16th century. l. 217 cm; w. 28 cm. Topkapı Palace Museum, 31/49.

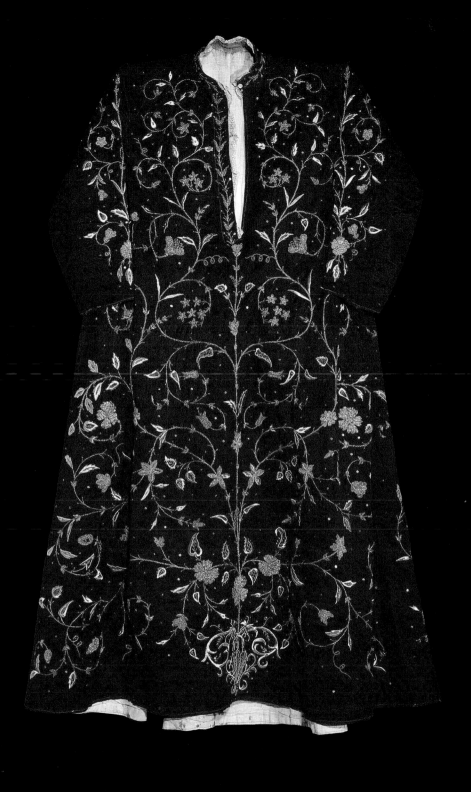

E 32 Embroidered Woman's Dress. 19th century. l. 140 cm; sleeves l. 141 cm; skirt: 154 cm. E. and N. Akın, 29.

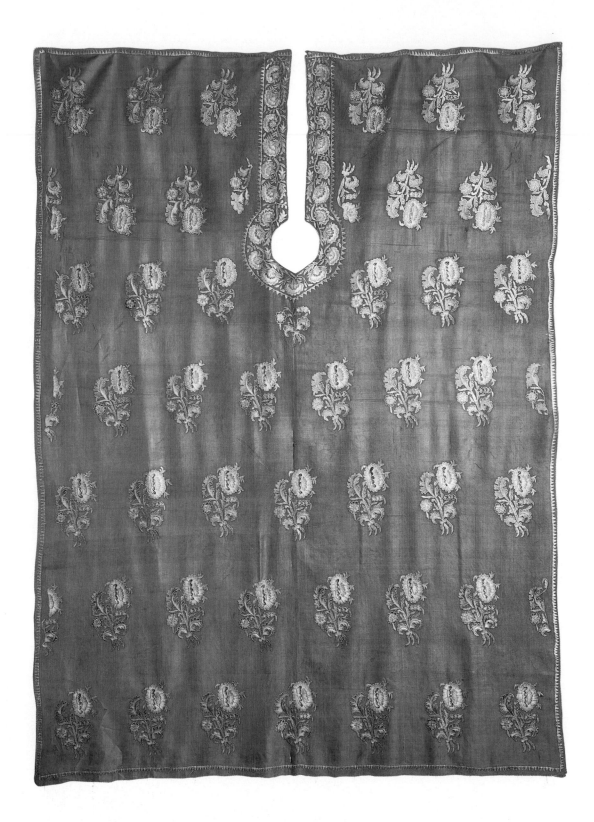

E 31 Embroidered Barber Cloth. 19th century. l. 173 cm; w. 125 cm. E. and N. Akın, 12.

E 44

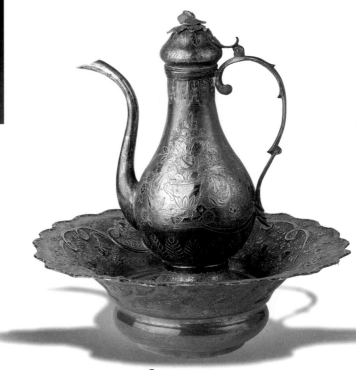

E 42
E 38

E 38 Silver Basin. 1840-1 (H. 1256). h. 10,8 cm; d. 32,5 cm. Topkapı Palace Museum, 16/865.

E 42 Silver Ewer. 1840-1 (H. 1256). h. 29 cm. Topkapı Palace Museum, 16/866.

E 44 Gilt-copper Jug. 19th century. h. 39 cm; d. at the bottom: 13 cm. Museum of Turkish and Islamic Arts, 4220.

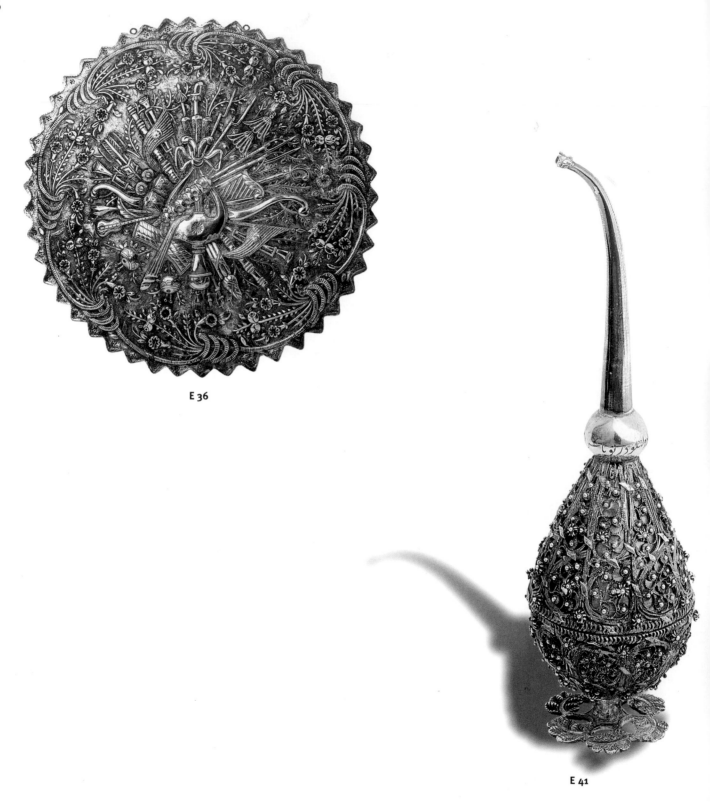

E 36

E 41

E 36 **Silver Mirror.** Second half of 19th century. d. 38 cm. Museum of Turkish and Islamic Arts, 3646.

E 41 **Silver Filigree (telkari) Rosewater Sprinkler.** Late 19th century. h. 22,5 cm. Museum of Turkish and Islamic Arts, 92.

E 37 **Silver Candlestick.** Early 17th century. h. 117,5 cm; d. at the bottom: 75,5 cm.
Museum of Turkish and Islamic Arts. 93 A-B.

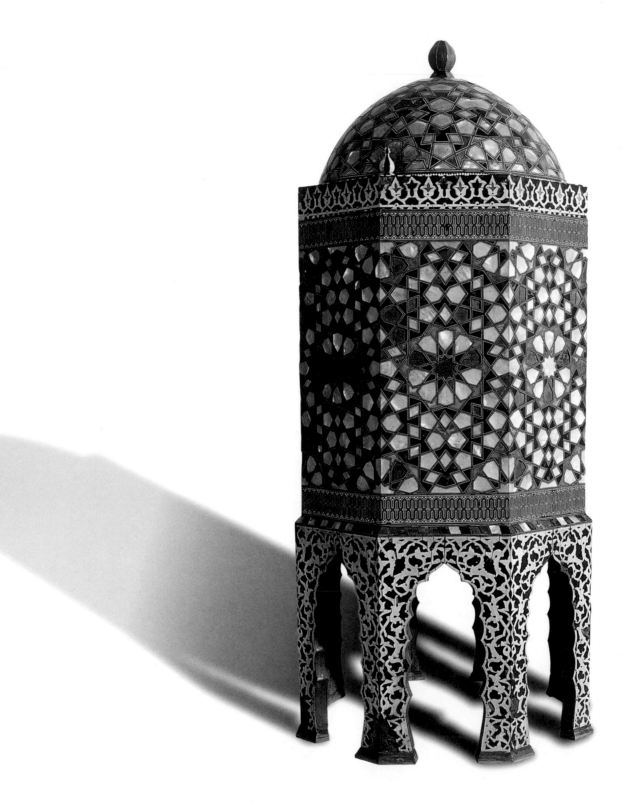

E 50 **Koran Box.** Second quarter of 16th century. h. 115 cm; h. of the dome: 39 cm; w. 47 cm four sides.
Museum of Turkish and Islamic Arts, 6.

E 35

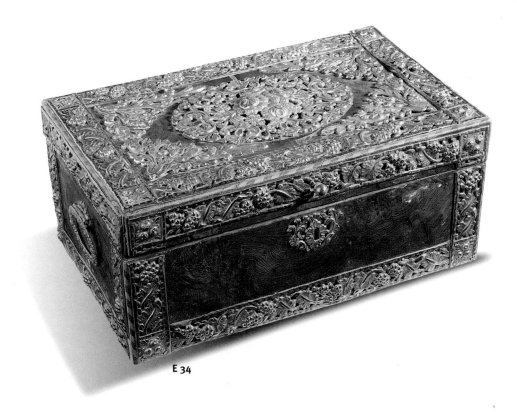

E 34

E 34 **Silver Box.** 19th century. l. 31 cm; w. 19 cm; h. 14 cm. Museum of Turkish and Islamic Arts, 38.

E 35 **Silver Box.** 19th century. l. 50 cm; w. 26 cm; h. 17 cm. Museum of Turkish and Islamic Arts, 43.

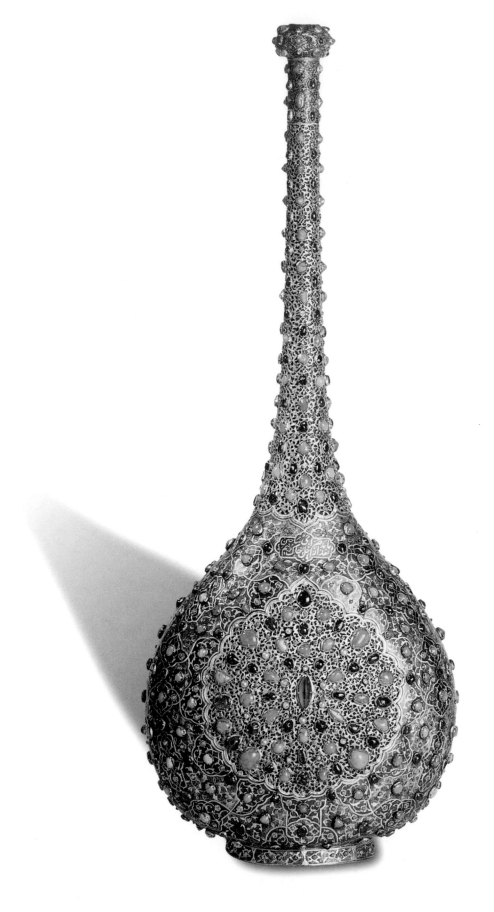

E 53 Jeweled Zinc (Tutya) Flask. ca. 1500. h. 58,5 cm, d. 22.5 cm. Topkapı Palace Museum, 2/2877.

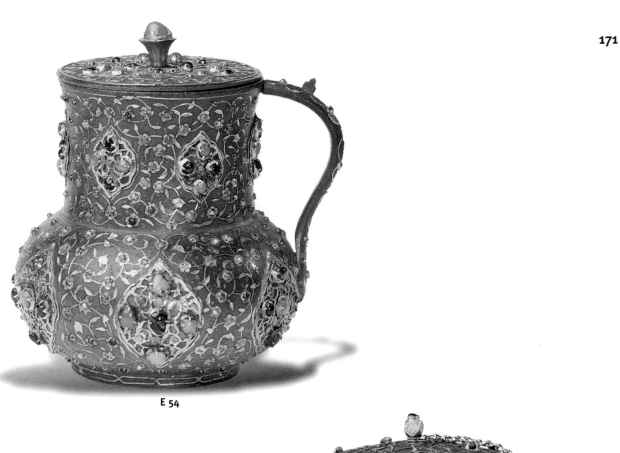

E 54

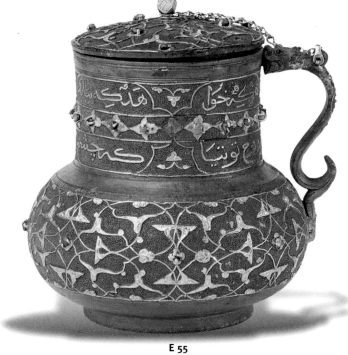

E 55

E 54 Jeweled Zinc (Tutya) Lidded Jug. 16th century. h. 13,5 cm; d. (at the rim): 7,7 cm; d. (on the body): 11,5 cm;
d. (at the foot): 6,5 cm. Topkapı Palace Museum, 2/2873.

E 55 Jeweled Zinc (Tutya) Lidded Jug. Lathe operator signed "work of Hüseyin". 16th century. h. 13,5 cm; d. 11,5 cm.
Topkapı Palace Museum, 2/2863.

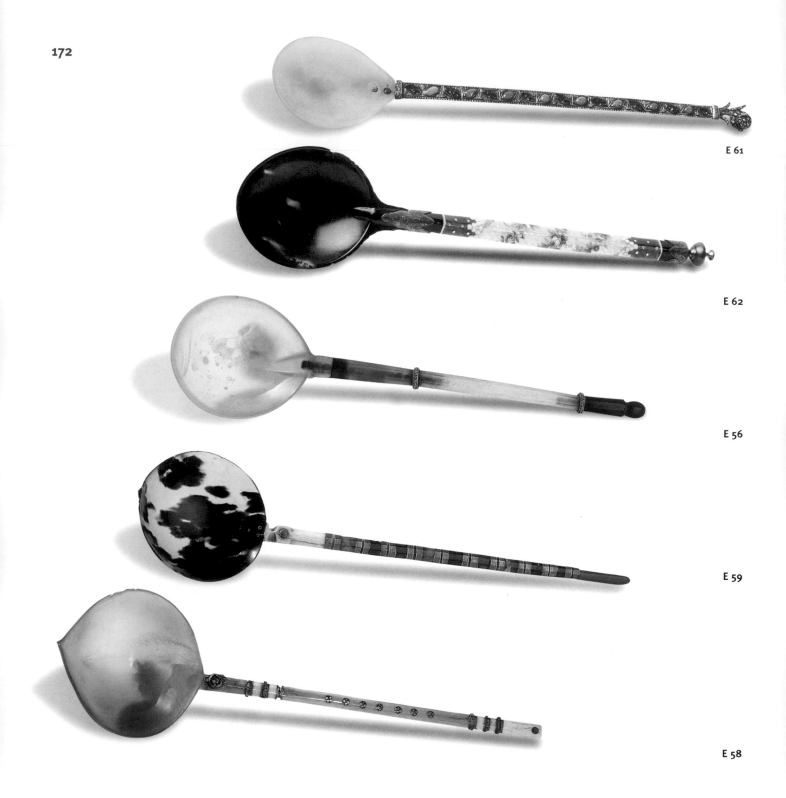

E 61

E 62

E 56

E 59

E 58

E 56 Spoon. 18th century or later. l. 17 cm. Topkapı Palace Museum, 2/2472.

E 58 Spoon. 18th century or later. l. 27 cm. Topkapı Palace Museum, 2/2590.

E 59 Spoon. 18th century or later. l. 27 cm. Topkapı Palace Museum, 2/2626.

E 61 Spoon. 18th century or later. l. 20 cm. Topkapı Palace Museum, 2/2488.

E 62 Spoon. 18th century or later. l. 17 cm. Topkapı Palace Museum, 2/2422.

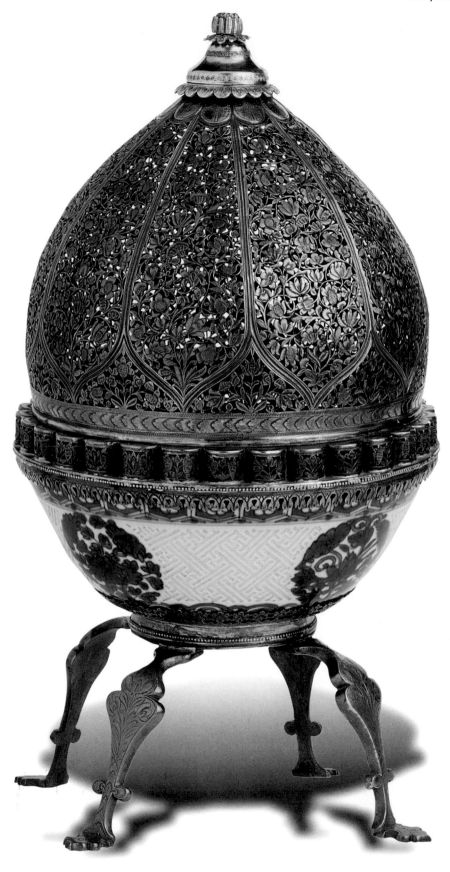

E 39 Porcelain Incense Burner with Silver Lid. Second half of 17th century. h. 40,5 cm; d. 22 cm.
Topkapı Palace Museum, 15/10912.

List of Objects

A 1 History of Mehmed the Conqueror
by Kritovoulos of Imbros
1451-1467
h. 22 cm; w. 14,8 cm; 310 folios
Topkapı Palace Museum, G.İ. 3

A 2 Book of the Sovereign/Hünkârname
by Ma'âli (Mir Seyyid Ali b. Muzaffer Tusî)
15th century
h. 25,5 cm; w. 18 cm; 183 folios
Topkapı Palace Museum, H. 1417

A 3 History of the Father of the Conquest/
Tarih-i ebu'l-feth by Tursun Beg
End of 15th century
h. 17,5 cm; w. 12,2 cm; 171 folios
Topkapı Palace Museum, H. 1470

A 4 Portrait of the Conqueror, Mehmed II
from Kıyafet al-İnsaniye fi Şemail
al-Osmaniye by Nakkaş Osman
ca. 1579
h. 23 cm; w. 12,5 cm
Topkapı Palace Museum, H. 1563,
fol. 47v

A 5 Kaftan of the Conqueror, Mehmed II
15th century
l. 140 cm
Topkapı Palace Museum, 13/20

A 6 Sword of the Conqueror, Mehmed II
l. 100 cm
Topkapı Palace Museum, 1/375

A 7 Talismanic Shirt of the Conqueror,
Mehmed II
15th century
l. 135,5 cm
Topkapı Palace Museum, 13/1408

A 8 A Portrait of Alexander the Great in
"Alexander's Journey to the Land of
Darkness" from Hamse-i Nizami
(Timurid Herat) copied by Yusuf
al- Jami; illustrated and illuminated
by Khwaja Ali al-Tabrizi 1445-6
(H. 849)
l. 24,5 cm; w. 16,6 cm; 326 folios
Topkapı Palace Museum,
H. 781, fol. 279b.

A 10 Steel Horse Frontal
15th century
l. 52 cm
Topkapı Palace Museum, 1/2328

A 11 Wooden Arrow Box with Nine Arrows
15th century
l. 68 cm; h. 12 cm; depth. 6 cm
Topkapı Palace Museum, 1/10463

A 12 Byzantine Column with Muses
Excavated from The Topkapı Palace,
Harem Area
Early Byzantine
l. 58 cm; w. 58 cm; h. 39 cm
İstanbul Archaeological
Museums, 6268

A13 Byzantine Column Capital with Angels
Excavated from The Topkapı Palace,
Soğukçeşme Area
Early Byzantine
l. 69 cm; w. 30 cm; h. 28 cm
İstanbul Archaeological
Museums, 4054

A 14 Byzantine Column Capital with Birds
Excavated from The Topkapı Palace,
Second Courtyard
11th-12th century
l. 30 cm; w. 25 cm; h. 25 cm
İstanbul Archaeological
Museums, 2810

A 15 Burgundian Rock Crystal Jug with a Lid
First half of the 15th century
h. 23 cm
Topkapı Palace Museum, 2/471

A 16 Italian Velvet
15th century
l. 425 cm; w. 64 cm
Topkapı Palace Museum, 13/1915

A 17 Italian-velvet Bookbinding for a
translation of Avicenna's Canones
(el-kanun fi't-Tıbb "Book on Medicine")
ca. 1480, text dated 1323-5
l. 40 cm; w. 28,5 cm; 253 folios
Topkapı Palace Museum,
A. 1939/1

A 18 Italian Velvet Yardage
15th century
l. 1,87 cm; w. 63 cm
Topkapı Palace Museum, 13/1008

A 19 Re Militari (Book on Military Arts)
Admagnimu Etillustrem Heroa
Sigismndum Andulfum Malatestan
by Robertis Valturis,1472
l. 33,5 cm; w. 23,2 cm; 264 folios
Topkapı Palace Museum, H. 2699

A 20 Map of Europe from Geographike
Hyphegesis II/Dionysios Periegesis
(Book on Geography)
by Claudius Ptolemaios; tr into Arabic
by Georges Amirutzes from Trabzon
End of 14th century
l. 40,1 cm; w. 28,9 cm
Topkapı Palace Museum, G.İ. 27

A 21 Bookbinding of Cam-u Cem
(Book of Mesnevi Poems)
by Rukn al-Din Evhadi (d. 1337);
copied by Şeyh Mehmed
1483
l. 20,7 cm; w. 14 cm; 152 folios
Museum of Turkish and Islamic
Arts, 2053

A 22 Enthronement Scene from Sultan Ali
Mirza's Shahname (The Book of Kings)
Firdausi, Ebul Kasım Mansur, 1494
l. 35 cm; w. 24 cm
Museum of Turkish and Islamic
Arts, 1978.

A 23 Mamluk Brass Bowl
1470-1490
h. 16,5 cm; upper d. 35 cm
Museum of Turkish and Islamic
Arts, 2959

A 24 Mamluk Tarot Cards (4)
15th century
h. 24,5 cm; w. 8,5 cm
Topkapı Palace Museum, Y.Y. 1066

A 25 Timur's Grandson, Uluğ Bey's
Wooden Casket
ca. 1420-49
h. 19,5 cm; l. 31,2 cm; w. 17 cm
Topkapı Palace Museum, 2/1846

A 26 Timurid Brass Jug
Husaynuddin Shihabuddin
al-Birjandi
Dated 871/AH 1467
h. 16,5 cm
Museum of Turkish and Islamic
Arts, 2961

A 27 Timurid Brass Jug
Husaynuddin Shihabuddin
al-Birjandi
Dated 871/AH 1467
h. 16,5 cm
Museum of Turkish and Islamic
Arts, 2963

A 28 Chinese Celadon Ewer
ca. 1400
h. 34 cm
Topkapı Palace Museum, 15/40

A 29 Chinese Celadon Dish
Early 15th century
d. 52 cm
Topkapı Palace Museum, 15/218

A 30 Chinese Celadon Bowl
Mid 14th century
d. 39,5 cm; h. 15 cm
Topkapı Palace Museum, 15/84

A 31 Blue-and-white Chinese Porcelain Dish
Early 15th century
d. 63,5 cm
Topkapı Palace Museum, 15/1372

A 32 Blue-and-white Chinese Porcelain Dish
Early 15th century
d. 64 cm
Topkapı Palace Museum, 15/1407

A 33 Blue-and-white Chinese Porcelain Bowl
Second half of 14th century to early
15th century
d. 41,3 cm; h. 16,2 cm; d: 23,2 cm
Topkapı Palace Museum, 15/1369

A 34 Blue-and-white Chinese Porcelain Pitcher
Early 15th century
h. 53 cm
Topkapı Palace Museum, 15/1378

A 35 Blue-and-white Chinese Porcelain Pitcher
Early 15th century
h. 27 cm
Topkapı Palace Museum, 15/1410

A 36 Blue-and-white Chinese Porcelain
Canteen
Mid 14th century
w. 27 cm; h. 39,5 cm
Topkapı Palace Museum, 15/1391

A 37 Bookbinding of Gurar al-Ahkâm
(Book on Hanefi Jurisprudence)
Muhamed b. Farâmuz b. Ali
al-Tarsusî, commonly known
as Molla Husrav
1474 (by the author's hand writing)
l. 25cm; w. 17,5 cm; 152 folios
Topkapı Palace Museum, A. 1032

A 38 Bookbinding of Al-Lama'at of Fakhr al-din
al-Iraqi (Book on Sufi Poems)
copy made in İstanbul by Ghiyath
al-din al-Mujallid
text completed on 19 February 1477
l. 18,4 cm; w. 11,7 cm; 71 folios
Museum of Turkish and Islamic
Arts, 2031

A 39 Bookbinding of a Single-volume Koran
ca. 1465-70
l. 40,6 cm; w. 27,5 cm; 334 folios
Museum of Turkish and
Islamic Arts, 448

A 40 Frontispiece of a Koran
by Calligrapher Şeyh Hamdullah
1495-6
l. 33 cm; w. 22,5 cm; 337 folios
Topkapı Palace Museum, E.H. 72

A 41 Frontispiece of Şerh es-Selâhiye
(Book on Arithmetics) by Salahi;
expanded by Şems ad-Din
Muhammed al-Hatibi
Second half of 15th century
l. 25,2 cm; w. 15 cm; 129 folios
Topkapı Palace Museum, A. 3141

A 42 Silver Lantern
from the Mosque of the Conqueror,
Fatih Cami, ca. 1450-60
d. 40 cm; h. 67 cm
Museum of Turkish and
Islamic Arts, 167

A 43 Gilt Mosque Lamp
1481-1512
d. 40 cm; h. 70 cm
Museum of Turkish and
Islamic Arts, 170

A 44 Gilt Candle Holder
15th century
h. 22,5 cm
Museum of Turkish and
Islamic Arts, 4017

A 45 Ivory Belt Piece
ca. 1500
l. 5,5 cm; w. 3,5 cm
Topkapı Palace Museum, 2/630

A 46 Ivory Belt Piece
ca. 1500
l. 3,9 cm; w. 3,9 cm
Topkapı Palace Museum, 2/633

A 47 Ivory Belt Piece
15th century
l. 6,6 cm; w. 4,8 cm
Topkapı Palace Museum, 2/634

A 48 Ivory Belt Piece
ca. 1500
l. 4,2 cm; w. 3,5 cm
Topkapı Palace Museum, 2/631

A 49 Ivory Belt Piece
ca. 1500
l. 7 cm; w. 4 cm
Topkapı Palace Museum, 2/632

A 50 Ivory Mirror
Second half of 15th century
d. 14,4 cm
Topkapı Palace Museum, 2/1805

A 51 Early İznik High-Footed Vessel
1490-1500
h. 13,7 cm; d. 37,5 cm
Istanbul Archaeological Museums,
Çinili Köşk, 41/331

A 52 West Anatolian Medallion Uşak Carpet
Late 15th century
l. 285 cm; w. 161 cm
Museum of Turkish and
Islamic Arts, 765

A 53 West Anatolian "Star Uşak" Carpet
Late 15th century or Early
16th century
l. 375 cm: w. 196 cm
Museum of Turkish and
Islamic Arts, 53

A 54 Blue and White Ceramic Mosque Lamp
Early 16th century
h. 21,5 cm; d at rim: 17,5 cm
Istanbul Archaeological
Museums, 41/1

B 1 Illuminated Tuğra of Süleyman I
By Kara Memi, ca. 1540-1550
h. 158 cm; w. 240 cm
Topkapı Palace Museum, G.Y. 1400

B 2 Campaign Throne
Mid 16th century
h. 129 cm; l. 163,5 cm; w. 75 cm
Topkapı Palace Museum, 2/2879

B 3 Tuğ
18th century
h. 346 cm
Topkapı Palace Museum, 1/1000

B 4 Seal of Ahmed III
(H. 1115)
oval; l. 2,5 cm; w. 1,9 cm; h. 3 cm
Topkapı Palace Museum, 47/4

B 5 Seal of Abdülhamid I
r. 1757-1774 (H. 1187)
square; l. 2,3 cm; w. 2,1 cm;
h. 2,8 cm
Topkapı Palace Museum, 47/20

B 6 Seal of Selim III
(H. 1203)
oval; l. 5,5 cm; w. 5 cm; h. 13 cm
Topkapı Palace Museum, 47/28

B 7 Seal Ring of Pertevnihal Sultan
Mid 19th century
d. 1.3 cm; h. 1.6 cm
Topkapı Palace Museum, 47/90

B 8 Seal of Nazikeda Başkadın
1879 (H. 1296)
d. 2 cm; h. 2,7 cm
Topkapı Palace Museum, 47/102

B 9 Seal of Cemile Sultan
1858-9 (H. 1275)
l. 3,6 cm; w. 2,2 cm
Topkapı Palace Museum, 47/83

B 10 Short-sleeved Kaftan, Associated
with Selim I
16th century
l. 140,5 cm
Topkapı Palace Museum, 13/42

B 11 Long-sleeved Kaftan Associated
with Süleyman I
16th century
l. 154,5 cm
Topkapı Palace Museum, 13/840

B 12 Baggy Trousers
16th century
l. 154 cm
Topkapı Palace Museum, 13/179

B 13 A Prince's Kemha Kaftan with
Detachable Sleeves
16th century
l. 73 cm; sleeve l. 47,3 cm
Topkapı Palace Museum, 13/1015
and 13/927

B 14 Princely Kaftan, Associated with Ahmed I
l. 76,5 cm
Topkapı Palace Museum, 13/267

B 15 Princely Kaftan, Associated with Ahmed I
l. 67,5 cm
Topkapı Palace Museum, 13/277

B 16 Kemha Kaftan of Osman II
r. 1618-1622
l. 137,5 cm
Topkapı Palace Museum, 13/584

B 17 Applique Kaftan of İbrahim
r. 1640-1648
l. 170 cm
Topkapı Palace Museum, 13/486

B 18 Luxury Garment of Fatma Sultan (?),
Daughter of Mustafa III (r. 1757-74)
Mid 18th century
l. 82 cm
Topkapı Palace Museum, 13/804

B 19 Detachable Sleeves
16th century
l. 98 cm
Topkapı Palace Museum, 13/928

B 20 Detachable Sleeves
16th century
l. 94 cm
Topkapı Palace Museum, 13/933

B 21 Detachable Sleeves
16th century
l. 70 cm
Topkapı Palace Museum, 13/1895

B 22 Detachable Sleeves
16th century
l. 95 cm
Topkapı Palace Museum, 13/72

B 23 Detachable Sleeves
16th century
l. 70 cm
Topkapı Palace Museum, 13/1896

B 24 Aigrette
18th century
h. without plumes: 32 cm; l. 62 cm
Topkapı Palace Museum, 2/284

B 25 Aigrette
17th century
l. of the chain: 18,5 cm; d. 16,5 cm
Topkapı Palace Museum, 2/205

B 26 Rock Crystal Pendant
18th century
d. 18 cm; l. 16,5 cm
Topkapı Palace Museum, 2/469

B 27 Jewelled Mace
17th century
l. 74 cm
Topkapı Palace Museum, 1/2393

B 28 Ivory Belt
Mid 16th century
l. 65,5 cm; w. 4,5 cm
Museum of Turkish and
Islamic Arts, 482

B 29 Rock Crystal Flask
17th century
h. 28,5 cm; w. 15 cm
Topkapı Palace Museum, 2/474

B 30 Jeweled Rock Crystal and Gold Pen Box
Late 16th century
w. 8,5 cm; l. 40 cm; h. 11 cm
Topkapı Palace Museum, 2/22

B 31 Jeweled Jasper and Gold Pen Box
Second half of 16th century
w. 3 cm; l. 27 cm; h. 3,5 cm
Topkapı Palace Museum, 2/2111

B 32 Jeweled 15th Century Blue-and-white
Chirese Porcelain Pen Box
Second half of 16th century
w. 7 cm; l. 27 cm; h. 8 cm
Topkapı Palace Museum, 2/894

B 33 Sword/Scabbard of Süleyman I
16th century
l. 93 cm; scabbard l. 86 cm
Military Museum, 19

B 34 Sword/Scabbard of Süleyman I
16th century
l. 94 cm; scabbard l. 80 cm
Topkapı Palace Museum, 2/1136

B 35 Broad Sword (Yatağan) of Süleyman I
by Ahmed Tekelü, 1526-7 (H. 933)
l. 66 cm
Topkapı Palace Museum, 2/3776

B 36 Topkapı Dagger
1746 (H. 1159)
l. 35 cm
Topkapı Palace Museum, 2/160

B 37 Helmet
16th century
h. 28 cm; d. 22 cm
Topkapı Palace Museum, 2/1192

B 38 Horse Frontal
Second half of 16th century
h. 61 cm; w. 48 cm
Topkapı Palace Museum, 1/1446

B 39 Horse Frontal
Late 16th century
h. 60 cm
Military Museum, 8359

B 40 Leather Saddle
18thcentury or later
saddle: l. 50 cm; w. 70 cm;
pistol holder: 50 cm;
saddle cover: 125 x 80 cm
Topkapı Palace Museum, 36/119

B 41 Banner Koran
16th century
l. 1105 cm; w. 9 cm
Topkapı Palace Museum, E.H. 485

B 42 Kaaba Curtain
16th century
l. 42 cm; w. 79 cm
Topkapı Palace Museum, 24/362

B 43 Kaaba Curtain
Late 19th century
l. 1018 cm; w. 68 cm
Topkapı Palace Museum, 24/631

B 44 Kaaba Lock and Key
1592 (H. 1002)
Lock l. 63 cm; key l. 30 cm
Topkapı Palace Museum,
2/2280, 2/2273

B 45 Reliquary Casket
ca. 1520-30
l. 15 cm; w. 7,5 cm; h. 8,5 cm
Topkapı Palace Museum, 2/2085

B 46 Reliquary Casket
Mid 16th century
l. 9 cm; w. 5,5 cm; h. 5,5 cm
Topkapı Palace Museum, 2/4736

B 47 View of the Mescid-i Haram in Mecca
from the Futûh el-Harameyn
text by Muhyî al-Dîn Lârî (d. 1526-7),
ca. 1545
h. 18 cm; w. 12 cm; 58 folios
Topkapı Palace Museum,
R. 917, fol. 14r

B 48 Ceramic Panel Depicting Kaaba
Early 17th century
l. 82 cm; w. 54 cm
Museum of Turkish and
Islamic Arts, 830

B 49 Koran
Calligraphy by Ahmed
Karahisari, 1526-7
l. 26,8 cm; w. 17 cm; 445 folios
Museum of Turkish and
Islamic Arts, 400

B 50 Incense-burner of Hatice Sultan,
Daughter of Mustafa III
1816 (H. 1232)
h. 26 cm
Topkapı Palace Museum, 2/3515

B 51 Rosewater-flask of Hatice Sultan,
Daughter of Mustafa III
1816 (H. 1232)
h. 17 cm
Topkapı Palace Museum, 2/3517

B 52 Endowment Deed of Zeynep Sultan,
Daughter of Ahmed III
calligraphy by Mustafa bin Mehmed,
August 1773 (H. 1187)
l. 34 cm; w. 28 cm; 30 folios
Museum of Turkish and Islamic
Arts, 2195

B 53 Map of Süleymaniye Waterways
1753 (H. 1166)
l. 18 m; w. 30 cm
Museum of Turkish and
Islamic Arts, 3336

B 54 Model of the Fountain of Ahmed III
1907
h. 65 cm; l. 68 cm; w. 68 cm
Yıldız Palace Museum, YSM/364

B 55 Uşak Carpet from Ayasofya,
Sultan Selim II Tomb
16th century
l. 821 cm; w. 382 cm
Museum of Turkish and
Islamic Arts, 61

B 56 Uşak Carpet from Konya,
Selimiye Mosque
16th century
l. 789 cm; w. 360 cm
Museum of Turkish and
Islamic Arts, 696-697

C 1 Writing Set (Pencil Sharpener Stand,
Pencil Sharpener, Scissors, Letter
Opening Knife)
by Hakkı Usta, 19th century
l. 15-30 cm
Museum of Turkish and
Islamic Arts, 4682

C 2 Ink Set with Inkpots, Pot to Hold Sand,
Scissors, Pen-knives, Pen Rest
A gift of Yaver Damad Ahmed
Zülküf Paşa, 1879 (H. 1296)
l. 40 cm; w. 26 cm
Topkapı Palace Museum, 2/769-778

C 3 Tortoise-shell Writing Box
Mid 18th century
l. 57 cm; w. 31 cm; h. 38 cm
Topkapı Palace Museum, 2/2820

C 4 Case for an Imperial Decree
18th century
l. 33,5 cm; d. 6, 2 cm
Museum of Turkish and
Islamic Arts, 4034

C 5 Ferman of Sultan Mahmud II
(r. 1808-1839)
11 February 1822 (H. 1237)
l. 96 cm; w. 55 cm
Museum of Turkish and
Islamic Arts, 2389

C 6 Mülkname of Sultan Mahmud I
(r. 1730-1754)
20 August-7 September 1745
(H. 1158)
l. 172,5; w. 85 cm
Museum of Turkish and
Islamic Arts, 2234

C 7 Sınırname of Sultan Murad III
1st-9th June 1575 (H. 983)
l. 174 cm; w. 44 cm
Museum of Turkish and
Islamic Arts, 4127

C 8 Mülkname of Sultan Murad III
20th-29th June 1575 (H. 983)
l. 258 cm; w. 44 cm
Museum of Turkish and
Islamic Arts, 4126

C 9 Futuhat-ı Cemile
text by Arifi, 1556-7 (H. 964)
l. 32,5 cm; w. 23 cm; 32 folios
Topkapı Palace Museum, H. 1592

C 11 Miniature Showing a Palace
Attendant, Polo Player
painting by Levni (?-1732),
18th century
l. 24,4 cm; w. 15,2 cm
Topkapı Palace Museum,
H. 2164, 16r

C 12 Miniature Showing a Palace
Attendant, Falconer
painting by Levni (?-1732),
18th century
l. 24,4 cm; w 15,2 cm
Topkapı Palace Museum,
H. 2164, 16v

C 13 Headgear of a Peyk
17th century
h. 30 cm; d. 18 cm
Topkapı Palace Museum, 1/1468

C 14 Headgear
18th century
h. 23 cm; d. 17 cm
Topkapı Palace Museum, 24/2113

C 15 Costume of a Water-Bearer
Saka/Tulumbacı
19th century
costume l. 118 cm; three apron:
77x77 cm; apron hangings
d. 12 cm; belt l. 45 cm, w. 15 cm
Topkapı Palace Museum,
13/1881-1885

C 16 Book of Seals
19th century
h. 16,4 cm; w. 10,8 cm, 23 folios
Topkapı Palace Museum, YY. 1116

C 17 Silver Seal of Grand Vizier
Mahmud Şevket Paşa
1912 (H. 1331)
h. 3 cm; d. 2,8 cm
Topkapı Palace Museum, 47/141

C 18 Seal of Babüssaade Ağası
Mehmed Emin Ağa
1889 (H. 1307)
h. 3 cm; d. 2,8 cm
Topkapı Palace Museum, 47/139

C 19 Seal of Darüssaade Ağası Hafız
Behram Ağa
1880 (II. 1297)
h. 3 cm; d. 2,1-2,3 cm
Topkapı Palace Museum, 47/137

C 20 Fortress Key: Tolcu
19th century
l. 30 cm
Topkapı Palace Museum, 2/2232

C 21 Fortress Key: Unidentifed
19th century
l. 45 cm
Topkapı Palace Museum, 2/2248

C 22 Fortress Key: Unidentified
19th century
l. 30 cm
Topkapı Palace Museum, 2/2243

C 23 Fortress Key: Silistre
1818-9 (H.1234)
l. 55 cm
Topkapı Palace Museum, 2/2247

D 1 Pair of Wooden Cupboard Doors
Second half of 18th century
h. 182 cm; w. 119,5 cm
Topkapı Palace Museum, 27/127

D 2 Ceiling Knob
19th century
h. 105 cm; w. 120 cm;
hexagon=each side: 60 cm
Topkapı Palace Museum, 27/135

D 3 Polychrome Tile
ca. 1530
d. 17,5 cm
İstanbul Archaeological Museums
Çinili Köşk, 41/515

D 4 Polychrome Tile
Second half of 16th century, 1565-75
h. 29 cm; w. 24 cm
İstanbul Archaeological Museums
Çinili Köşk, 41/1349

D 5 Polychrome Tile
Second half of 16th century
h. 20,7 cm; w. 10,5 cm
Istanbul Archaeological Museums
Çinili Köşk, 41/495

D 6 Polychrome Tile
ca. 1530-40
d. 21,7 cm
İstanbul Archaeological Museums
Çinili Köşk, 41/517

D 7 Prayer Rug with Ayet al-Kursi
and Rumi Field
16th century or later
l. 153 cm; w. 110 cm
Topkapı Palace Museum, 13/2028

D 8 Prayer Rug with Religious Inscriptions
16th century or later
l. 160 cm; w. 112 cm
Topkapı Palace Museum, 13/2030

D 9 Prayer Rug with Inscriptions
16th century or later
l. 145 cm; w. 102 cm
Topkapı Palace Museum, 13/2041

D 10 Medallion Uşak Carpet
17th century
l. 304 cm; w. 180 cm
Museum of Turkish and
Islamic Arts, 1599

D 11 Uşak Carpet
16th century
l. 218 cm; w. 167 cm
Museum of Turkish and
Islamic Arts, 712

D 12 Palace Carpet from Eskişehir,
Seyyid Battal Gazi Tomb
l. 880 cm; w. 465 cm
Museum of Turkish and
Islamic Arts, 768

D 13 Carpet from Western Anatolia
17th century
l. 247cm; w. 157 cm
Museum of Turkish and
Islamic Arts, 771

D 14 Carpet from Sivrihisar, Şıh Baba
Yusuf Mosque
17th century
l. 244 cm; w. 148 cm
Museum of Turkish and
Islamic Arts, 699

D 15 Uşak Carpet
Early 17th century
l. 295 cm; w. 172 cm
Museum of Turkish and Islamic
Arts, 865

D 16 Embroidered Hanging
Second half of 16th century
l. 232 cm; w. 170 cm
Topkapı Palace Museum, 31/4

D 17 Embroidered Sofa Skirt
19th century
l. 430 cm; w. 40 cm
Topkapı Palace Museum, 31/96

D 18 Embroidered Cushion Cover
19th century
l. 260 cm; w. 125 cm
Topkapı Palace Museum, 31/953

D 19 Embroidered Cushion Cover
Mid 18th century
l. 100 cm; w. 67 cm
Topkapı Palace Museum, 31/1835

D 20 Velvet Cushion Cover
17th century
l. 119 cm; w. 65 cm
Topkapı Palace Museum, 13/1440

D 21 Velvet Cushion Cover
17th century
l. 104 cm; w. 61 cm
Topkapı Palace Museum, 13/1442

D 22 Embroidered Cushion Cover
19th century
l. 72 cm; w. 44 cm
E. and N. Akın, 1

D 23 Embroidered Towel
18th century
l. 168 cm; w. 80 cm
E. and N. Akın, 2

D 24 Embroidered Towel
18th century
l. 160 cm; w. 80 cm
E. and N. Akın, 3

D 25 Embroidered Towel
18th century
l. 106 cm; w. 47 cm
E. and N. Akın, 10

D 26 Embroidered Spread
19th century
l. 88 cm; w. 88 cm
E. and N. Akın, 9

D 27 Embroidered Napkin
19th century
l. 136; w. 60 cm
E. and N. Akın, 7

D 28 Embroidered Towel
19th century
l. 192 cm; w. 82 cm
Topkapı Palace Museum, 31/1845

D 29 Embroidered Napkin
19th century
l. 158 cm; w. 55 cm
E /N Akın, 8

D 30 Embroidered Bundle Wrapper (Bohça)
Late 18th-early 19th century
l. 100 cm; w. 94 cm
E. and N. Akın, 14

D 31 Venetian Glass Lamp in Turkish Style
Second half of 16th century
h. 28 cm; d. 20 cm
Topkapı Palace Museum, 34/468

D 32 Pair of Candle Sticks
Early 17th century
h. 87 cm
Museum of Turkish and Islamic
Arts, 149 A-B

D 33 Clock
Mid 17th century
d. 18 cm
Topkapı Palace Museum, 53/86

D 34 Calligraphic Panel
by Sultan Ahmed III, 18th century
w. 59 cm; h. 26 cm
Topkapı Palace Museum, H. 2280/12

D 35 Calligraphic Panel
by Kazasker Mustafa İzzet Efendi
1870-1871 (H. 1287)
h. 180 cm; w. 136 cm
Topkapı Palace Museum, G.Y. 379

D 36 Calligraphic Panel
"A Poem on the Occasion of
Hatice Sultan's Birth"
1897 (H. 1315)
h. 83 cm; w. 81 cm
Museum of Turkish and Islamic
Arts, 3314

D 37 Calligraphic Panel
by Mehmed İzzet Efendi
1847 (H. 1263)
h. 45 cm; w. 85,5 cm
Topkapı Palace Museum, G.Y. 1304

D 38 Calligraphic Panel
by İsmail Derdi
1690 (H. 1101)
h. 19 cm; w. 28 cm
Topkapı Palace Museum, G.Y. 325/66

D 39 Calligraphic Panel
by Çarşanbalı Hacı Arif Bey
1887-8 (H. 1305)
h. 86 cm; w. 74 cm
Topkapı Palace Museum, G.Y. 1203

E 1 Fairy by Velican from Tabriz
ca. 1550-75
l. 36,2 cm; w. 26 cm
Topkapı Palace Museum,
H.2162, f.8r

E 2 Story-telling Cards "The Prophet
Hamza flying on a Phonix"
17th century
l. 38 cm; w. 46 cm
Topkapı Palace Museum, H. 2134/2

E 3 An Album with Samples of Calligraphy
calligraphy by Hüseyin Bin
Ramazan el-Habli,
end of 18th century
l. 30 cm; w. 22 cm; 5 folios
Museum of Turkish and
Islamic Arts, 2454

E 4 Stamped and Gilded Binding of
Divan-ı Muhibbi
ca. 1560
l. 26,5 cm; w. 19 cm; 252 folios
Museum of Turkish and Islamic
Arts, 1962

E 5 Koran Illumination
calligraphy by Katib el-Antalyevi,
1559-60
l. 53 cm; w. 38 cm; 276 folios
Museum of Turkish and
Islamic Arts, 383

E 6 Jewelled Gold Bookbinding
Last quarter of 16th century
l. 12,9 cm; w. 7,7 cm
Topkapı Palace Museum, 2/2086

E 7 Golden Rosewater Sprinkler
End of 16th century
h. 32 cm
Museum of Turkish and
Islamic Arts, 91

E 8 Jade Mirror
Late 16th-early 17th century
d. 19 cm; handle: 24,5 cm; l. 46 cm
Topkapı Palace Museum, 2/1797

E 9 Jewelled Jade Cup
18th century
h. 6 cm; d. 7 cm
Topkapı Palace Museum, 2/3787

E 10 Jewelled Jade Cup
18th century
h. 5,5 cm; d. 7 cm
Topkapı Palace Museum, 2/3793

E 11 Jewelled Hardstone Jug
16th century
l. 19 cm; d. 9 cm
Topkapı Palace Museum, 2/3831

E 12 Sword made for Murad IV
ca. 1623-40
l. 95,8 cm; l. 84 cm
Topkapı Palace Museum, 1/484

E 13 Knife
1514 (H. 920)
l. 31,5 cm
Topkapı Palace Museum, 2/254

E 14 Composite Bow by Mehmed
1672-3 (H. 1083)
l. 67 cm
Topkapı Palace Museum, 1/8950

E 15 Composite Bow
Late 19th century
l. 70cm
Military Museum, 25717

E 16 Arrow Case and Two Arrows
19th century
l. 74 cm
Military Museum, 25708

E 17 Jade Archer's Thumb Stall
Late 16th century
d. 4 cm
Topkapı Palace Museum, 2/74

E 18 Jade Archer's Thumb Stall
Late 16th century
d. 3,7cm
Topkapı Palace Museum, 2/83

E 19 Destivan
17th century
l. 34 cm
Topkapı Palace Museum, 31/883

E 20 Ceremonial Wicker Shield
ca. 1560-1570
d. 62 cm
Topkapı Palace Museum, 1/2441

E 21 Rock Crystal Mace
Early 17th century
l. 80 cm
Topkapı Palace Museum, 2/727

E 22 Rock Crystal Mace with Eagle's Talons
17th century
l. 55 cm
Topkapı Palace Museum, 2/713

E 23 Green Glass Mace
17th century
l. 70 cm
Topkapı Palace Museum, 2/724

E 24 Flintlock Pistol
by Hacı Mustafa (on the barrel) and
Ahmed (on the trigger)
First quarter of the 18th century
l. 47 cm
Topkapı Palace Museum, 1/4090

E 25 Flintlock Musket
18th century
l. 155 cm
Military Museum, 1902

E 26 Skullcap
18th century
h. 18 cm; d. 17 cm
Topkapı Palace Museum, 13/1950

E 27 Çizmeci Leather Boot
ca. 1566-74
h. 53 cm
Topkapı Palace Museum, 2/4440

E 28 Çizmeci Leather Boot
ca. 1566-74
h. 53 cm
Manisa Museum

E 29 Gold-thread Embroidered Sash
Mid 16th century
l. 217 cm; w. 28 cm
Topkapı Palace Museum, 31/49

E 30 Embroidered Child's Underware
18th century
h. 51 cm
Topkapı Palace Museum, 31/82

E 31 Embroidered Barber Cloth
19th century
l. 173 cm; w. 125 cm
E. and N. Akın, 12

E 32 Embroidered Women's Dress
19th century
l. 140 cm; sleeves l. 141 cm;
skirt: 154 cm
E. and N. Akın, 29

E 33 Single Page from "La Saison Journel,
Illustré des Dames" VII, no. 4–16, p. 206
Febrier 1874
h. 38.4 cm; w. 27 cm
Topkapı Palace Museum, D. 6914

E 34 Silver Box
19th century
l. 31 cm; w. 19 cm; h. 14 cm
Museum of Turkish and
Islamic Arts, 38

E 35 Silver Box
19th century
l. 50 cm; w. 26 cm; h. 17 cm
Museum of Turkish and
Islamic Arts, 43

E 36 Silver Mirror
Second half of 19th century
d. 38 cm
Museum of Turkish and
Islamic Arts, 3646

E 37 Silver Candlestick
Early 17th century
h. 117,5 cm;
d. at the bottom: 75,5 cm;
Museum of Turkish and
Islamic Arts, 93 A-B

E 38 Silver Basin
1840-1 (H. 1256)
h. 10,8 cm; d. 32,5 cm
Topkapı Palace Museum, 16/865

E 39 Porcelain Incense-burner with Silver Lid
Second half of 17th century
h. 40,5 cm; d. 22 cm
Topkapı Palace Museum, 15/10912

E 40 Silver Filigree Incense-burner
Late 19th century
h. 19 cm
Museum of Turkish and Islamic
Arts, 5

E 41 Silver Filigree Rosewater Sprinkler
Late 19th century
h. 22,5 cm
Museum of Turkish and Islamic
Arts, 92

E 42 Silver Ewer
1840-1 (H. 1256)
h. 29 cm
Topkapı Palace Museum, 16/866

E 43 Copper Bowl
Early 16th century
h. 25 cm; w. 47 cm
Topkapı Palace Museum, 25/3216

E 44 Gilt-copper Jug
19th century
h. 39 cm; d. at the bottom: 13 cm
Museum of Turkish and Islamic
Arts, 4220

E 45 Gilt-copper Jug
Second half of 18th century
h. 21 cm
Museum of Turkish and
Islamic Arts, 290

E 46 Gilt-copper Bowl
19th century (H. 1233)
h. 23,5 cm; d. at the rim: 19,8 cm;
d. at the base: 10,2 cm
Topkapı Palace Museum, 25/3796

E 47 Gilt-copper Dish with a Lid
18th-19th century
h. 14,5 cm; d. 17 cm
Topkapı Palace Museum, 25/3774

E 48 Gilt-copper Bowl
18th century
h. 9,8 cm; d. at the rim: 16,7 cm;
d. at the base: 8 cm
Topkapı Palace Museum, 25/3795

E 50 Koran Box
Second quarter of 16th century
h. 115 cm; h. of the dome: 39 cm;
w. 47
Museum of Turkish and Islamic
Arts, 6

E 51 Book Stand
Mid 16th century
closed l. 82 cm; w. 29 cm
Museum of Turkish and
Islamic Arts, 127

E 52 Kanun, A Stringed Musical Instrument
19th century
l. 96 cm; w. 39cm
Topkapı Palace Museum, 8/867

E 53 Jeweled Zinc (Tutya) Flask
ca. 1500
h. 58,5 cm; d. 22,5 cm
Topkapı Palace Museum, 2/2877

E 54 Jeweled Zinc (Tutya) Lidded Jug
16th century
h. 13,5 cm; d. at the rim 7,7 cm;
d. on the body 11,5 cm;
d. at the foot 6,5 cm
Topkapı Palace Museum, 2/2873

E 55 Jeweled Zinc (Tutya) Lidded Jug
Lathe operator signed "work of
Hüseyin"
16th century
h. 13,5 cm; d. 11,5 cm
Topkapı Palace Museum, 2/2863

E 56 Spoon
18th century or later
l. 17 cm
Topkapı Palace Museum, 2/2472

E 57 Spoon
18th century or later
l. 24,5 cm
Topkapı Palace Museum, 2/2455

E 58 Spoon
18th century or later
l. 27 cm
Topkapı Palace Museum, 2/2590

E 59 Spoon
18th century or later
l. 27 cm
Topkapı Palace Museum, 2/2626

E 60 Spoon
18th century or later
l. 24 cm
Topkapı Palace Museum, 2/2542

E 61 Spoon
18th century or later
l. 20 cm
Topkapı Palace Museum, 2/2488

E 62 Spoon
18th century or later
l. 17 cm
Topkapı Palace Museum, 2/2422

E 63 Spoon
18th century or later
l. 25,5 cm
Topkapı Palace Museum, 2/7713

E 64 Register of the Artists and the Craftsmen
(Ehl-i Hiref Defteri)
1624 (H. 1033)
h. 41 cm; w. 14,5 cm; 12 folios
Topkapı Palace Museum, D. 489